GENE KLOSS ETCHINGS

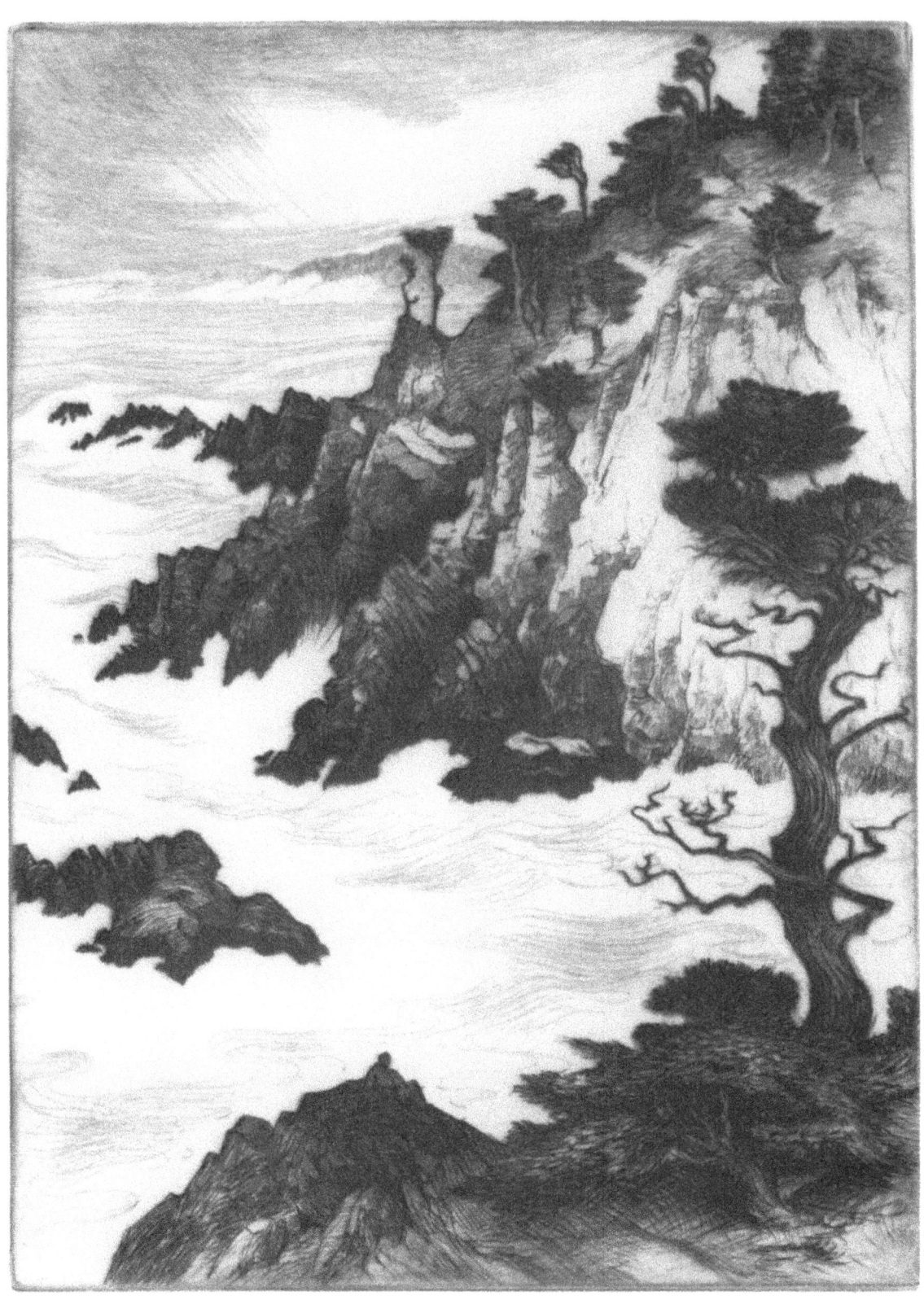

Strength From The Sea

GENE KLOSS ETCHINGS

Text By Phillips Kloss

SUNSTONE PRESS

SANTA FE

© 2000 by SUNSTONE PRESS
All Rights Reserved.

No part of this book may be reproduced in any form or by any electronic or mechanical means including information storage and retrieval systems without permission in writing from the publisher, except by a reviewer who may quote brief passages in a review.

Sunstone books may be purchased for educational, business, or sales promotional use. For information please write: Special Markets Department, Sunstone Press, P.O. Box 2321, Santa Fe, New Mexico 87504-2321.

Library of Congress Cataloging-in-Publication Data:

Kloss, Gene, 1903–
 Gene Kloss etchings.

 1. Kloss, Gene, 1903-1996 I. Kloss, Phillips Wray, 1902-1995
ll. Title
NE2012.K6A4 1981 769.94'4 81-16737
ISBN: 0-86534-008-0 AACR2

Published by SUNSTONE PRESS
 Post Office Box 2321
 Santa Fe, NM 87504-2321 / USA
 (505) 988-4418
 FAX (505) 988-1025
 www.sunstonepress.com

CONTENTS

7 Introduction

13 PLATES & COMMENTARY

14 Desert Drama / 575
16 High In The Rockies / 524
18 Whisper-Haunted Cliff Cave / 556
20 Turtle Dance At Sunrise / 391
22 Indian Moonlight Song / 251
24 Taos Eagle Dancers / 458
26 Enduring Sanctuary / 561
28 Church Of The Storm Country / 374
30 Penitente Fires / 359
32 Penitente Prayer / 349
34 Penitente Easter / 580
36 February In The San Juans / 523
38 New Mexico Harvest / 358
40 Gorge Shadows / 402
42 Cottonwoods And Adobe / 346
44 Late Sunlight On The Cliffs / 377
46 City / 329
48 Fog Over The Golden Gate / 455
50 On The Rocks / 409
52 Cable Spinning – San Francisco Bay Bridge / 327
54 Pacific Coast Evening / 444
56 Strength From The Sea / 355
58 Desert Peaks / 344
60 Exiled / 423
62 War's End / 417
64 Survival / 422
66 Indian Pueblo / 292

68 Christmas Eve–Taos Pueblo / 295
70 Return Of The Processional / 518
72 Taos Devil Dance / 315
74 Taos Indian Jesters / 397
76 Horseplay Of Indian Jesters / 454
78 Indian Jesters Making Dust / 443
80 Song of Creation / 435
82 Here Come The Singers / 390
84 Circle Dance / 357
86 Moonlit Kiva / 452
88 Fiesta Afternoon / 497
90 Pueblo Leader / 506
92 Indian Singer / 504
94 Old Indian Chief / 279
96 Santiago / 271
98 Manuelita / 470
100 Corn Dance Maiden / 555
102 Crusita / 505
104 Reflection / 527
106 The Visitor's Tale / 538
108 Deer Dance / 531
110 Rabbit Hunters On The Way / 545
112 The Old Road To Taos / 428
114 Yesteryear In Talpa / 558
116 The Valley of Valdez / 553
118 Taos Valley In Winter / 548
120 Winter Sunrise / 576
122 Hondo Valley Westward / 571
124 "Quoth The Raven, Nevermore" / 559
126 Eve Of The Green Corn Ceremony / 306
128 Domingo Basket Dance / 562

120 On Christmas Day / 581
132 Winter Solstice Dance / 491
134 Pueblo Feather Dance / 543
136 Age-Old Rhythm / 539
138 San Felipe Buffalo Dance / 493
140 Song Of The Buffalo Hunt / 584
142 Young Apache Wife / 457
144 Wintertime Dance – Cochiti / 579
146 End Of Dance – Cochiti / 578
148 Blessings On San Felipe Day / 570
150 Shadowed Buttes / 595
152 Roadside Pottery Vendors / 591
154 Old Pueblo Road / 566
156 Trip To Town / 592
158 Centuries Old / 583
160 Forsaken Church
 At The Edge Of The Great Plains / 590
162 Timsy Sleeping / 407
164 Magpies And Red-Tailed Hawk / 492
166 Force And Fate / 501
168 Indian Infusion / 508
170 Turtle Dance – Taos Pueblo / 348
172 Tribute To The Earth / 542

175 / CATALOGUE RAISONNÉ

INTRODUCTION

A sense of beauty is no longer acknowledged the primary incentive of art. The term is too relative, since what may seem beautiful and significant to one person may seem repulsive, banal, inane to another. Nevertheless, it is her own sense of beauty that distinguishes all of Gene Kloss's work, whether etchings, watercolors or oils. She draws or paints what she honestly feels is worth representing.

The etchings in this volume constitute not only an aesthetic record but also a historical record. She has done over six hundred copper plate etchings, too many to be included in one book, and we have selected the ones that reveal the full scope of her work. A biographical sketch of the salient events of her life may help illuminate the historical aspect and aesthetic scope.

She was born Alice Geneva Glasier in Oakland, California in 1903 at a time when oaks still grew around and in her native city, a time when the San Francisco Bay was still uncluttered by bridges and neon lights and the Golden Gate was the enchanted portal for the ships of the world. One of her first etchings depicted the web-like silhouette of the masts and riggings of the Alaska packers harbored side by side in the Oakland estuary, relics of a bygone age. She was fortunate in experiencing the natural beauty of California, her high school teachers and college professors all excellent. Authorities like Alfred Kroeber and Robert Lowie in anthropology were matched by authorities in other departments at the University of California, a stimulating atmosphere, the students serious, purposeful, idealistic. Perham Nahl, her instructor in life class and anatomy and himself a sensitive perfectionist draughtsman, gave a seminar course in etching which she attended one semester. He provided the class with basic information on materials, tools, and technique and let them go their own way. He was amazed at the first print she pulled from his huge hundred-year-old star-handled press, enthusiastically predicting she would be an etcher.

She graduated with honors in art at Berkeley in 1924, continued study at the San Francisco School of Fine Arts for the year term. In 1925 she married the present writer and shortened her name to Gene Kloss for phonetic reasons. Together they

set out to explore the Southwest, loading a large tent, camping equipment and small etching press in a small car. The roads were dirt, sand or gravel, often corduroy, often bare rocks and chuckholes, the accommodations were sparse and crude, but the adventure was adventure. The vast beautiful land fascinated us, and when we reached the border of New Mexico a saffron sunset throwing magic lights over the grama grass plain enthralled us and we became addicts.

The Indian impact in New Mexico focalized our mutual study of man and nature. But we claimstaked the whole Southwest from the Rocky Mountains to the sea our special province, established dual residences in Taos and Berkeley, commuted annually between the two places with wide tangent trips.

We were fortunate in seeing Taos in its primeval glory, the great Taos Mountain dominating the high crescent valley lifting the entire landscape skyward and you with it, green fields irrigated by the waters of seven mountain streams, sheep grazing the grass and sagebrush plain, Indians riding horseback singing as they rode, adobe houses and cottonwood groves, a quaint little plaza with hitching rails for horses and shade trees for people. Spanish types prevailed, a good-looking race, handsome men, strikingly pretty girls. They all seemed friendly and happy though some were extremely poor. Many of them raised their own food, ground their own wheat and corn in little grist mills called molinitos powered by waterwheels along the streams. Some of the Indians ground their own corn by hand the aboriginal way. Spanish, Indian and Anglo peoples got along well together. The artists were compatible and we understood why they had settled in Taos.

We rented an old adobe house at the foot of the hills for ten dollars a month for ten years, adding a few dollars extra every month, carried water from a spring a mile up canyon, cooked on a wood-burning stove, worked incessantly. Gene bought a secondhand Sturges etching press from a defunct Christmas-card shop and we felt it anchored us to Taos inasmuch as it weighed twelve hundred pounds. It had a geared turnwheel and lower block print press, quite an instrument, quite a personality. Then we gradually acquired forty acres of mesa land at the

northeast corner of the San Fernando de Taos Grant, built a three-room adobe studio house there, moved the press there, and thought we were settled for life. It was an idyllic place with a scrub forest of juniper and piñon trees, an irrigated glade, and an old pueblo ruin on a spur of the mesa. It was bordered on the east by the Carson National Forest land, on the north by the Indian reservation with a magnificent view of Taos Mountain.

In Berkeley we had built a redwood studio house on a ridgecrest opposite the Golden Gate with a view, always a view, thirty miles seaward to the Farallon Islands on the horizon curve, eastward to the Contra Costa hills and on a clear day the Sierra Nevada Mountains. Gene bought a duplicate Sturges press in order to keep working there. We retained the Berkeley place chiefly to take care of our two widowed mothers, never leaving them alone in their separate homes for over three months at a time. We regretted we couldn't take them with us back and forth, but they were confirmed Californiacs.

The contrast between the two places was good for us, a reciprocal stimulus. The seasons in New Mexico were part of the contrast, summer, autumn, winter all glorious, the colors of autumn breath-taking, the autumn air intoxicating. There is no spring season in New Mexico. There is in California, gorgeous wildflowers. The deaths of our two mothers and unexpected adversities forced us to sell both places. In 1965 we moved to Colorado, toting the Sturges press along, disassembling and reassembling it. We bought four acres on the Cory bench above the Gunnison River at the foot of Grand Mesa with a superlative view, always a view, of the San Juan range south, the West Elk Mountains east, and again thought we were settled for life. The people were hard-working fruit growers, truck and grain farmers, cattle and sheep ranchers, storekeepers, townspeople, every one of them likeable and admirable except for a few crusty offbeats. There were sketchable scenes everywhere, high mountain passes, high mountain lakes, deep steep canyons, torrential rivers, old ghost towns, remnant glamour towns such as Ouray and Telluride and Ophir and Silverton.

Every country has its drawbacks. Mosquitoes and black gnats are the curse of Colorado. And a serious allergy compelled our return to the Taos elevation and Taos climate. We built our final home in a sagebrush district with a 360-degree view, always a view, and bought a new motorized press to replace the old Sturges that had served Gene faithfully for forty-five years. But sentimentally and practically we keep the Sturges set up in the garage ready for instant use in case the electricity shuts off.

The economic struggle has been difficult but not inhibitive. We both avoided teaching jobs. I took various supportive jobs, and Gene's etchings sold fairly well at minimal prices. She was never concerned with the money-value of art. She won many prizes and honors, including election to the National Academy of Design. Her work has been exhibited internationally and is represented in many public and private collections.

Her main objective has always been to record her impressions of things she considers beautiful and important. She sketches direct, never resorts to photographs or trick contrivances. She has never subscribed to current fads or egregious contemporary edicts, believing that rhythm, balance, design, consonances, modulations are intrinsic to all art of all ages. The sense of beauty, the inspirations and aspirations of life, the affinities and friendships, the communication of ideas — these are the motivating forces of any true artist.

<div style="text-align: right">Phillips Kloss</div>

PLATES AND COMMENTARY

DESERT DRAMA
575

The Southwest was generally regarded as desert country in pioneer days despite the different elevations and different life-zones, from the impenetrable cholla of the Lower Sonoran Zone to the sage brush and junipers of the Upper Sonoran on up through the lush forest zones to timberline in the Arctic Alpine Zone. Wildflowers and wild animals flourish in every zone of the so-called desert, and the earth itself has a vivid variety of color and form, the cloud effects, storm effects often dramatic. Even on serene days it has a contrapuntal force to it, but lightning, thunder and one of those intense incredible double rainbows can attain a terrific climax.

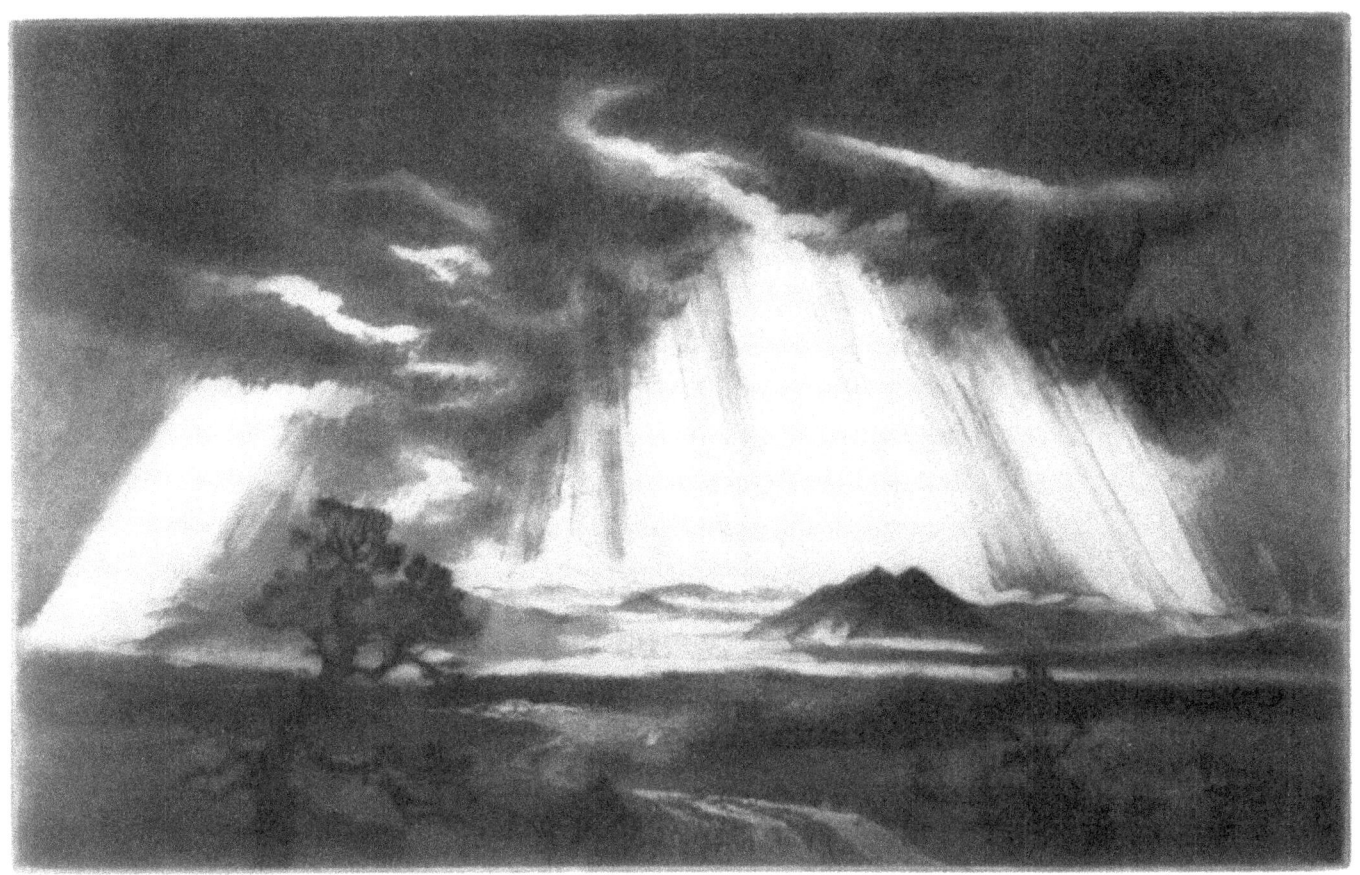

Desert Drama

HIGH IN THE ROCKIES
524

The Rocky Mountains are the backbone of North America, the Continental Divide, infinite wealth in them, gold, silver, copper, lead, zinc, tungsten, coal, uranium, turquoise, amethyst, chalcedony, opal, marble, alabaster, infinite beauty, wonderful forests and wildflowers, incomparable scenery. This etching and drypoint print is of a scene along the spur of the San Juan range between Ouray and Telluride, high country, divine country.

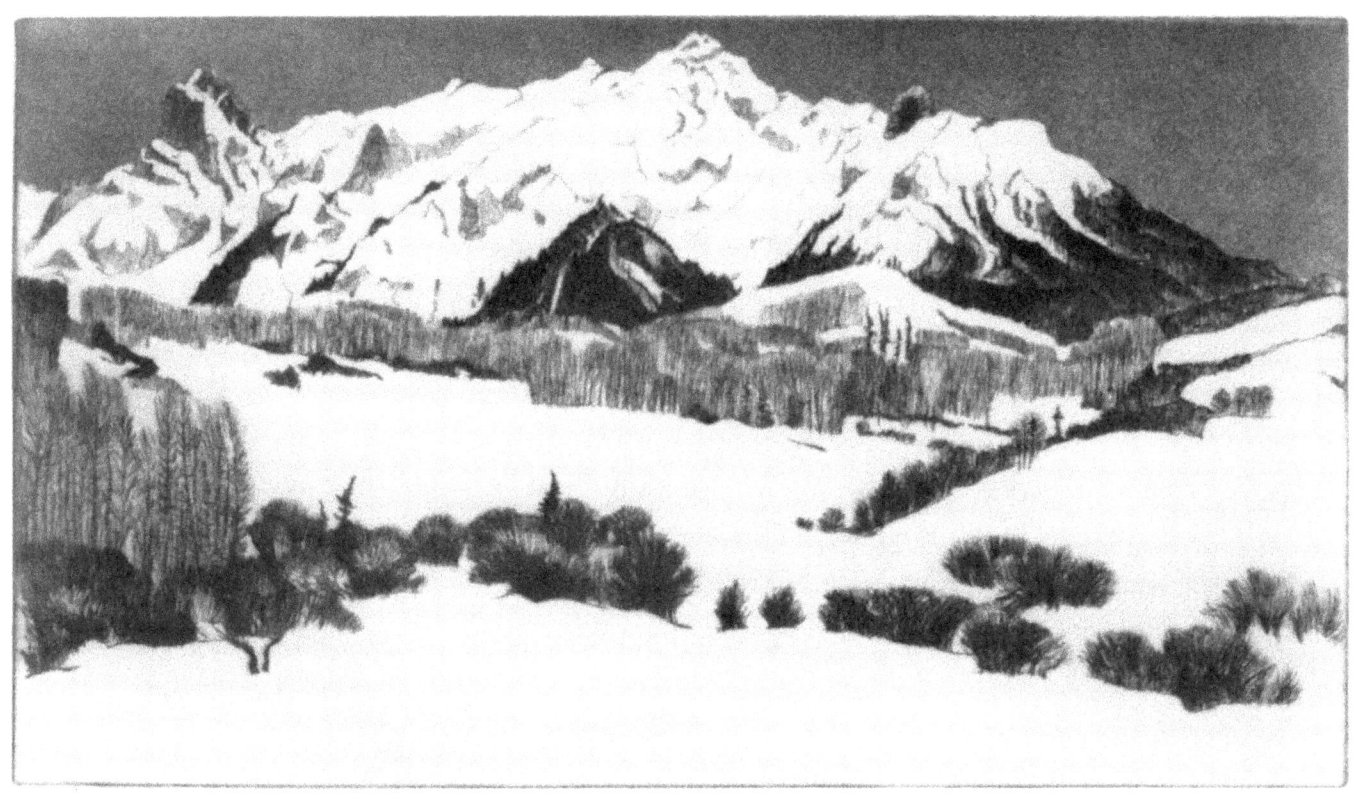

High In The Rockies

WHISPER-HAUNTED CLIFF CAVE
556

Archaeologists have preserved and restored some of the Mesa Verde cliffdwellings with remarkable fidelity. You can almost hear the ghosts of the people who once lived there whispering to you. They were a peaceful, independent, self-sufficient, aspiring people, their pottery and handicrafts marvelous, but no doubt they had taken refuge in more or less inaccessible cliff caves because of predatory enemies. In the 1930s Gene was given special permission to sketch anywhere she wished in Mesa Verde. One of her PWAP Government etchings happened to be hanging on the wall of the museum office and when she informed the director that she was the artist he gave her the invisible key to all the visible ruins. The etching herewith, however, was sketched in 1973 from the rimrock opposite the Spruce Tree House.

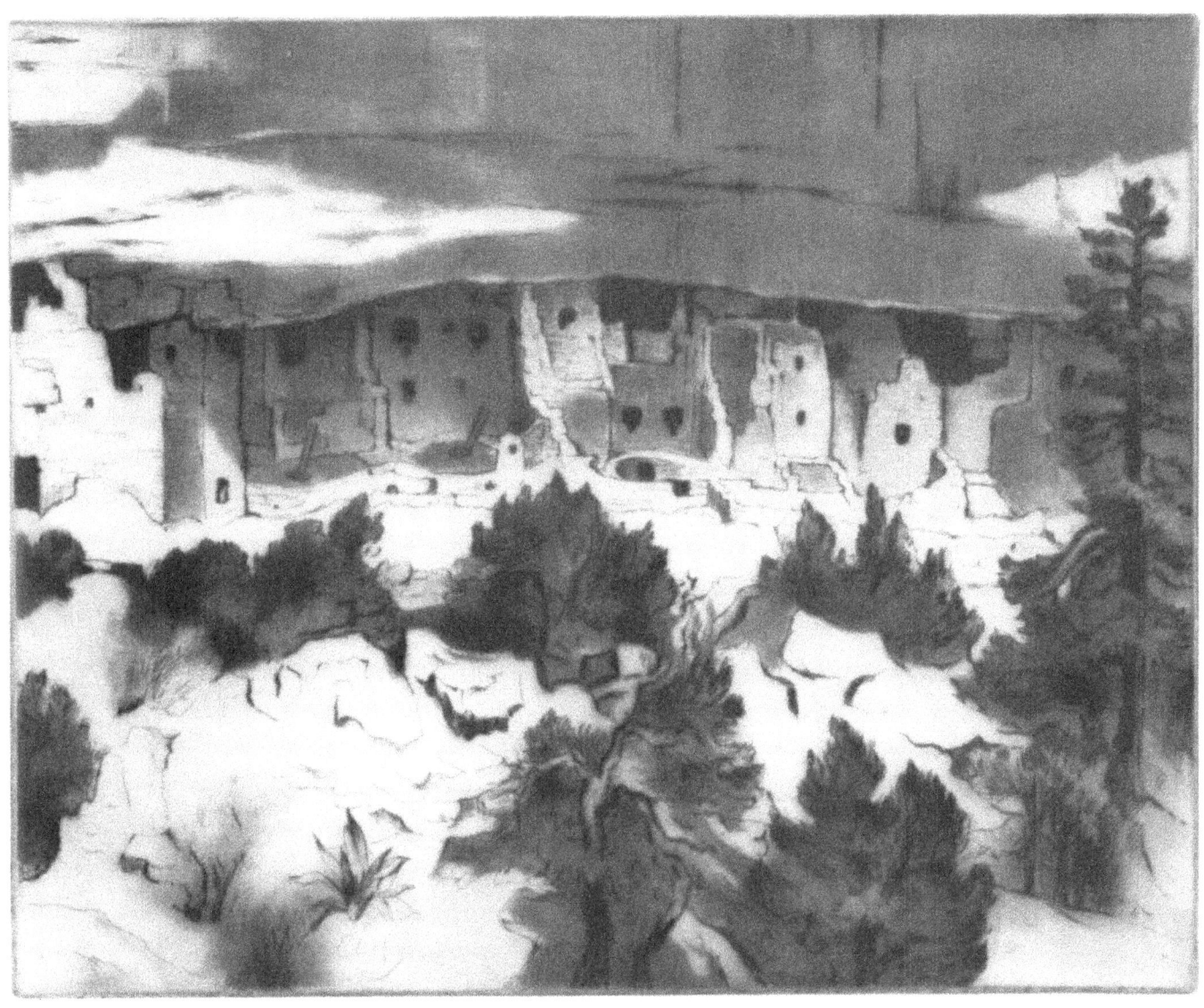

Whisper-Haunted Cliff Cave

TURTLE DANCE AT SUNRISE
391

When the sun turns north from the mountain notch
'Tis time for the Turtle Dance at Taos
The footsteps of the sun are slow
The footsteps falter in the snow
Dance and help the sun along
Dance and sing the Turtle Song.

So then at sunrise a line of men
Came from the kiva, from winter's den,
And faced the east and lifted their feet
In slow low rhythm to the slow drumbeat,
Their bodies bare in the icy air
Except for Awanyu kilts they wear,
And they chanted about the Turtle who
Swam on the floods the warm thaws brew,
Dove down deep and brought up mud,
Remade the hills so the trees could bud,
Remade the fields so the corn could grow,
Remade the greenness from under the snow.
Those are his footsteps pam pam pam
Walking on the earth where once he swam.

The drum beats louder, the song loud gay,
Spring is on the way,
Summer is i-cummin in, the joy of ancient chants,
Eternal resurrection, the winter solstice dance.

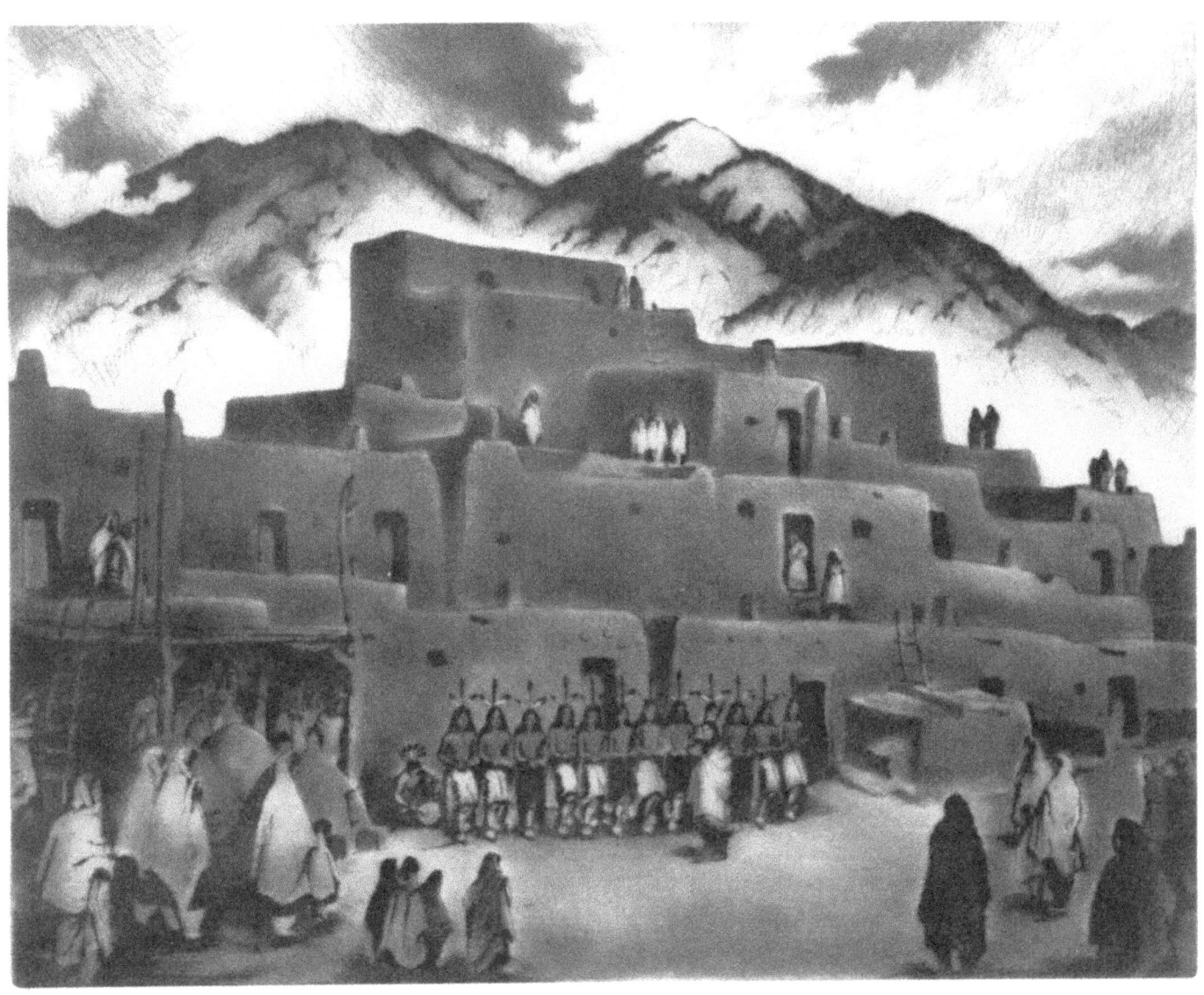

Turtle Dance At Sunrise

INDIAN MOONLIGHT SONG
251

Gathered on the log bridge across the mountain stream between the North House and South House, groups of Taos Indians sing their tribal songs at night. They all have good voices, their songs melodic and graspable, their Tiwa language full of musical vowels. Taos Tiwa is supposed to be the most archaic of Indian languages, indicating a very old origin of the people. The Moonlight Song has archaic sounds and intervals, difficult for the young Indians to sing. When we first heard it in 1928 we were fascinated by the strangeness of it. Years later, knowing we were interested in old Indian music, a longtime Indian friend brought his drum, sat by our fireplace and sang a sequence of songs for us. At the end he put the drum aside, stood up, and said: "Now I sing old old song nobodies hear before. Old old mans teach me this song. I don't see him around no more. He go away somewhere. He teach me this song." It had much stranger intervals than the Moonlight Song, minor and fatalistic, the construction ungraspable, no repetition of phrase. We felt a weird atavistic depth to it, something far back in the past we could never fathom.

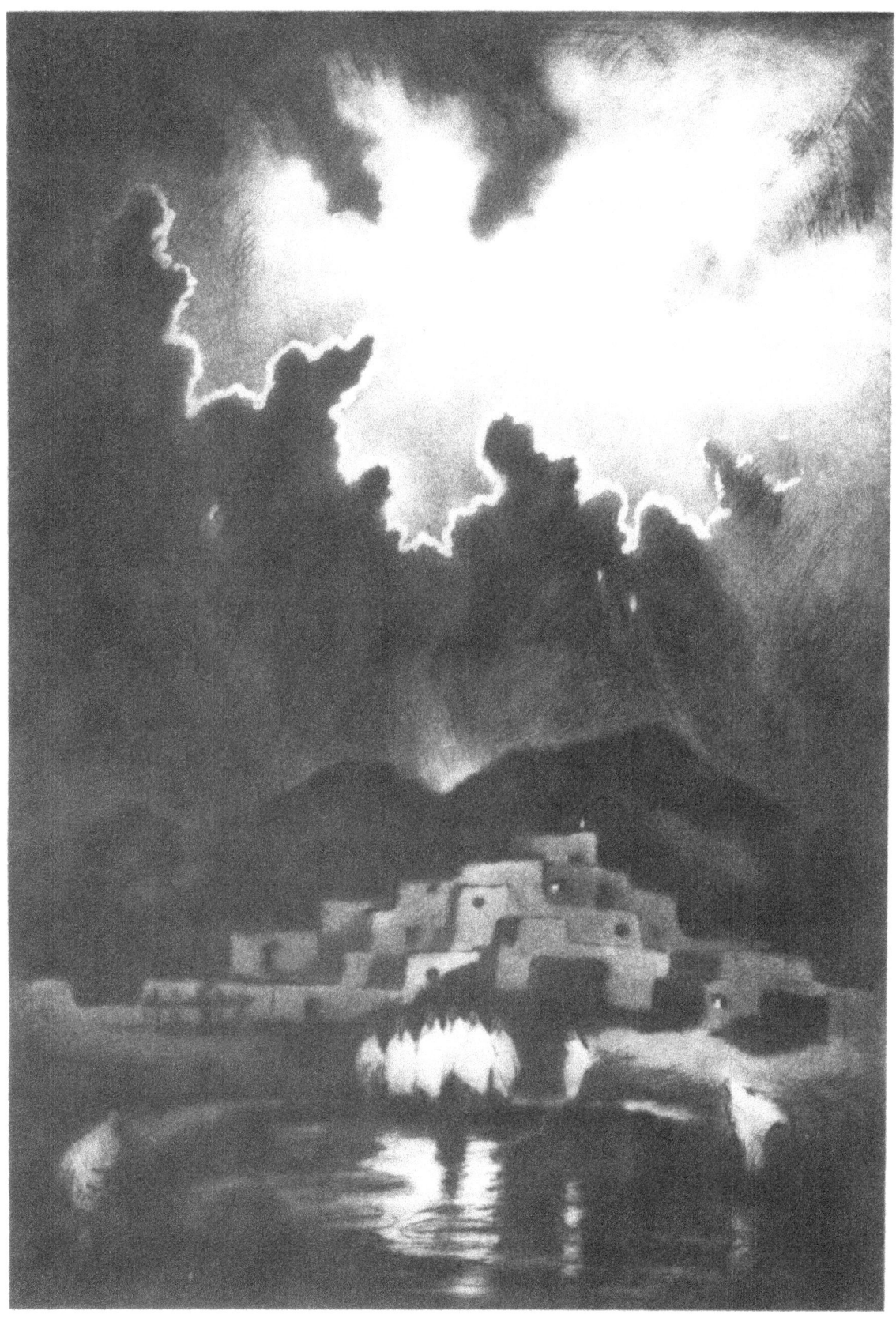

Indian Moonlight Song

TAOS EAGLE DANCERS
458

Red Deer, Pai-paĕna, was a sympathetic model willing to pose alone or with partners in the various positions of various entertainment dances such as the Taos Indians performed in public, Shield Dance, Horsetail Dance, Hoop Dance, Fire Dance, War Dance, Eagle Dance, never, of course, ceremonial dances. He was a famous dancer himself, managed his own troupe performing in cities from Coast to Coast. He trained his sons and grandsons to follow in his footsteps. The Eagle Dance simulates the movements of the great bird beating its wings to rise from the ground, lifting in the air, soaring in the sky.

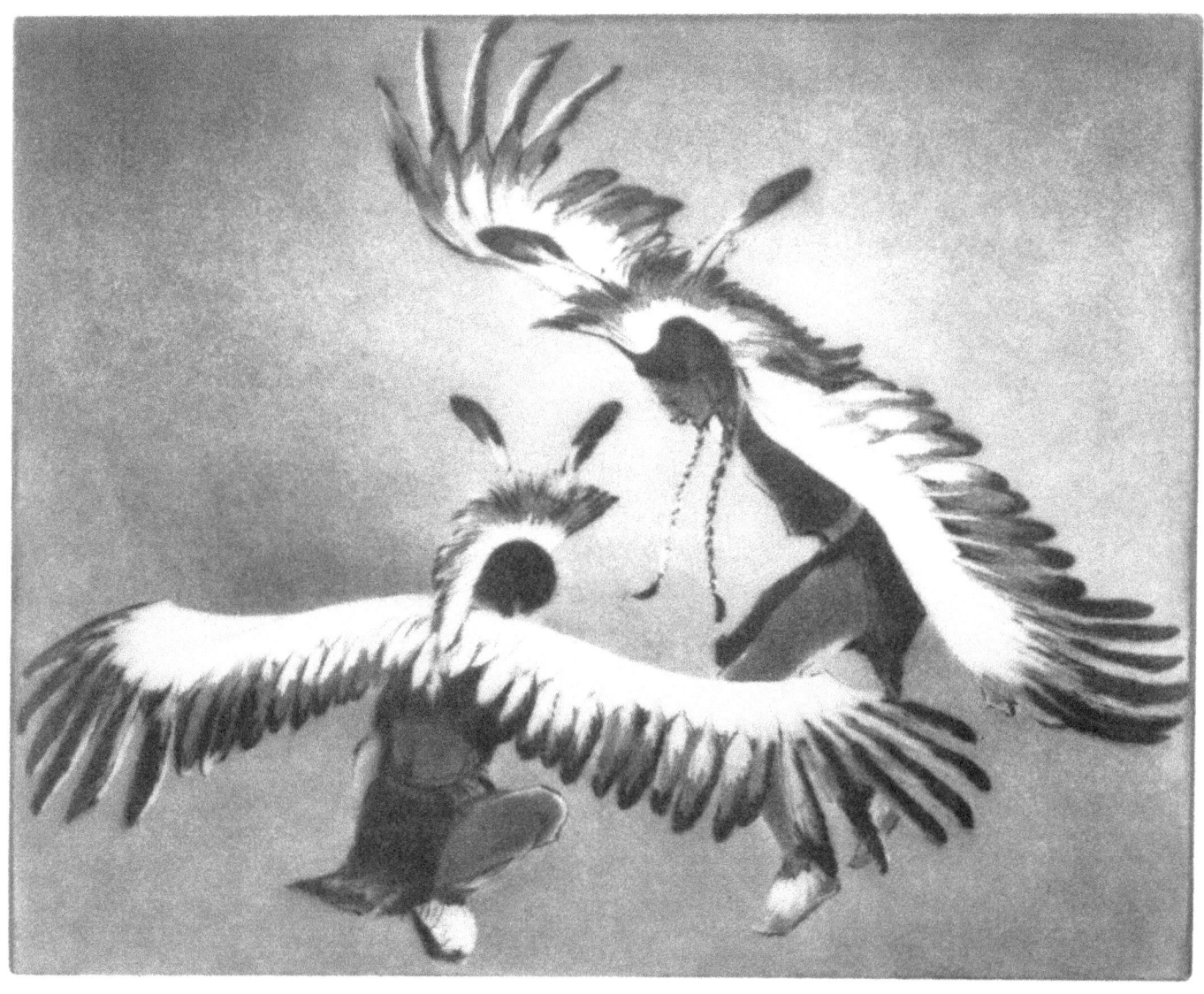

Taos Eagle Dancers

ENDURING SANCTUARY
561

The Franciscan mission church in Ranchos de Taos was built in the 1770s and has been in continual use ever since. It gave solace and security to the people of the Faith and is revered today by people of all faiths. Thousands of artists have drawn or painted the back of the Ranchos church, the huge adobe buttresses a unique composition.

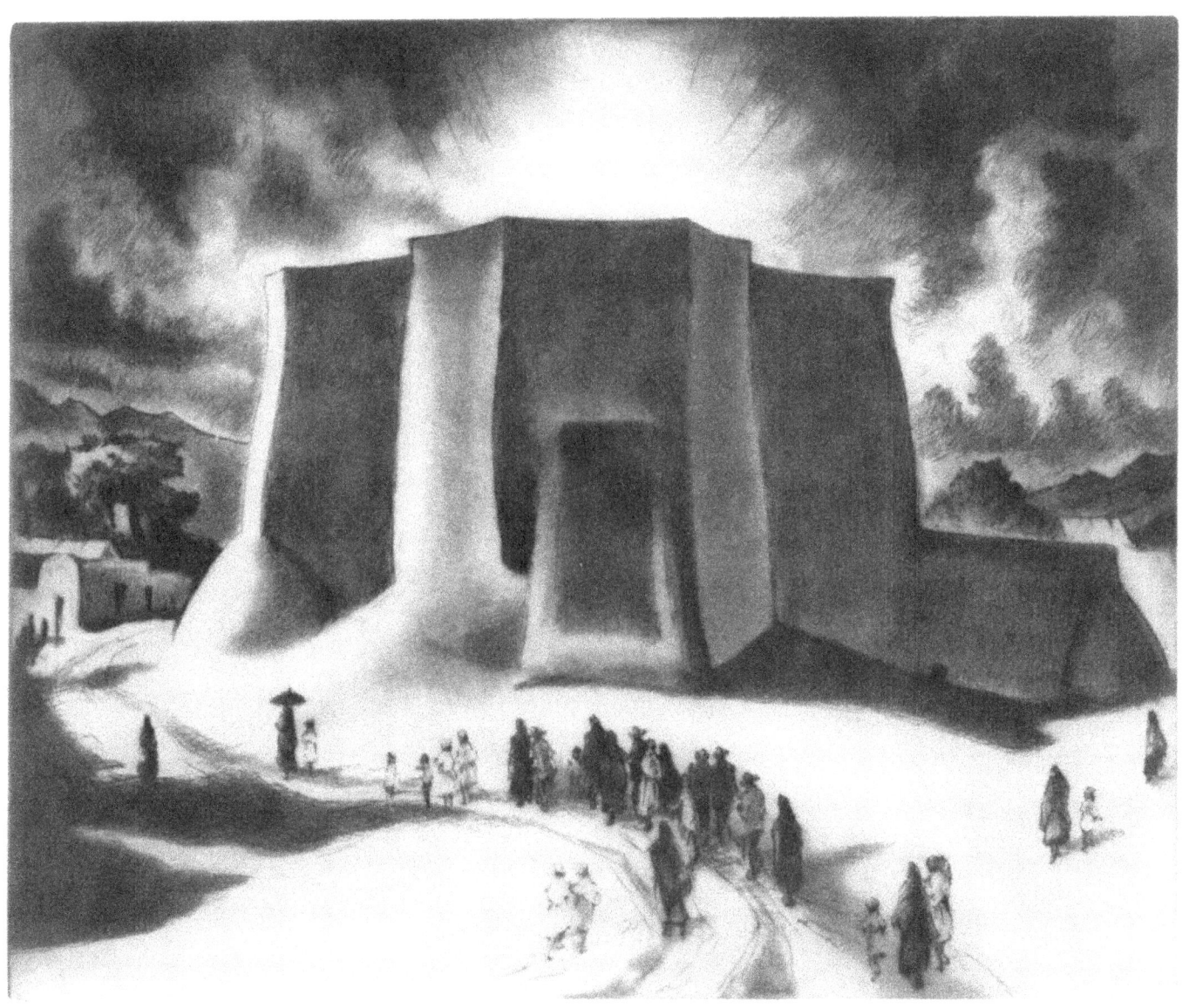

Enduring Sanctuary

CHURCH OF THE STORM COUNTRY
374

The remote Spanish Colonial villages were always Spanish, not Mexican. Their churches have been the nucleus of the little communities for nearly four hundred years, withstanding the storms of nature as well as the encroachments of outsiders. Juan de Oñate was the instigator of colonial expansion. His settlement at Yunque Yunque at the confluence of the Rio Grande and Chama River in 1598 was the center of dispersion. It was the first capital settlement in what is now the United States. Saint Augustine in Florida was merely a huddle of huts without official status. Santa Fe and Taos were offshoots of Yunque Yunque.

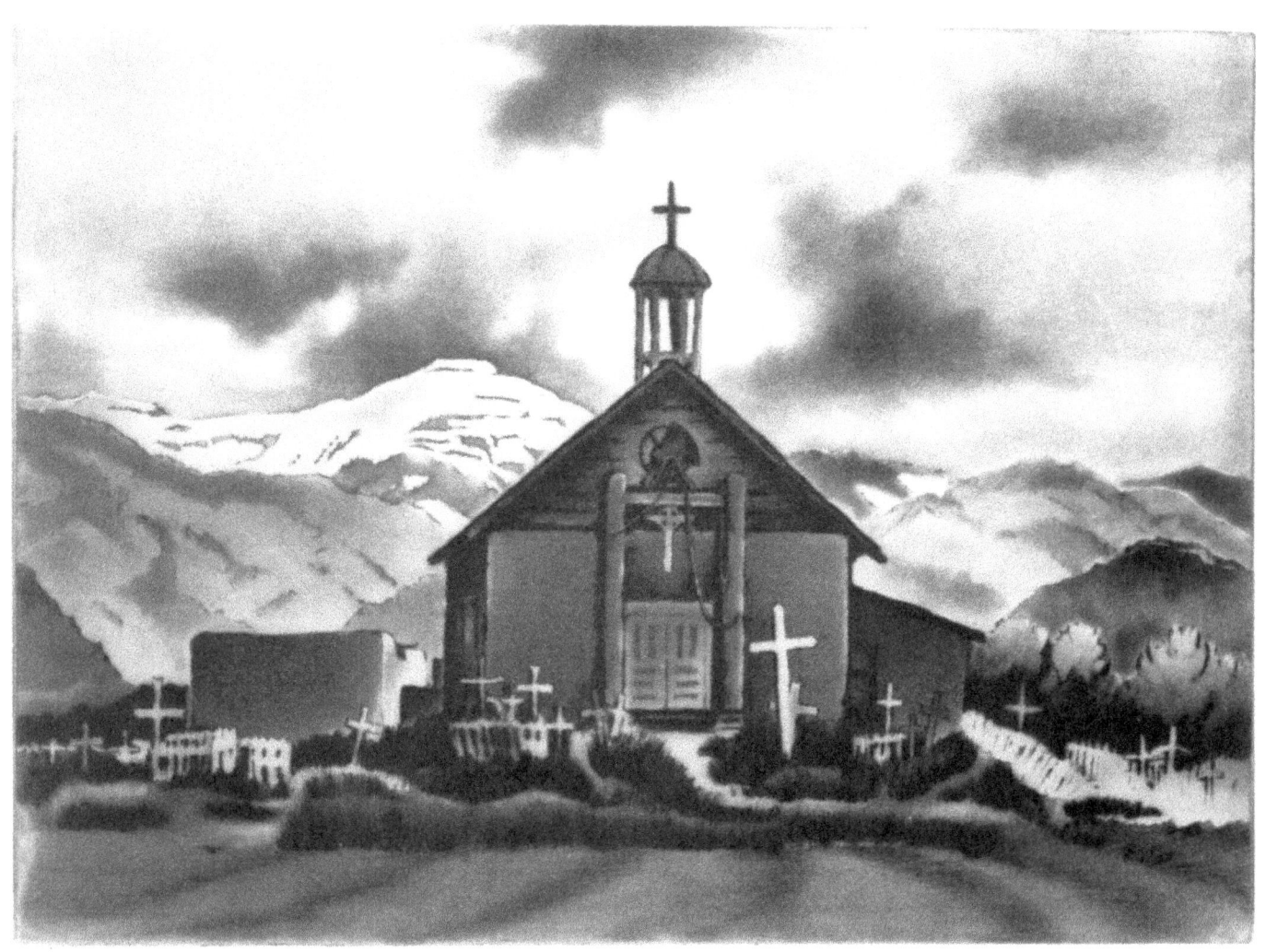

Church Of The Storm Country

PENITENTE FIRES
359

The adobe house we rented in Taos for ten years was situated across the road from a Penitente morada, a kind of death church. We never snooped on their activities but we couldn't help hearing their shrill fifes and dismal dirges at a funeral ceremony for one of their brotherhood, nor could we help seeing their night fires at Eastertime. Apparently they held imitation crucifixions on a large wooden cross in the hills behind the morada. The practice was discountenanced by orthodox Catholics. In fact the Penitentes were a separate sect. They came from Spain after the communities in New Mexico were well-established. Their flagellant penances were excessive.

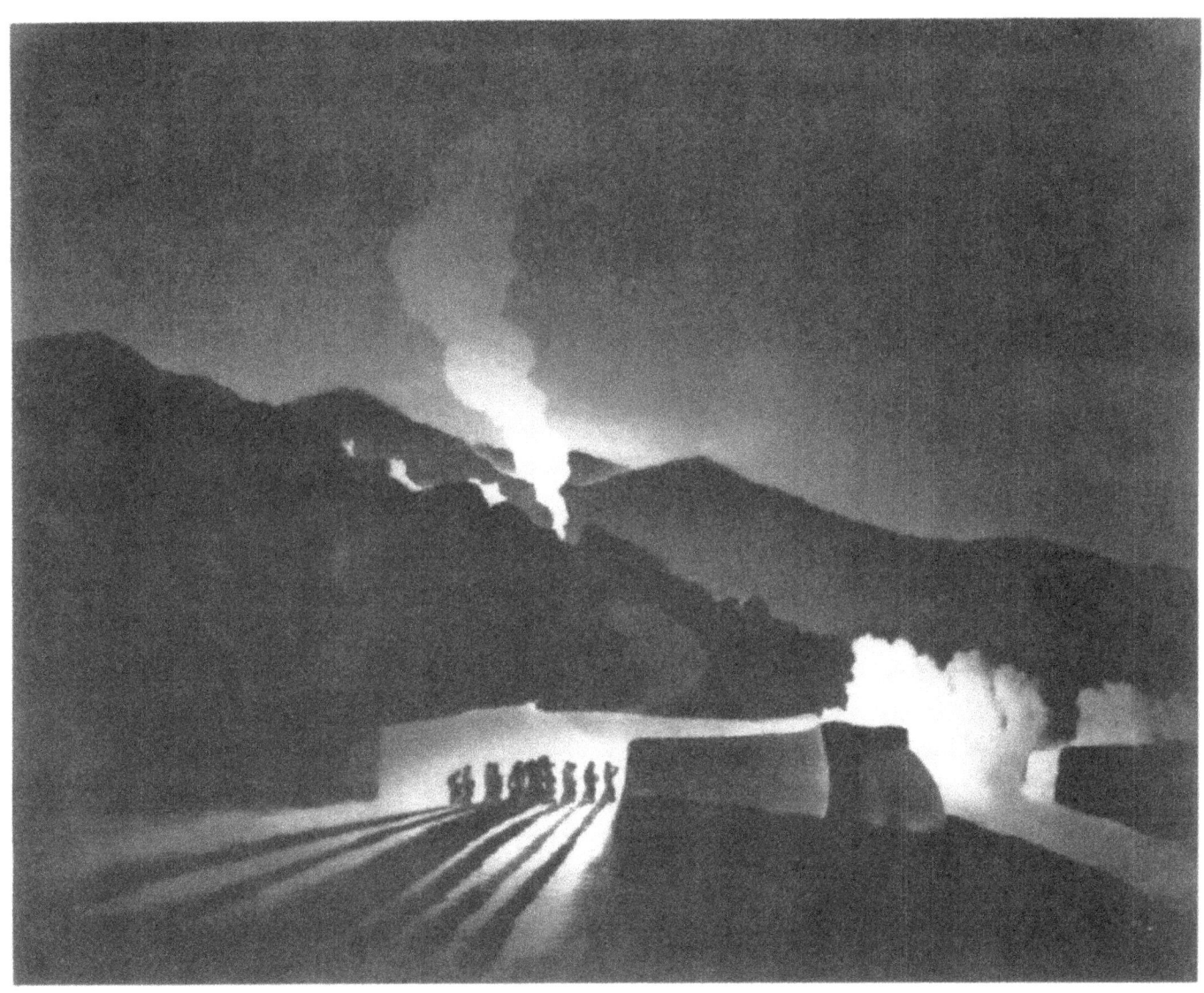

Penitente Fires

PENITENTE PRAYER
349

Prayer was the humble aspect of the Penitente rituals, group prayer, hence slightly ostentatious as to who was the most prayerful. The Deer Dance of the Taos Indians is a group prayer also, a petition to the spirits of the slain deer, begging their forgiveness for the necessity of obtaining venison, a pantheistic unity to it. The Penitente attitude was more egocentric, a petition to the spirit of Christ, have pity on me, dear Master, as I kneel here before thy Cross, save me from suffering and misfortune.

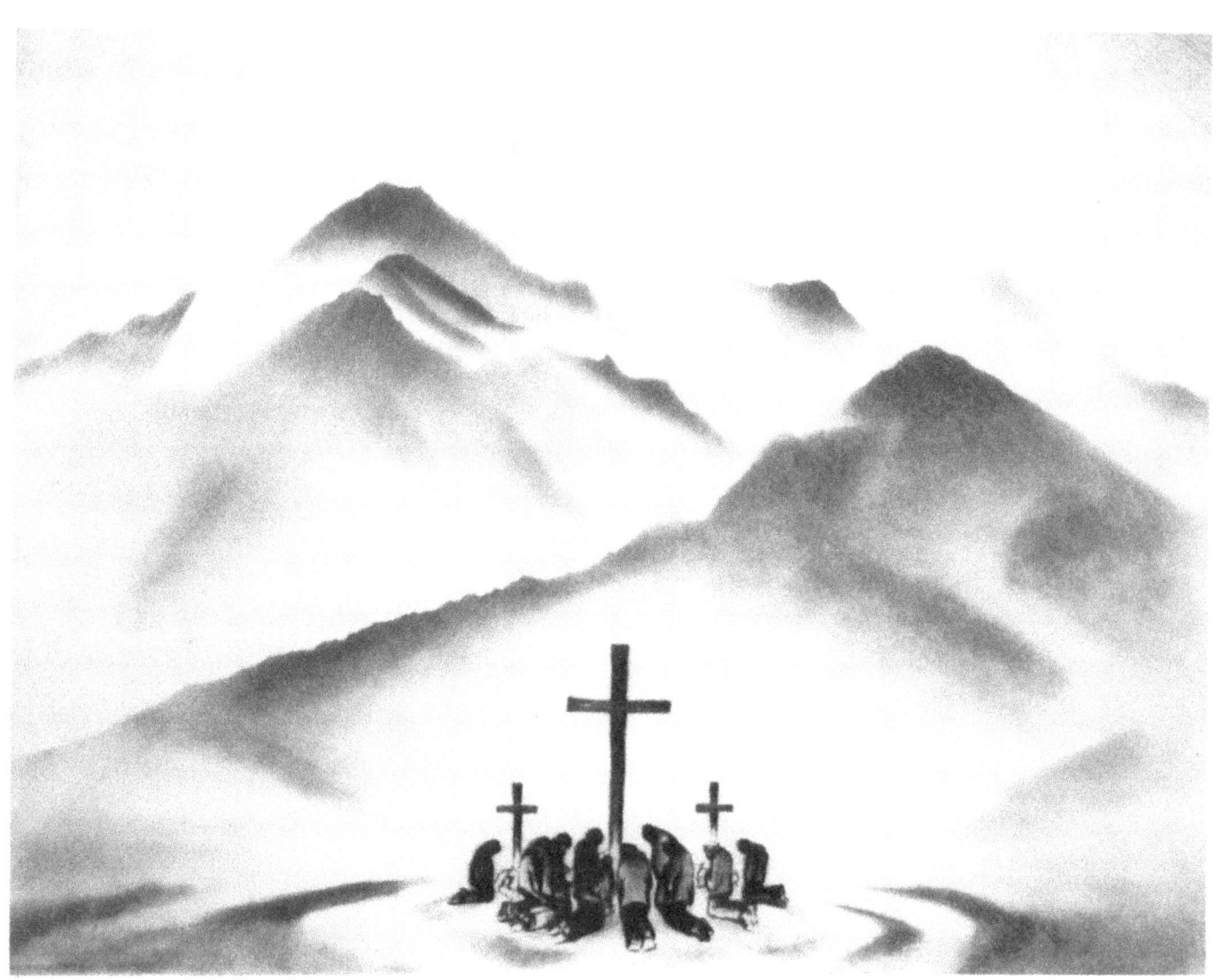

Penitente Prayer

PENITENTE EASTER
580

The main Penitente morada at Taos was located on Indian land just west of the glass gazebo house of Mabel Luhan, who was known as the-woman-who-married-an-Indian. There was nothing Indian in the Penitente ceremonies. At Eastertime we often watched their pilgrimages from the morada to the Cross and back. Our house lacked a glass gazebo but it had a flat observation roof and was located a discreet distance south of the morada. April clouds, Easter clouds are quick and ephemeral, throwing theatrical spotlights on the silver sage and adobe houses. The morada was more or less abandoned in the 1960s and the Kit Carson Museum bought it from the surviving Penitente members in 1979. Inasmuch as it is on Indian land the title is obscure. An Indian council years ago permitted the Penitentes to use the land, and the Bureau of Land Management backed it up with a grant of title. The identity of the morada is now as empty as the title.

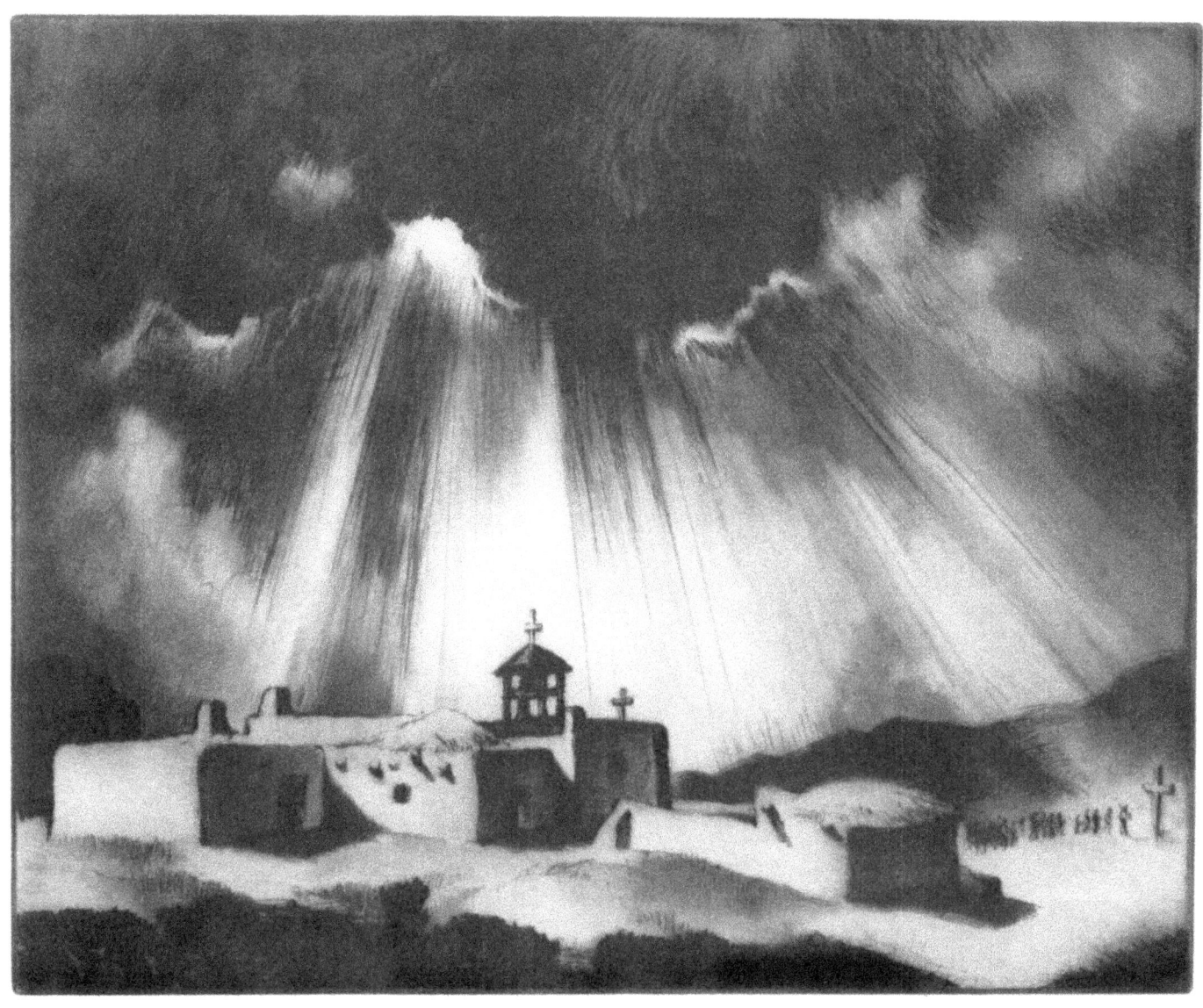

Penitente Easter

FEBRUARY IN THE SAN JUANS
523

In this scene you are looking at the richest mining district in the U.S.A. The mother lode extends from Telluride, Ophir and Rico to Ouray, Silverton and Lake City. Mt. Sneffels, or Snaefels, the center mountain here, is over 14,000 feet high, a peak above a vortex. On the other side of it is the famous Camp Bird mine, named for the Canada jay who is a camp robber and camp companion. He will intercept a flapjack tossed for a turn in the air from a frying pan or he will sit at the camp table with you sharing buttered slices of pancake soaked in syrup. The Camp Bird mine made millions for old Tom Walsh and his daughter Evalyn Walsh McLean, she who procured the Hope diamond and ruled Washington society. Any view of Mt. Sneffels is worth more than a million.

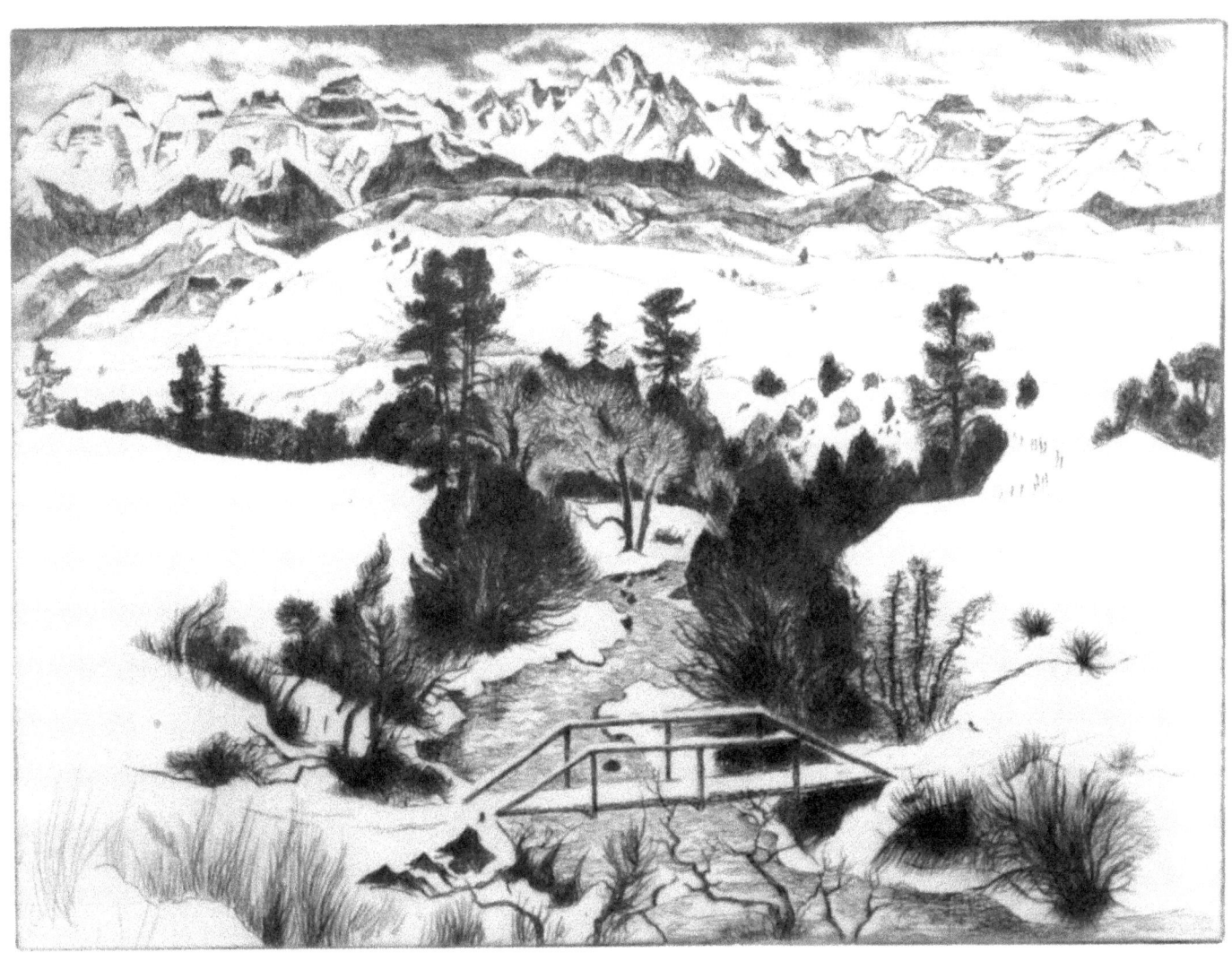

February In The San Juans

NEW MEXICO HARVEST
523

And the real economic wealth of America was and is the harvesting of crops. The Indians harvested corn, beans, squash, yucca pods for sugar, wild plums for fruit, plenty of wild game for meat. Today in northern New Mexico, the crops are winter wheat, corn, pinto beans, red potatoes, chili, apples, livestock, alfalfa. Before the advent of mowing machines and combines wheat was cut by sickle, the sheaves taken to a goat or horse corral and threshed by the trample of feet, winnowed by tossing the grain from wide baskets in the breezy air. This etching gets the essence of it, does it not?

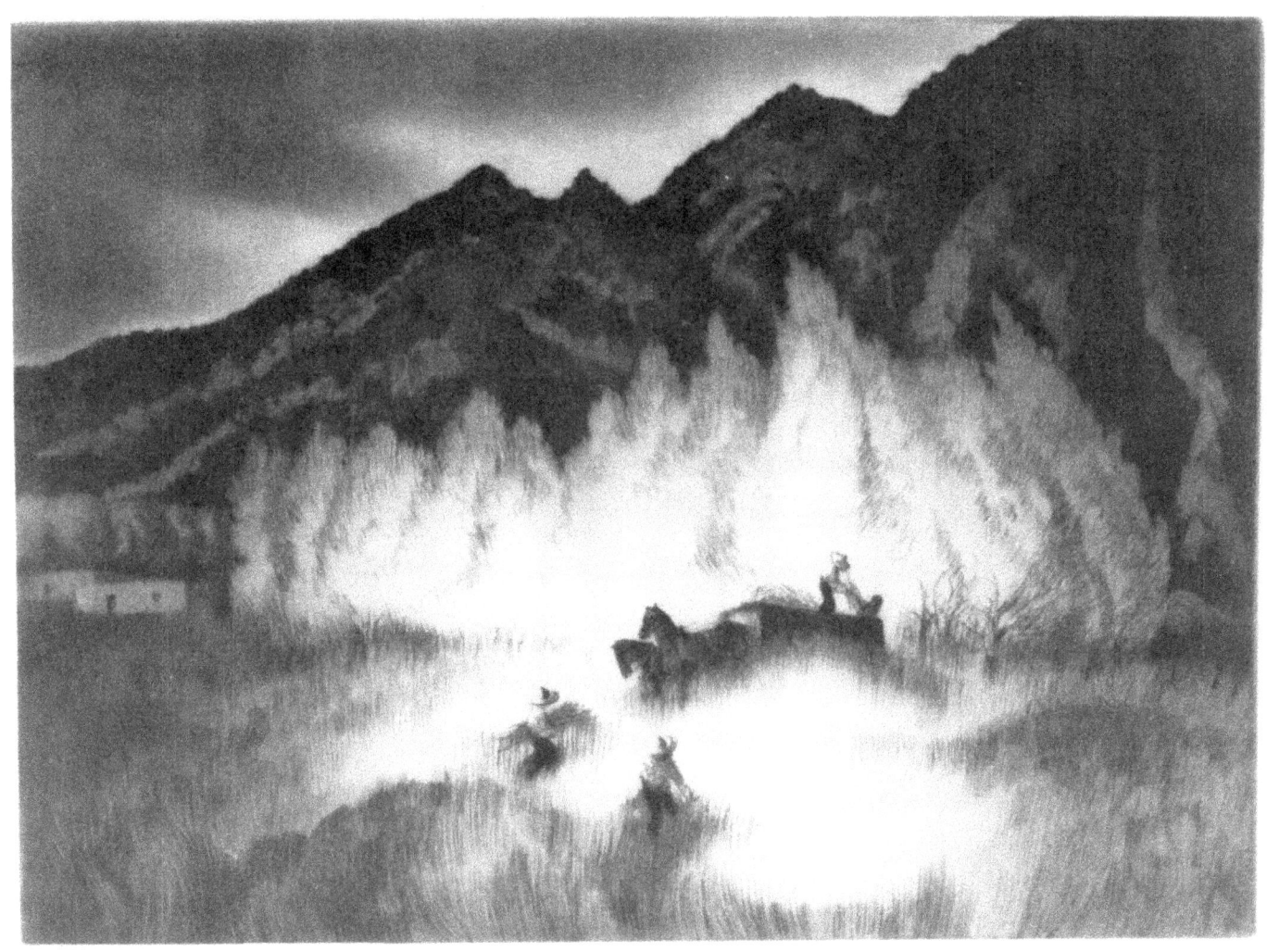

New Mexico Harvest

GORGE SHADOWS
402

The Rio Grande Gorge is a long basaltic cleft in the basin between the San Juan-Jemez range and the Sangre de Cristo range. It begins at the old Indian turquoise mine in Colorado and extends down to the Cochití Pueblo in New Mexico. The green Española Valley cuts across the black basalt and at Cochití the Government has built a colossal dirt dam impounding the Cochití Lake, otherwise the Gorge is wild and rugged. Even on a bright day there's a darkness to it, the shadows intense.

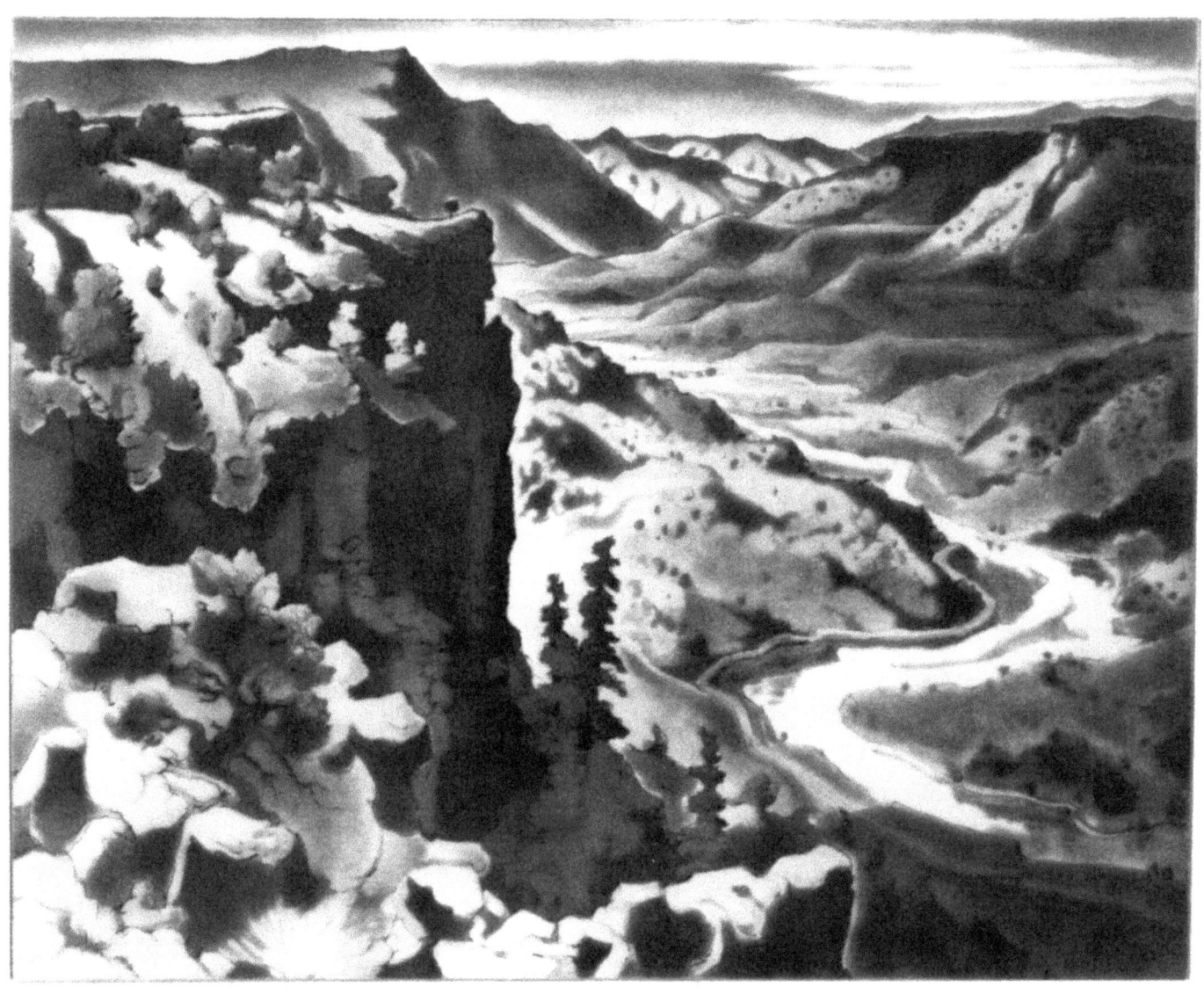

Gorge Shadows

COTTONWOODS AND ADOBE
346

An adobe house and cottonwood trees have a nostalgic appeal to all oldtime Taosians, and where a stream was available for water and a burro available to carry a load of firewood, sweet-smelling cedar or pungent piñon, life was complete. This familiar scene a mile north of the Taos plaza on the old road to Questa and Colorado has been rendered unrecognizable by a new highway and modern improvements. But the print still has a nostalgic appeal.

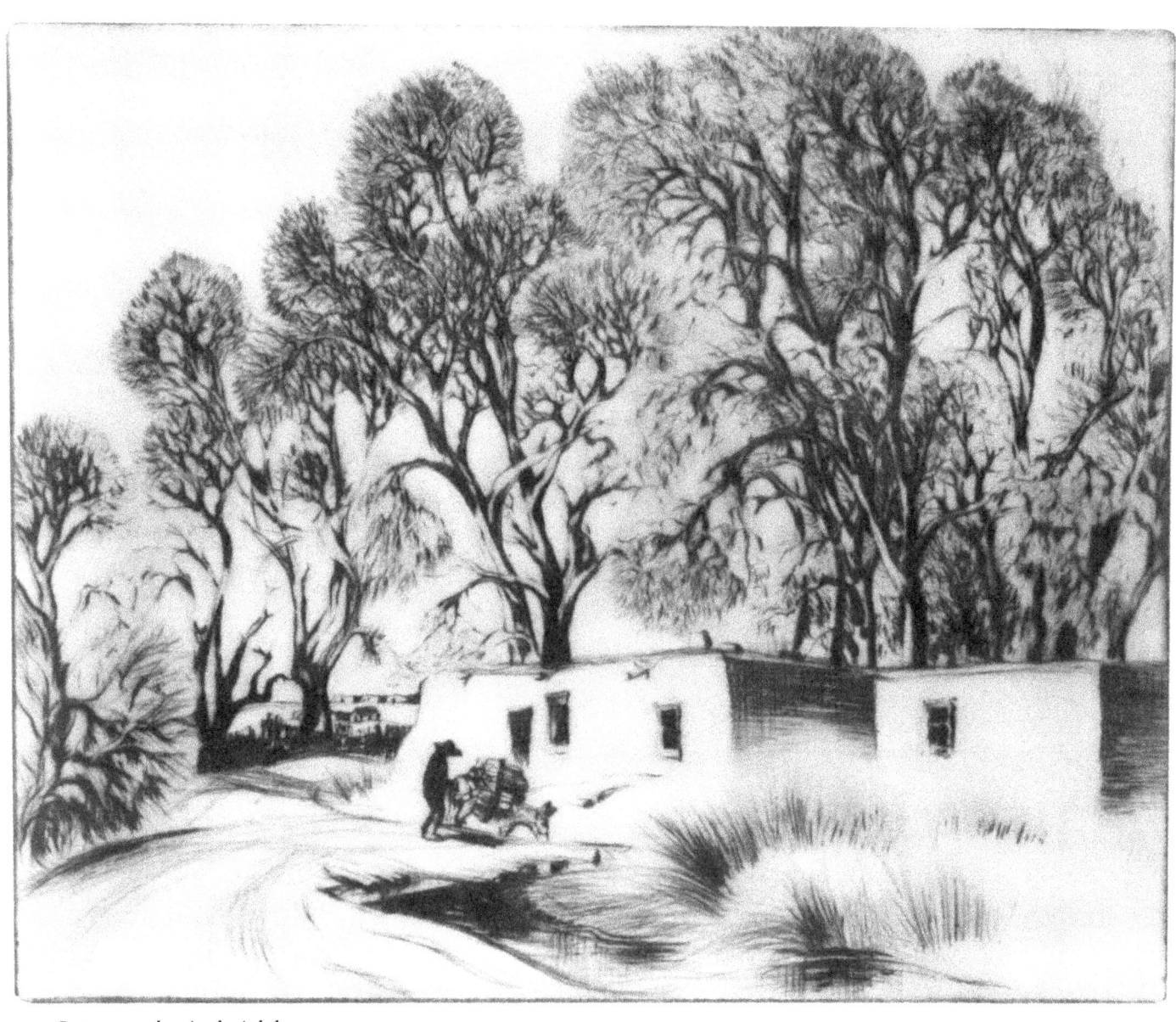

Cottonwoods And Adobe

LATE SUNLIGHT ON THE CLIFFS
377

Exploring a steep trailless ridge in the Hondo Canyon we found ourselves in a cliff-walled amphitheater stage-set with ponderosa pines and douglas fir. One pine was so sketchable that we returned the next afternoon properly equipped with drawing material and plenty of time for study and contemplation.

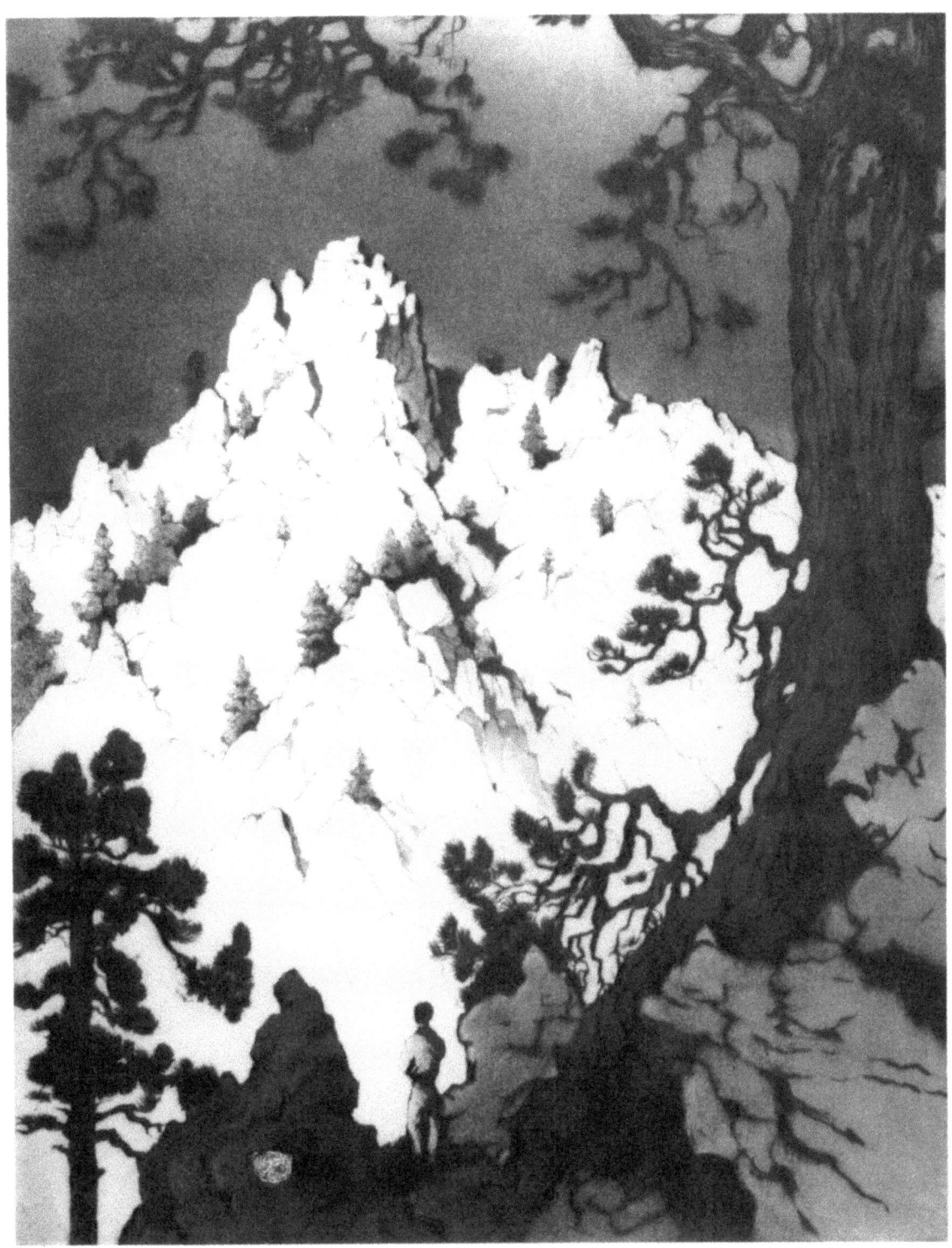

Late Sunlight On The Cliffs

CITY
329

In contrast to the structures that nature haphazardly creates, the structures that man builds are deliberate, symmetrical, artificial and often oppressing. We admire the great works of our architects and engineers, we are amazed at the machines and utilities our inventors produce, and we humbly take off our hats to the physicists and experts who can land a spaceship on the moon. The city is the centripetal centrifugal center of civilization, yet it is a menace to natural living. There is no reason to limit our experiments and explorations but we must limit the enormity of our cities with a more balanced population. San Francisco and Seattle once upon a time were very livable cities.

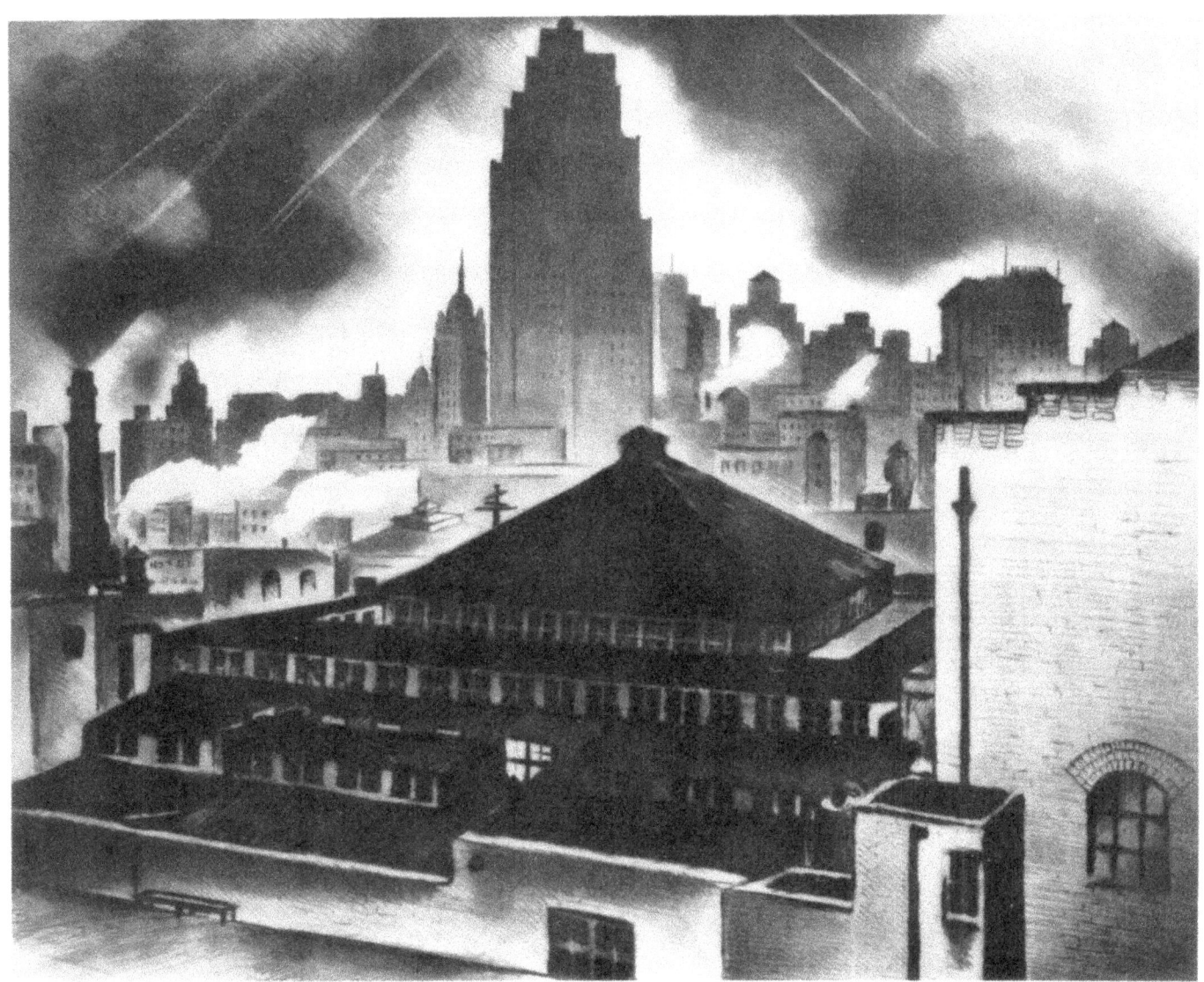

City

FOG OVER THE GOLDEN GATE
455

Crossing the Golden Gate bridge after a dull trip in the heat and haze of the Sonoma Valley, Gene suddenly grabbed her sketchpad and pencil and quick-stroked her impressions, the cool fog, cool water and the lone accentuating ship. The traffic was scant on the bridge. We drove slowly. The etching evolved.

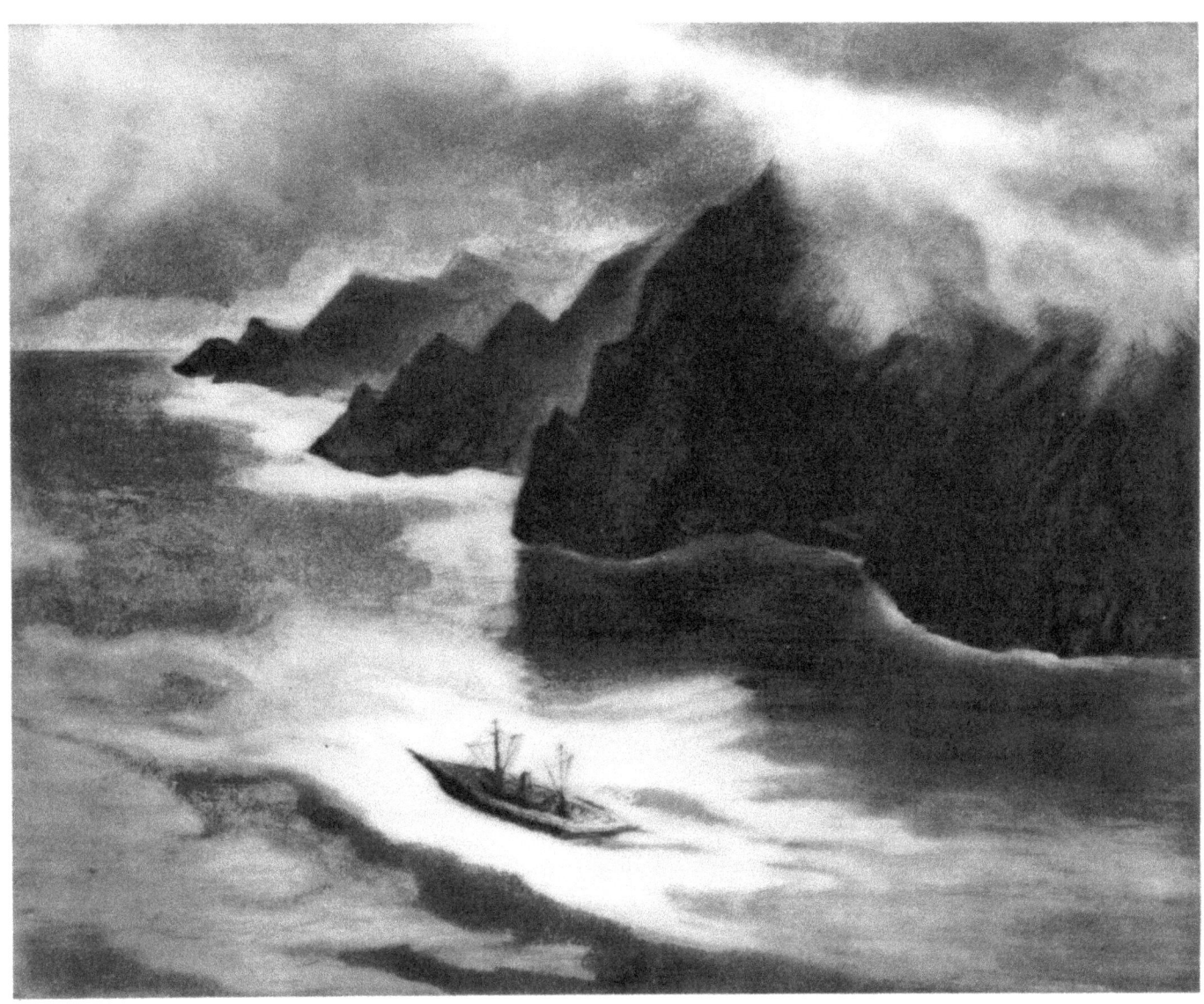

Fog Over The Golden Gate

ON THE ROCKS
409

In the widening strait outside the Golden Gate ships occasionally crashed on the rocks near Land's End during a heavy fog. In spite of modern detection and direction instruments ships still crash. The wreck shown here hung on the rocks for over a decade. At low tide it was sometimes boarded by beachcombers and curiosity seekers. They got wet.

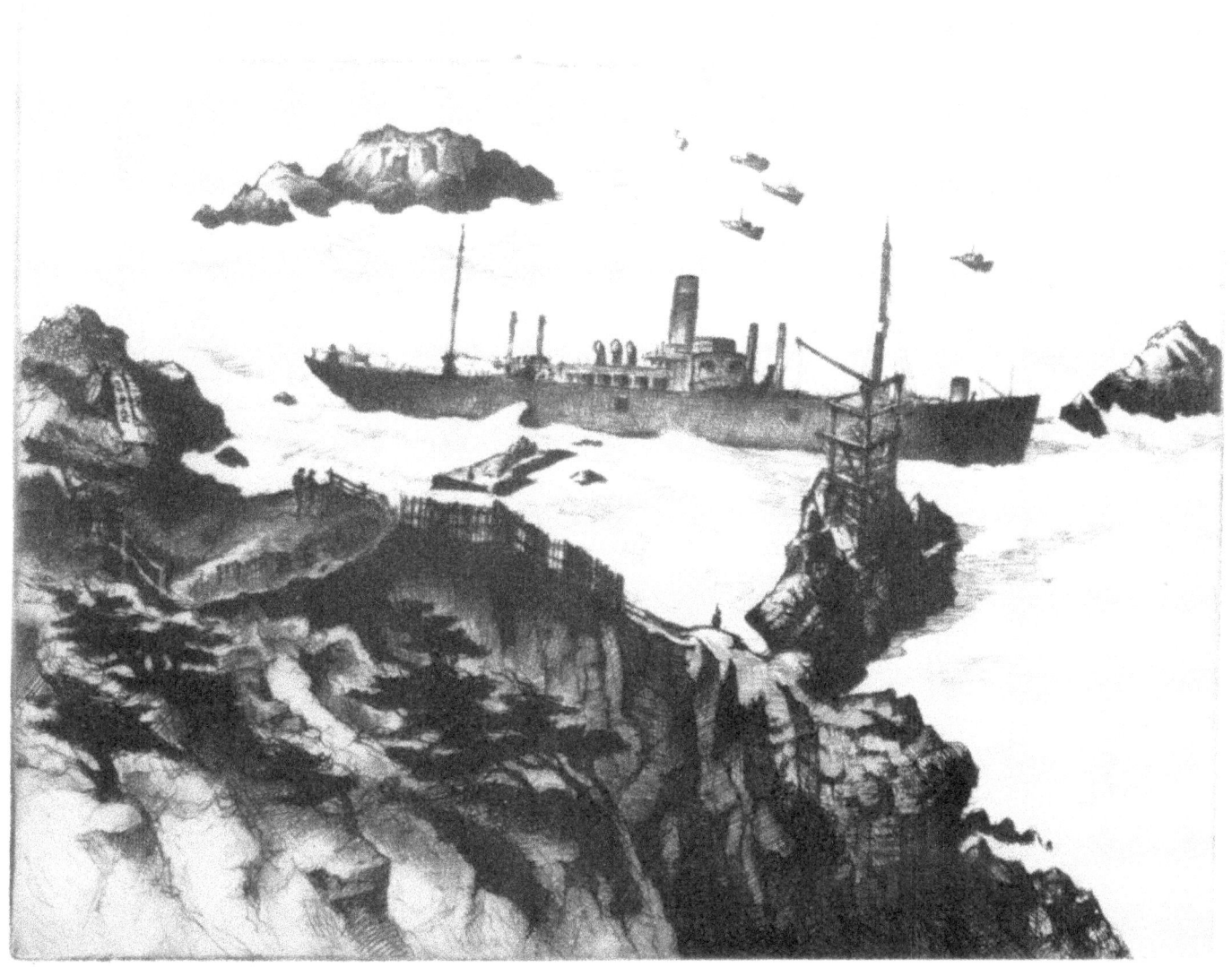

On The Rocks

CABLE SPINNING–SAN FRANCISCO BAY BRIDGE
327

Gene liked to sketch along the waterfront in the old days, the wharves all open to visual access, ships moored there posing for her without squirming in the docks or batting a lashing eye. The building of the bay bridge was a tougher subject, and she was bothered by small crowds gathering behind her to watch her sketch. Before the cables were strung, when she was trying to draw a single tower, a marine fireman observed her predicament and invited her to come sketch from the fire department wharf where she would have a closer view of the tower unmolested by people looking over her shoulder. She gladly accepted, and the whole crew of big brawny marine firemen treated her like a princess, fetched a chair and shade umbrella for her, brought her a tray of tea and roast beef sandwiches at noontime. They were so courteous and kindly that she considered they had tacitly adopted her as a member of the San Francisco Marine Fire Department.

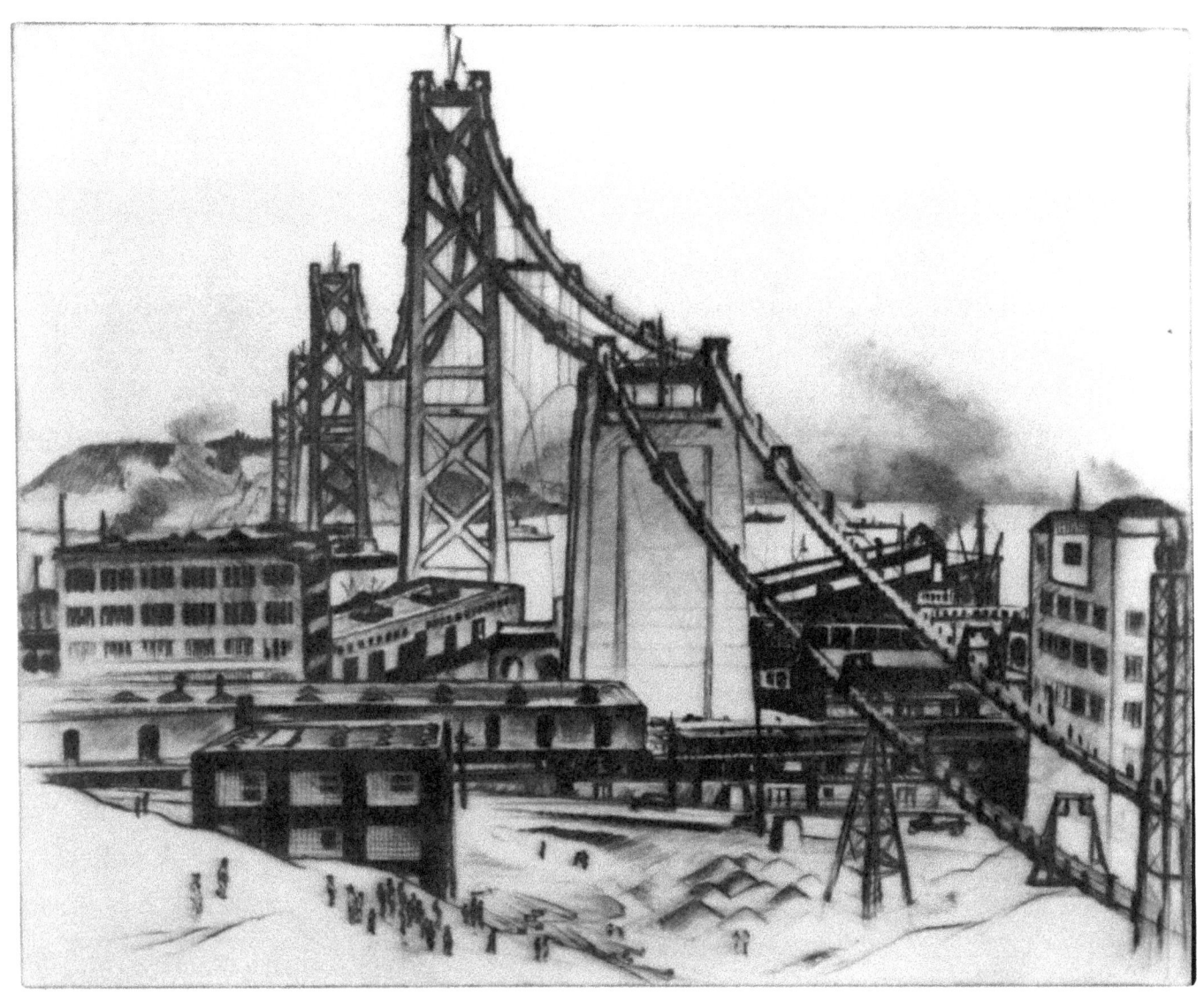

Cable Spinning – San Francisco Bay Bridge

PACIFIC COAST EVENING
444

The northern California coast has many a bleak little harbor unspoiled by commercial development, many a bleak promontory untouched by civilization. The winds and storms are severe, the tranquil days lovely, especially at evening. Behind the bleakness in the coast hills grow redwood groves, Sequoia sempervirens, the tallest and oldest trees in the world, their fragrant leaf-fronds precipitating fog during the rainless summers, always cool and lush, and you can hear the song of the russet-backed thrush.

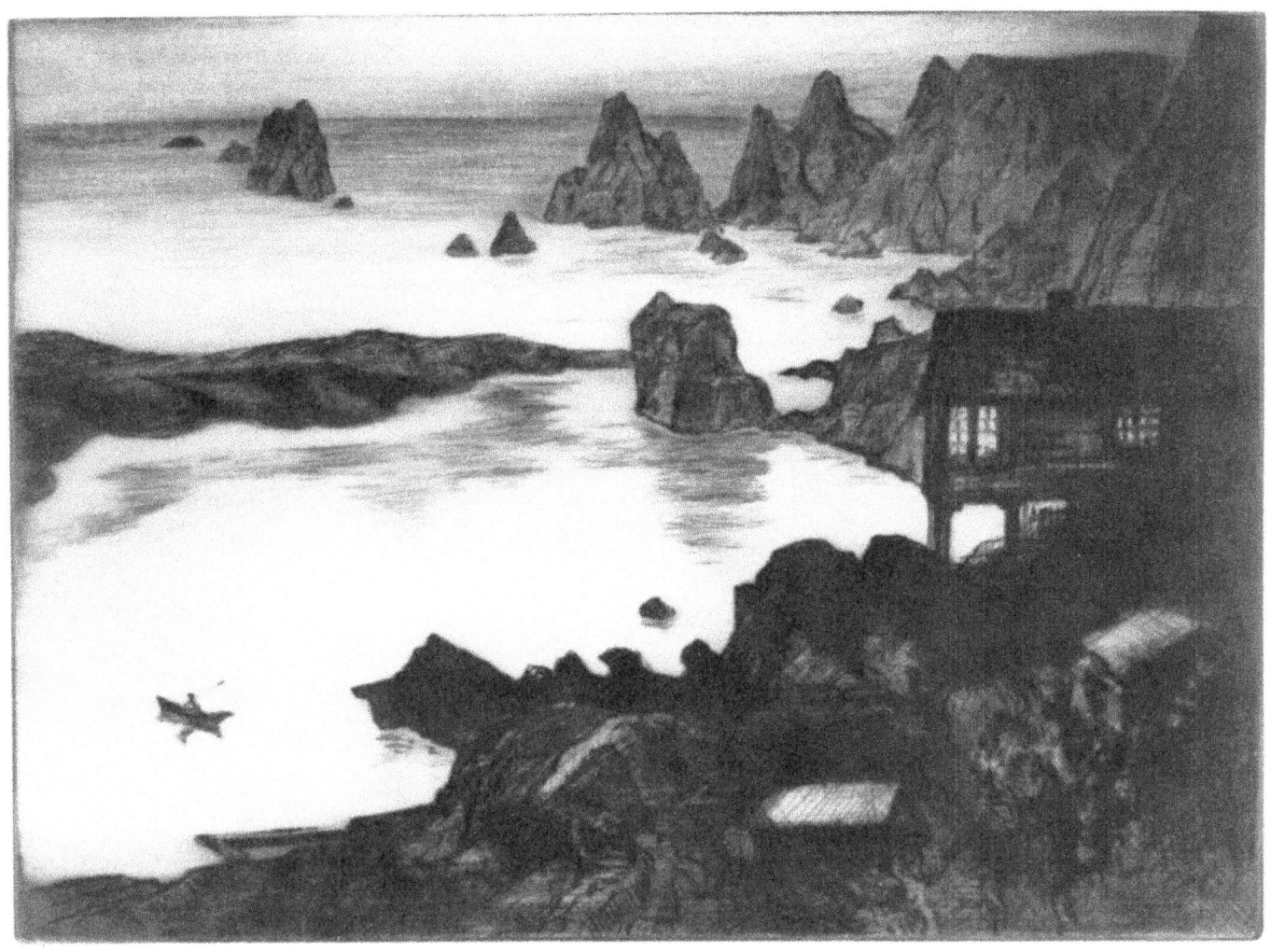

Pacific Coast Evening

STRENGTH FROM THE SEA
355

Point Lobos was the favorite tramping ground of Carmel artists, writers, poets. The artists set up their easels and painted waves breaking on rocks, mist transforming the stiff dark cypress trees to mysterious phantom forests, coves in the granite cliffs sparkling with clear, deep, blue-green water, pinnacles studded with pine trees, meadows of lupine, poppies, suncups, globe lanterns, owlclover. The sea surged around the point with tremendous force, a marine trench there, the place where earth, sky and sea converged in wondrous wildness giving inspiration and impetus to all of us. Artists were allowed to sketch anywhere on Point Lobos until the erosive feet of too many sightseers compelled rope trails and no trespassing limits.

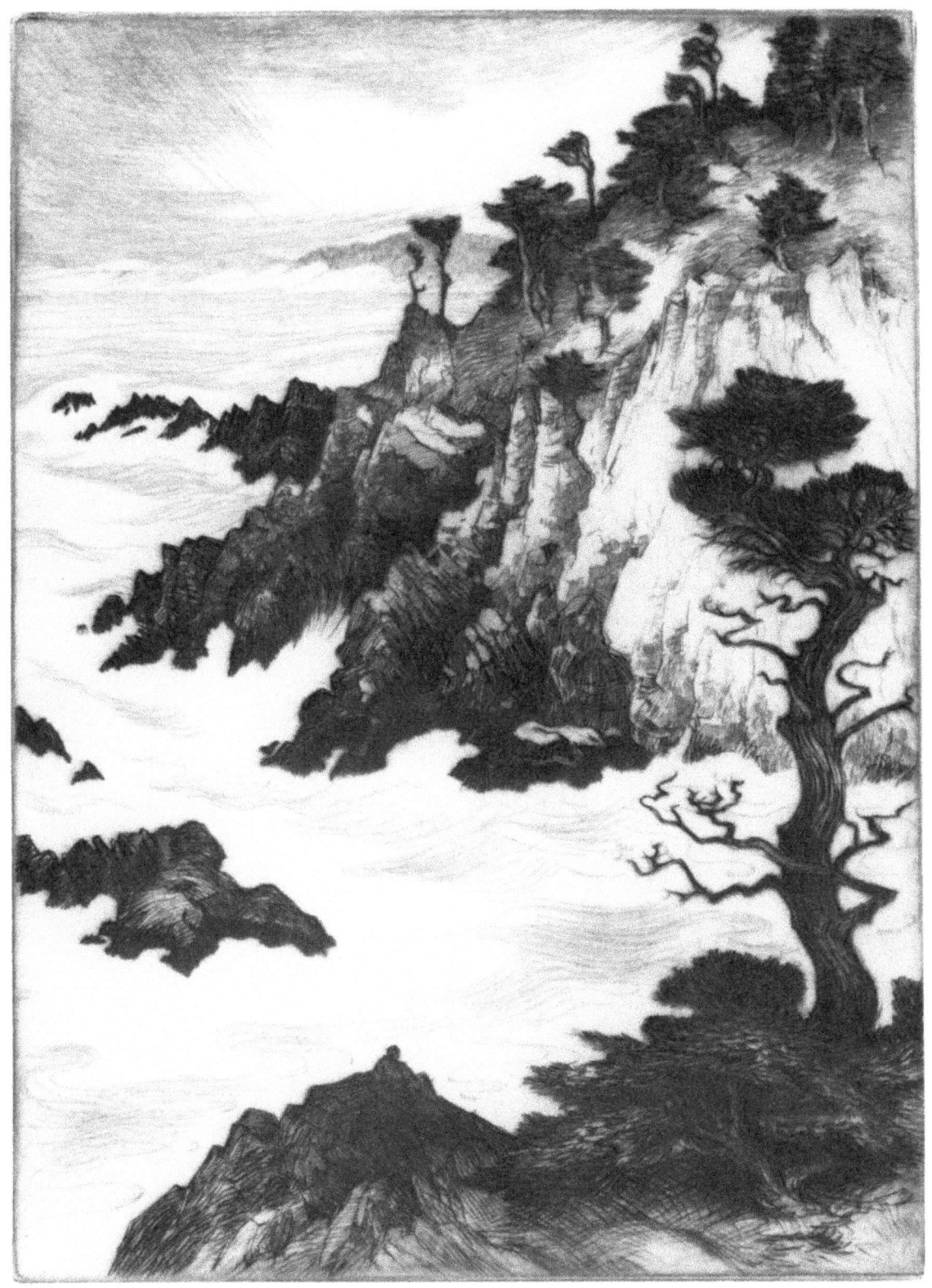

Strength From The Sea

DESERT PEAKS
344

Solitude. Contemplation. The desert has nourished dreams, and dreams have nourished civilizations. Here the broad-leafed yucca, datil, amole has nourished Indian cultures — food, clothing and hygiene in one plant. The fibers of the leaves were used to make sandals, capes, mats, baskets. The seeds of the pods were ground for meal. The pod itself was used for sugar. The roots were used as soap to wash the hair and body. A sacred plant to the Indians, the yucca. Steroid cortisone for us, the yucca. A shrine for contemplation, the desert.

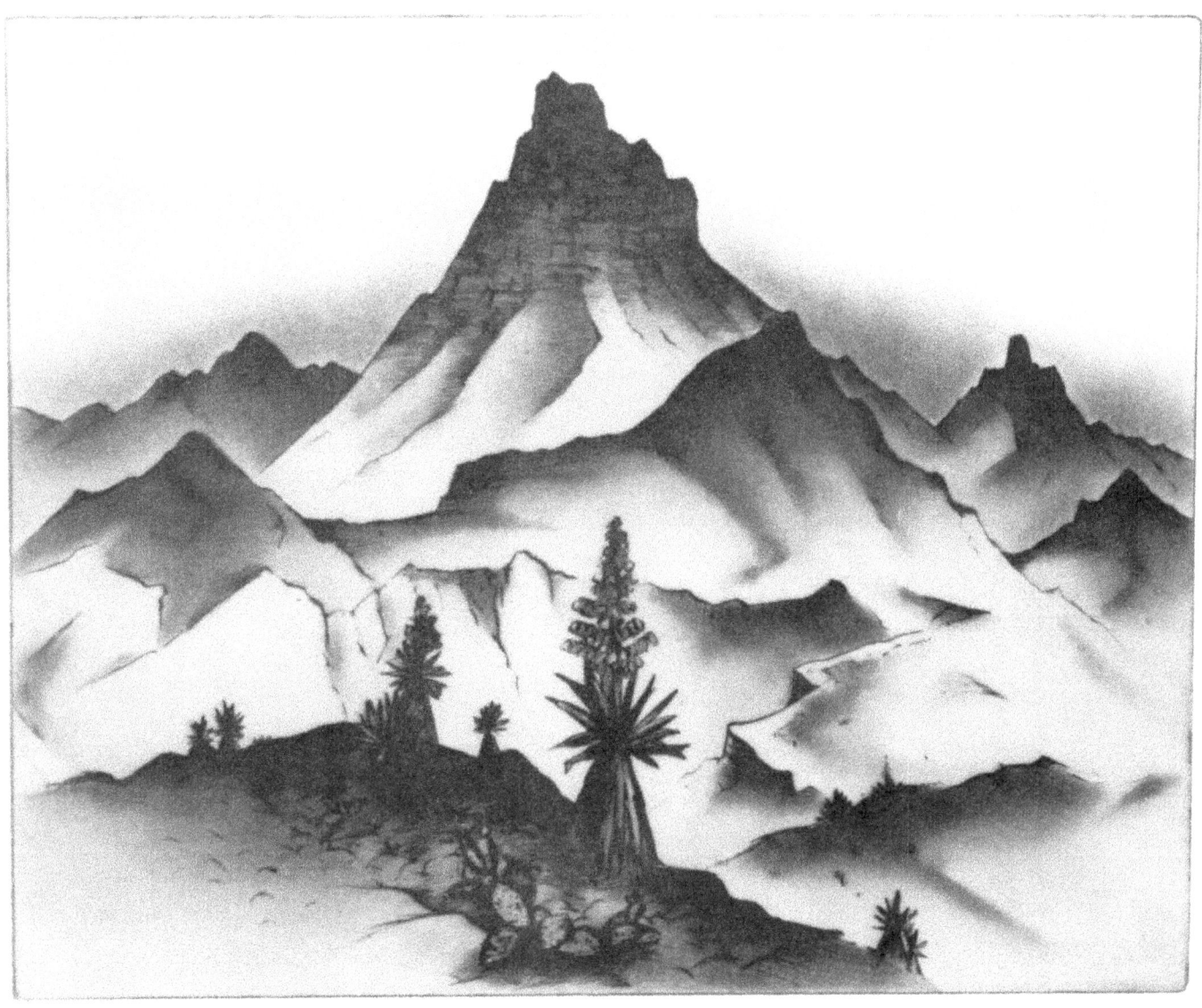

Desert Peaks

EXILED
423

The three etchings *Exiled, War's End* and *Survival* are for me a powerful triad, profound in conception, profound in depiction, profound in technique. Observe in this one the different attitudes of the people exiled from their homeland by the ruthlessness of conquest. Refugees. One of the refugees, a Czech doctor, Eric Hausner, M.D., served in the Army at Bruns Hospital during the war, settled in Santa Fe, and became a leading physician. His background was Latin, Greek, philosophy, literature, music as well as medicine. He was an excellent pianist but the piano he bought here stayed silent while he devoted himself to the science and art of healing others. He deeply appreciated this etching *Exiled*.

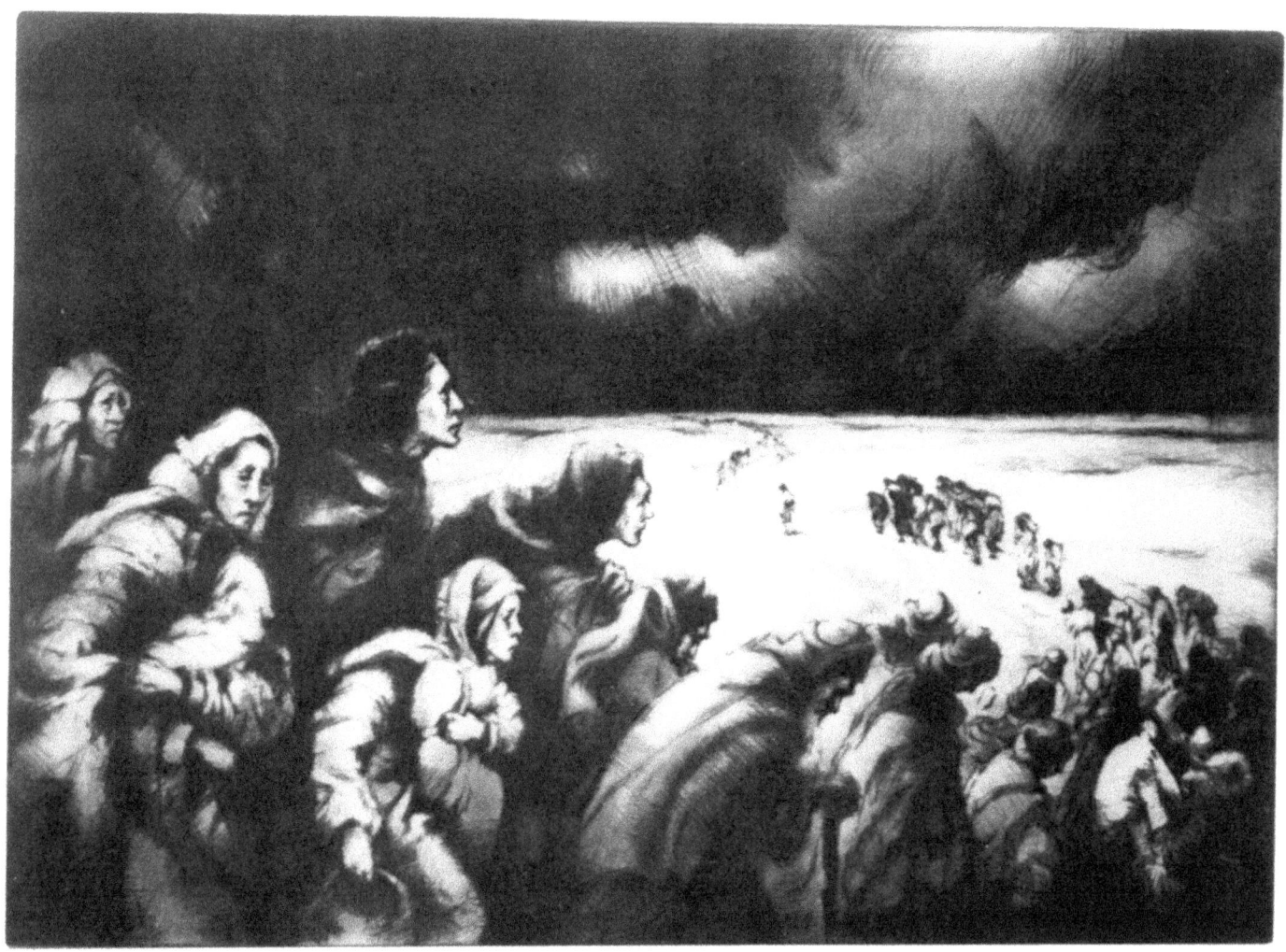

Exiled

WAR'S END
417

A grandmother and child left to face the future, the generation between them lost. The anguish and determination in the old eyes, the pathetic reliance of the child.

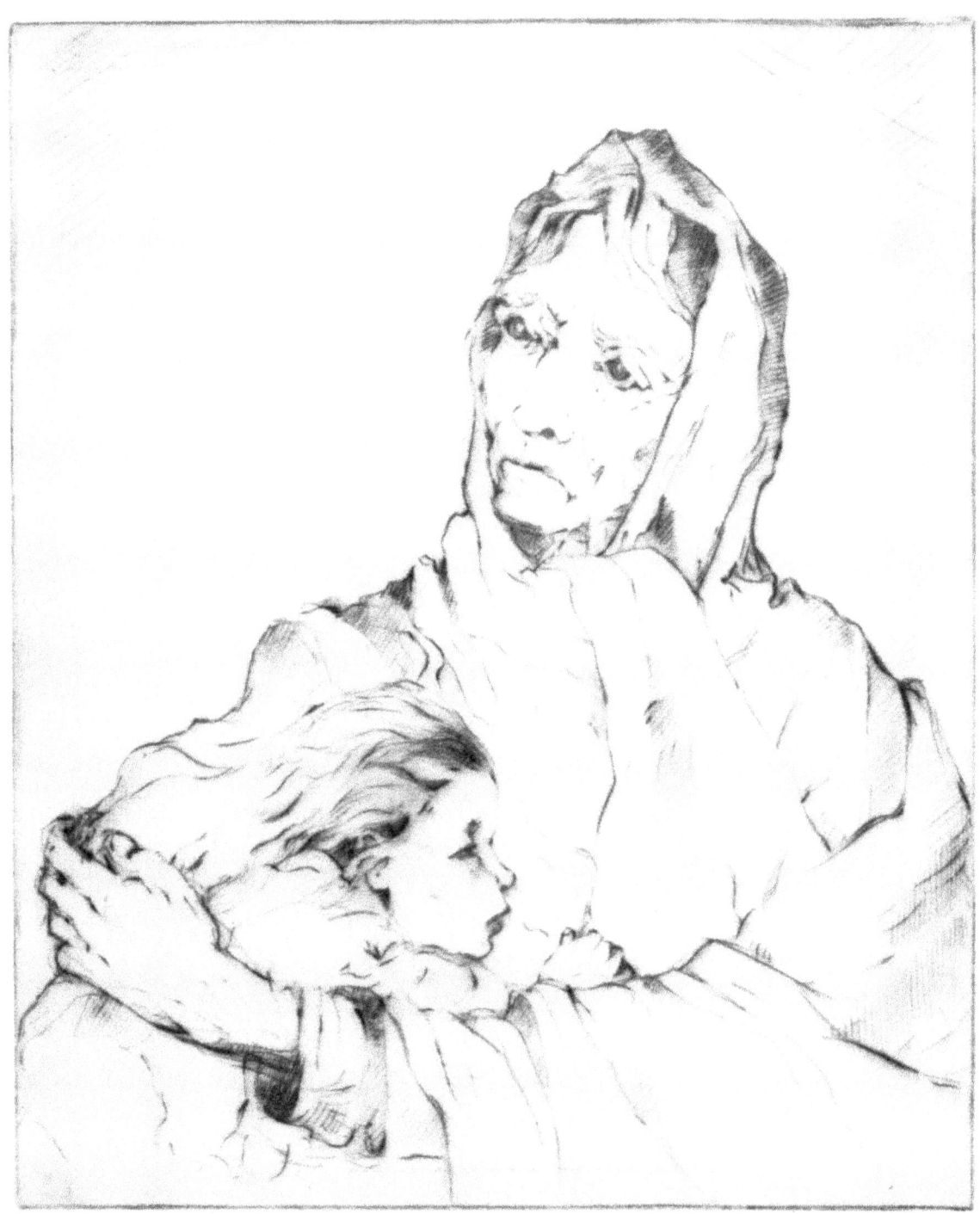

War's End

SURVIVAL
422

For those to whom the Cross means compassion for the suffering of humanity rather than salvation from sin it is a sustaining symbol. Yea verily, I am with you always, even unto the end of the world.

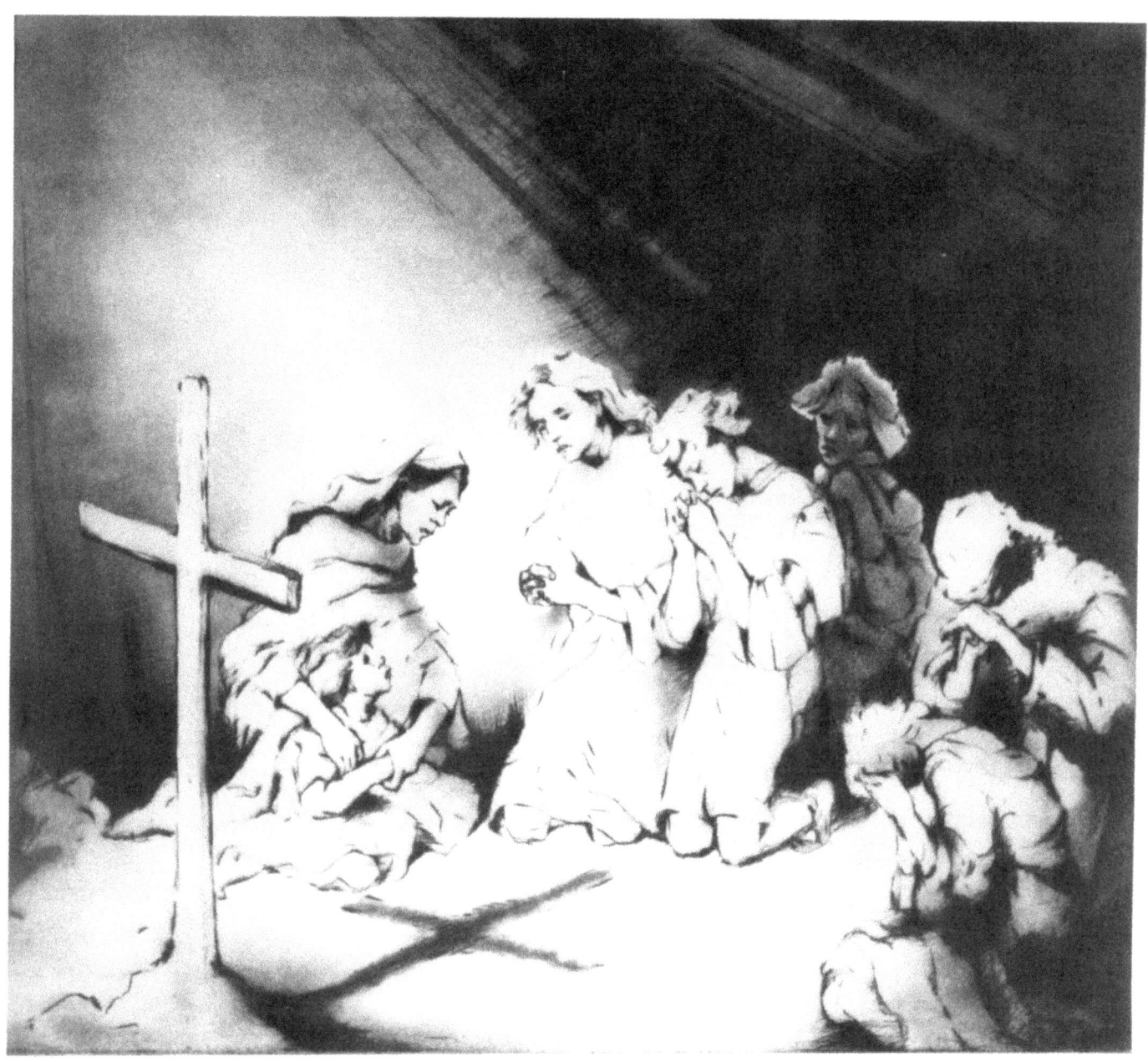

Survival

INDIAN PUEBLO
292

When Taos was Taos years yond ago,
Valley and mountains sky-enchanted,
Streams aflow with melting snow,
Fields sheen green new-ploughed new-planted,
There you could live in an ageless age,
Live in the cedars, live in the sage,
Cedar and sage, wild rose, wild plum,
Indian song and Indian drum.

'Tis not to deny the mind's delight —
Imagine, explore, invent, create —
'Tis living more natural, primitive, right
Fulfilling the faith you advocate.
Don't seek tomorrow, go back there
In the pine, in the spruce, in the balsam air,
In the cedars and sage, wild rose, wild plum
Rebegin, rebecome.

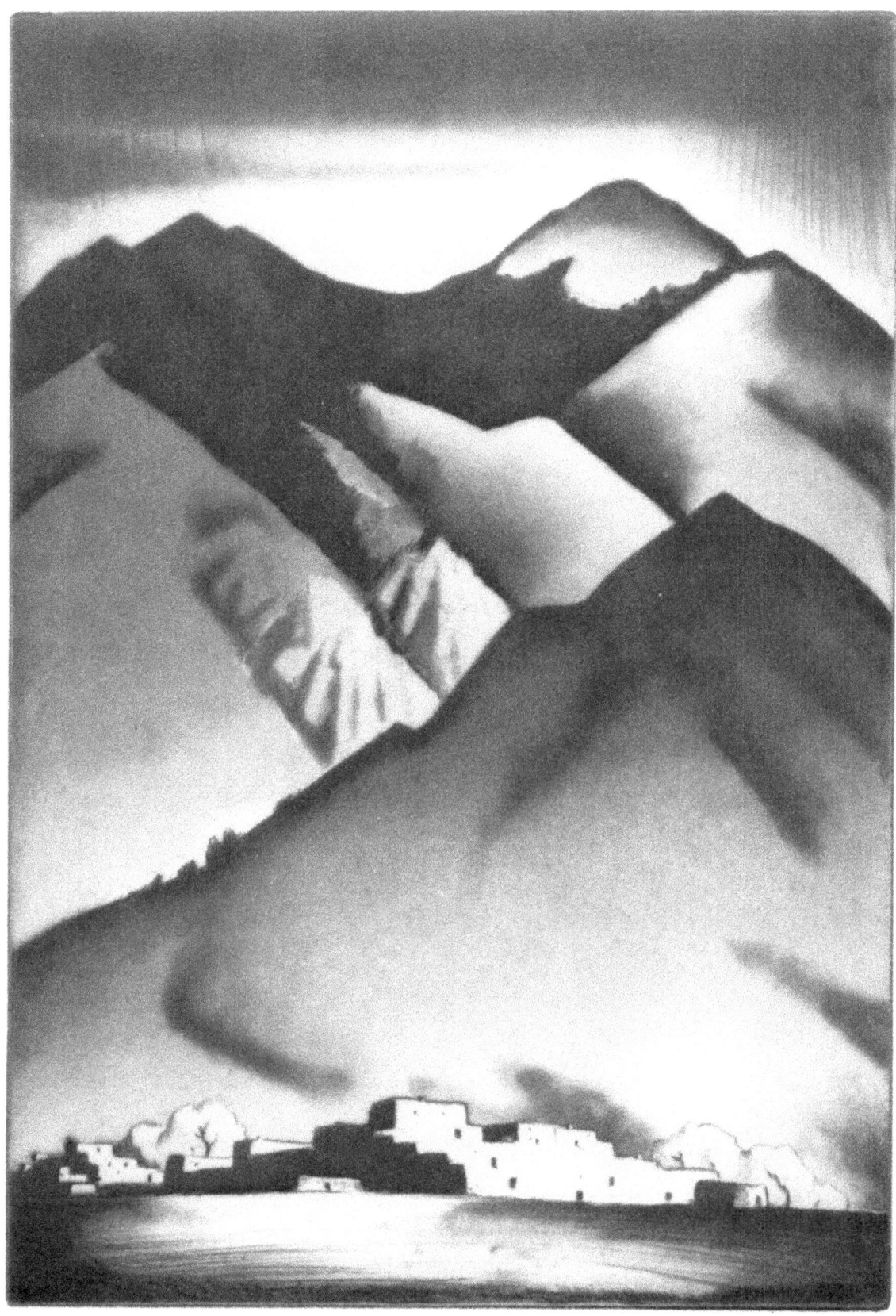

Indian Pueblo

CHRISTMAS EVE–TAOS PUEBLO
295

The oldtime Taos artists classified the Christmas Eve ceremony at the Pueblo a Christian and Pagan combination. Formerly, not shown in this etching, a group of feathered Indians danced beside the litter of the canopied patron saint as it was carried from the Catholic church to the danceground in front of the kivas, which are Indian churches. The pitchpine bonfires blazing on the ground and atop the flat fireproof adobe roofs added a barbaric glamour to it. All Taos Indians are baptized Christians. They have accepted the White Man's religion, whether Quansyna white men or Ponsyna white men, with sincere fervor. They retain, however, their own religious beliefs and practices.

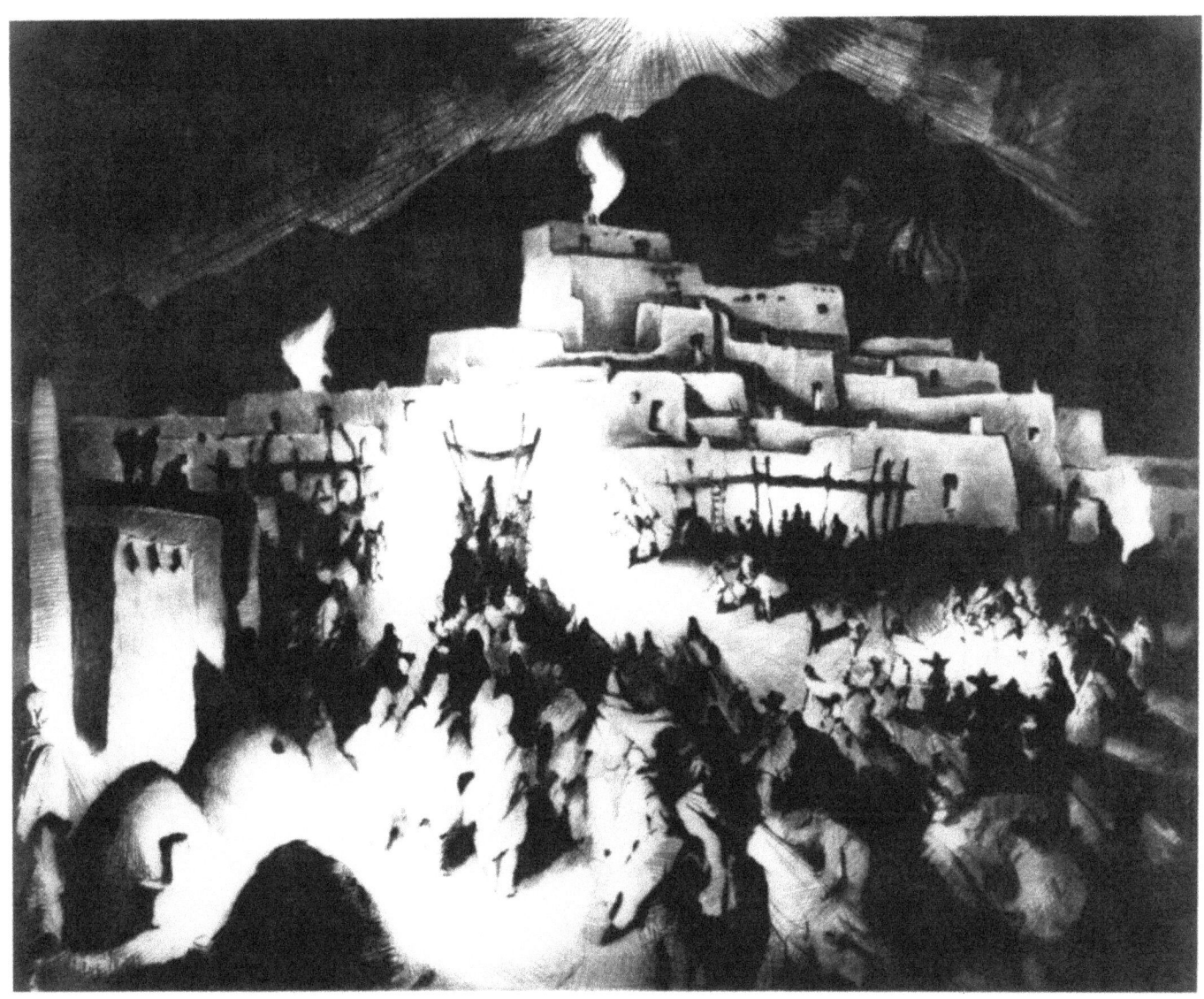

Christmas Eve–Taos Pueblo

RETURN OF THE PROCESSIONAL
518

Having made the rounds of the Pueblo the patron saint is carried back to the Catholic church, the processional integrated altogether Christian. The Taos Indians apparently had a Christ concept of their own before the Spaniards came, not a culture hero or Quetzalcoatl diety, a very benevolent transfigurational man whose face shone with an inner light like the sun.

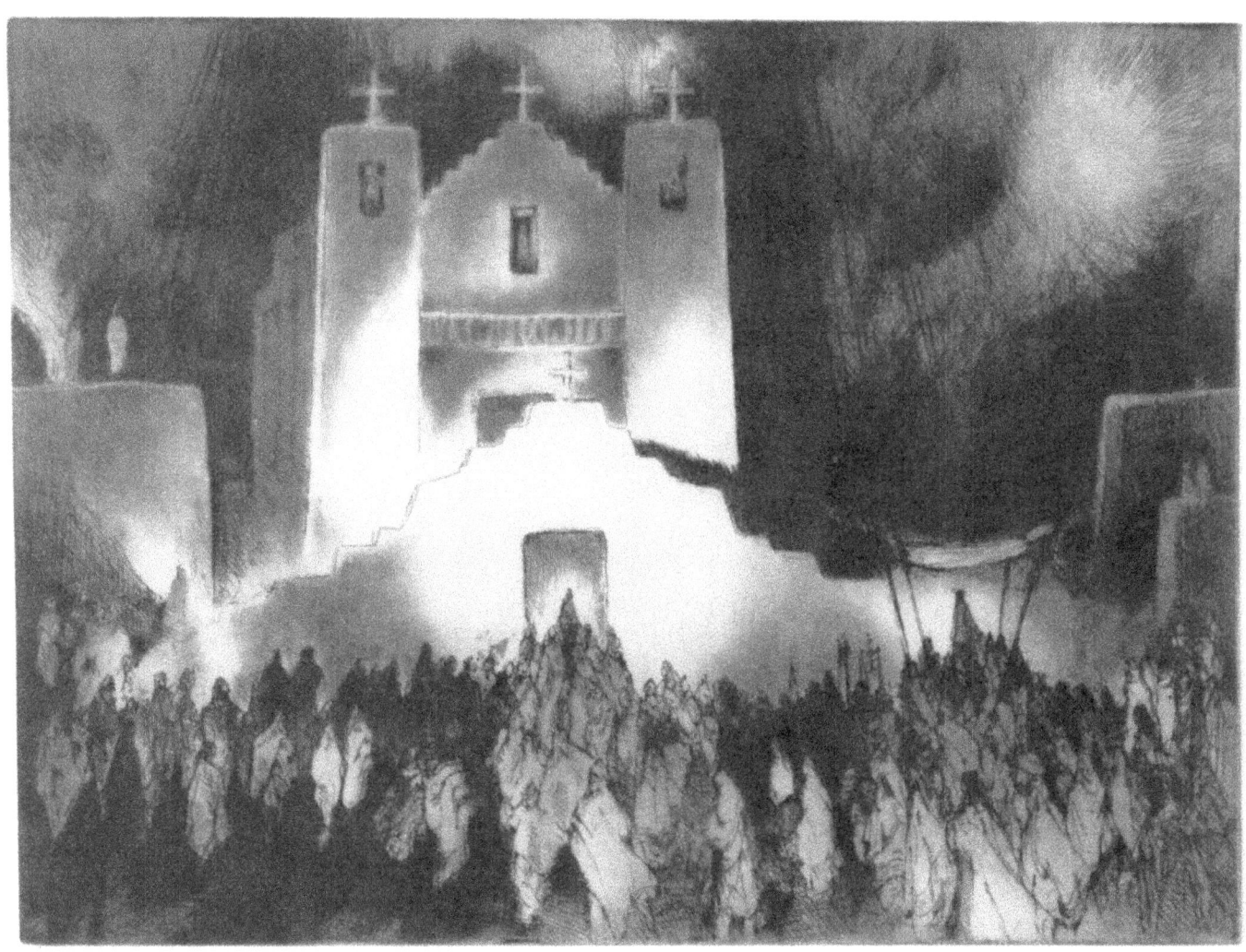

Return Of The Processional

TAOS DEVIL DANCE
315

Partly an entertainment dance, partly an exorcise dance the Devil Dance is put on by a group going from house to house. Red Deer invited us to watch it at his house one evening. He was not one of the group, but later he posed for Gene in Devil Dance attire, taking the juxtapositions the group had taken and suggesting the differentiation of headdresses. She followed his instructions, drew direct on the copper plate with a diamond drypoint tool. He approved the finished print, remarking: "Yes, that is the way it looked at our house that night."

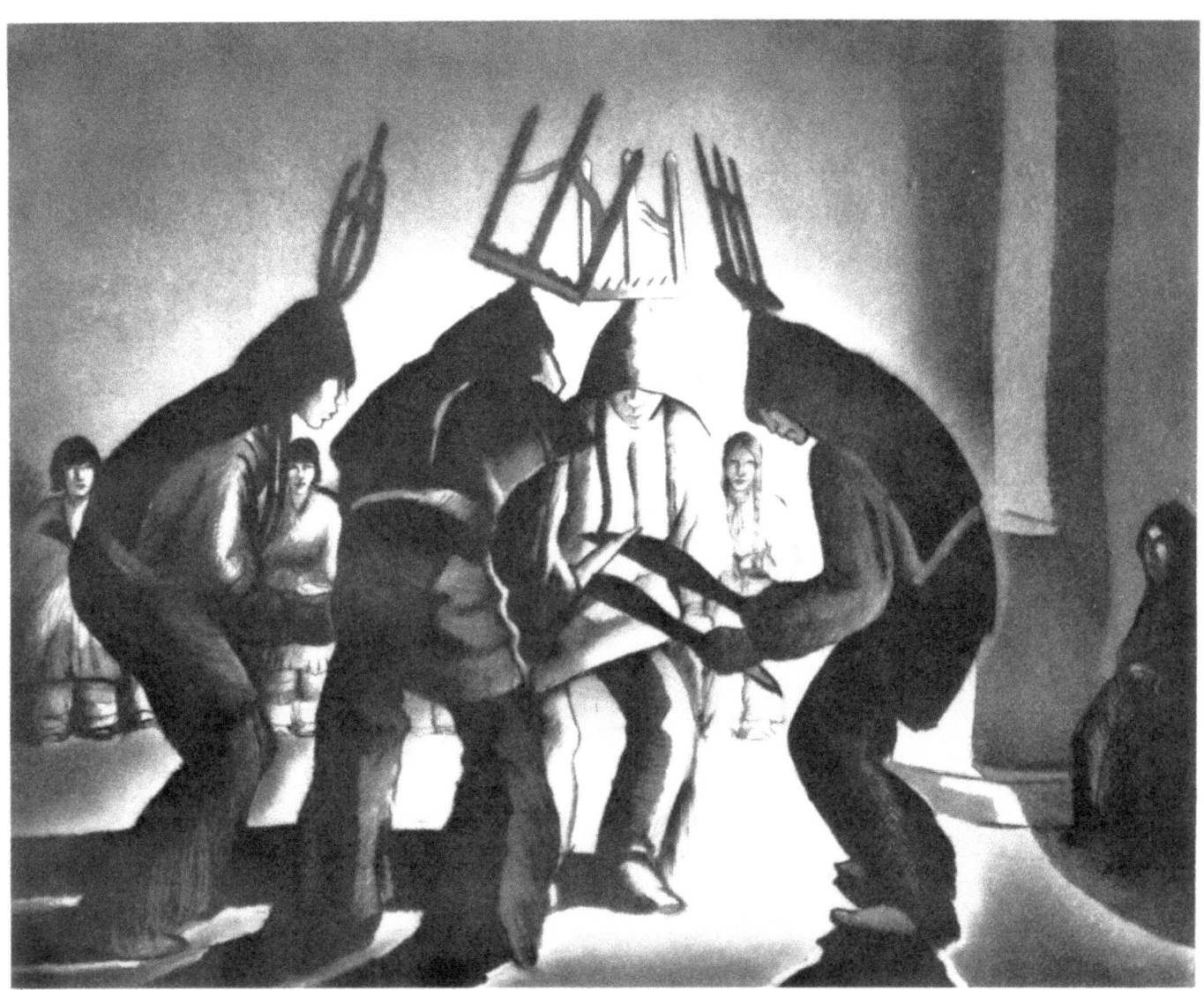

Taos Devil Dance

TAOS INDIAN JESTERS
397

The Taos Indian jesters correspond to the Domingo Koshairi, the so-called Delight Makers, and are called Chiffunana. They wear corn husks in their white-plastered hair and paint black circles around their eyes. They go naked except for dirty loincloths. Their pranks on San Geronimo Day, fiesta day, are funny if often rough and profane. A filthy fellow daubed with ashes will approach a neatly dressed white lady in the crowd of spectators, make her an elaborate bow with his right hand over his heart, then offer his arm to lead her onto the ballroom danceground. If she doesn't take it he'll take hers and lead her up and down the danceground with pompous dignity. Then he'll let her go with a bow of dismissal and walk behind her precisely mimicking her high-heeled step and the sway of her hips. She had better be a good sport, or else! A horse, a dog, a raccoon can provide a funnier subject than a fastidious white lady, utterly ga-ga.

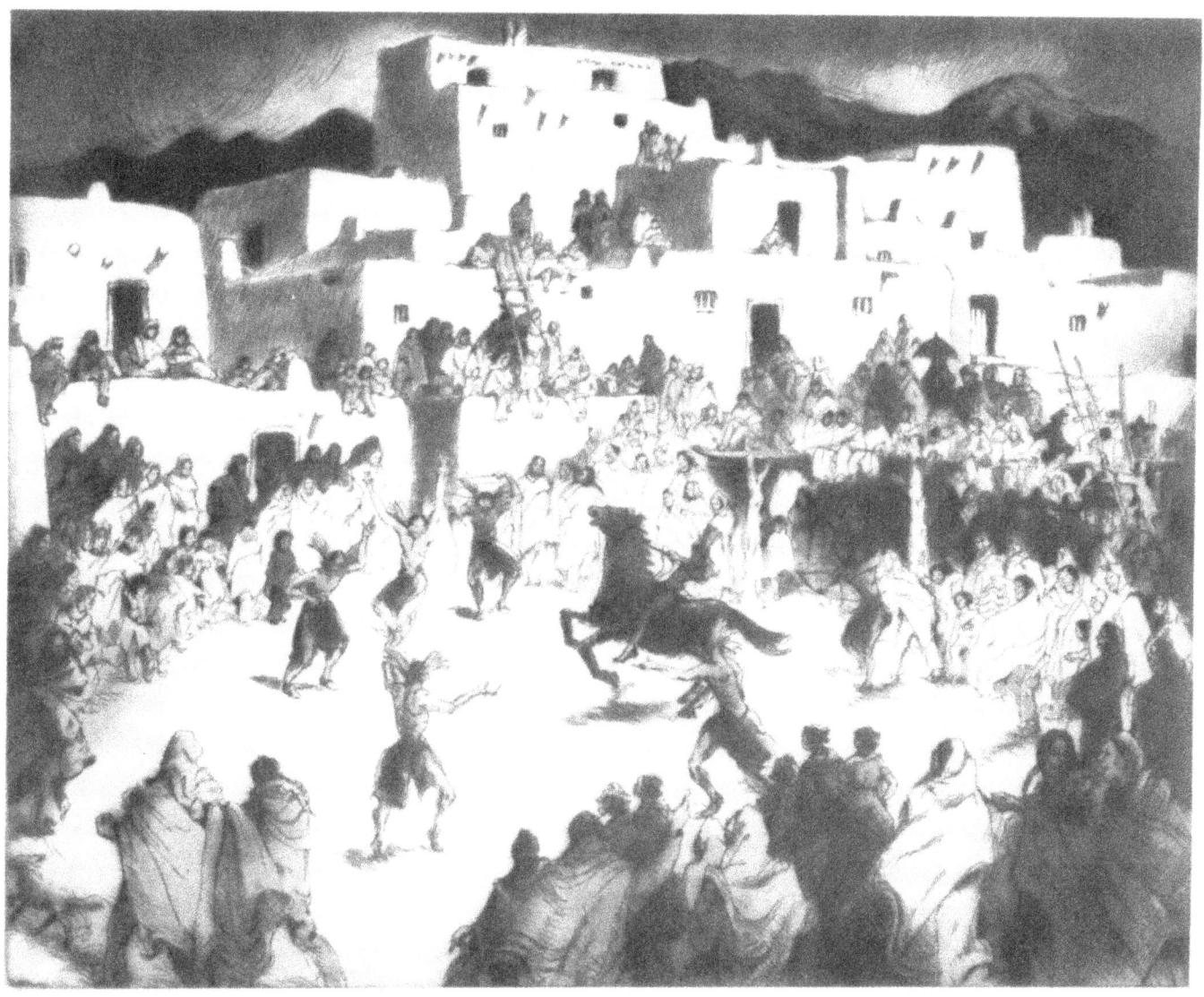

Taos Indian Jesters

HORSEPLAY OF INDIAN JESTERS
454

A mock horserace against a mock horse with a Chiffunana astride a real horse burlesquing frantic ways of riding bareback can make a clown circus for sure.

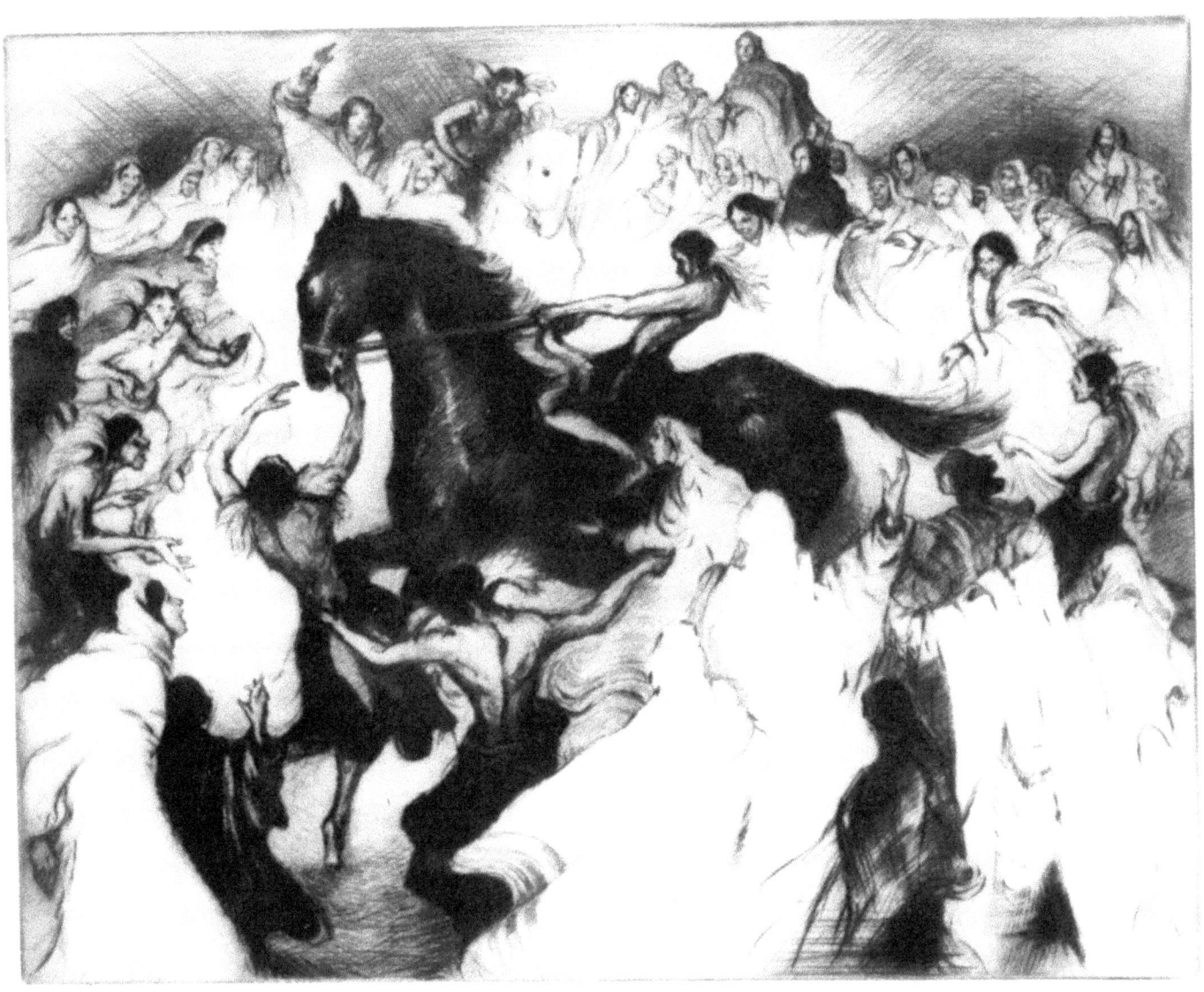

Horseplay Of Indian Jesters

INDIAN JESTERS MAKING DUST
443

Pretending to have discovered something of great interest in a pile of dirt, a lost pocketbook or silver bracelet maybe, a two-headed calf or three-eyed Picasso painting maybe, the jesters will gather around it peering and gesticulating, chattering like a flock of magpies. Naturally the tourist spectators want to see what's there and come close, whereupon the jesters scatter dust on them, some leaning forward with both hands in the pile of dirt and flinging dust backward like a dog digging in a rabbit hole. Naturally the spectators disperse.

The serious function of the Taos Chiffunana is not known. They seem to have considerable influence and power but it is doubtful whether they represent Ancestor Spirits as the Domingo Koshairi do. We don't ask, we don't snoop. Gene makes memory sketches of Indian activities from her own point of view, with respect for the unknowable Indian point of view. Beforehand or afterward, as permitted to artists when no ceremony or special activity is in progress, she makes detailed drawings of the Pueblo area, background for her memory sketches. Portraits, of course, she sketches direct in her studio.

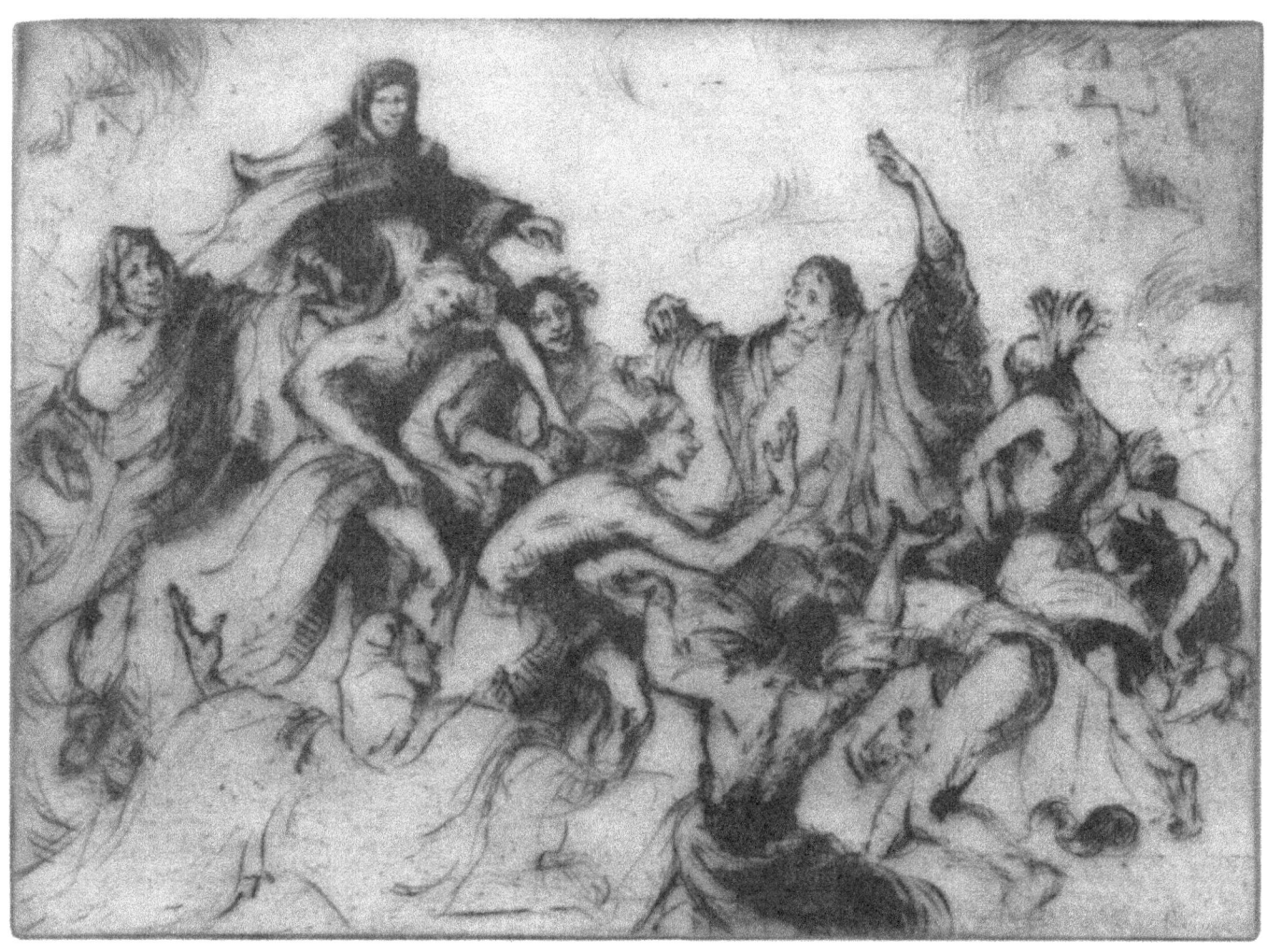

Indian Jesters Making Dust

SONG OF CREATION
435

Again the Turtle Dance. The song of re-creation after the Great Flood, the white inundation of winter, or perhaps an actual biblical flood. And how was the world made in the beginning? The process of earth-building was slow like a turtle's footsteps, the process of evolution was slow. Who knows what was or will be? The inferences here are poetic.

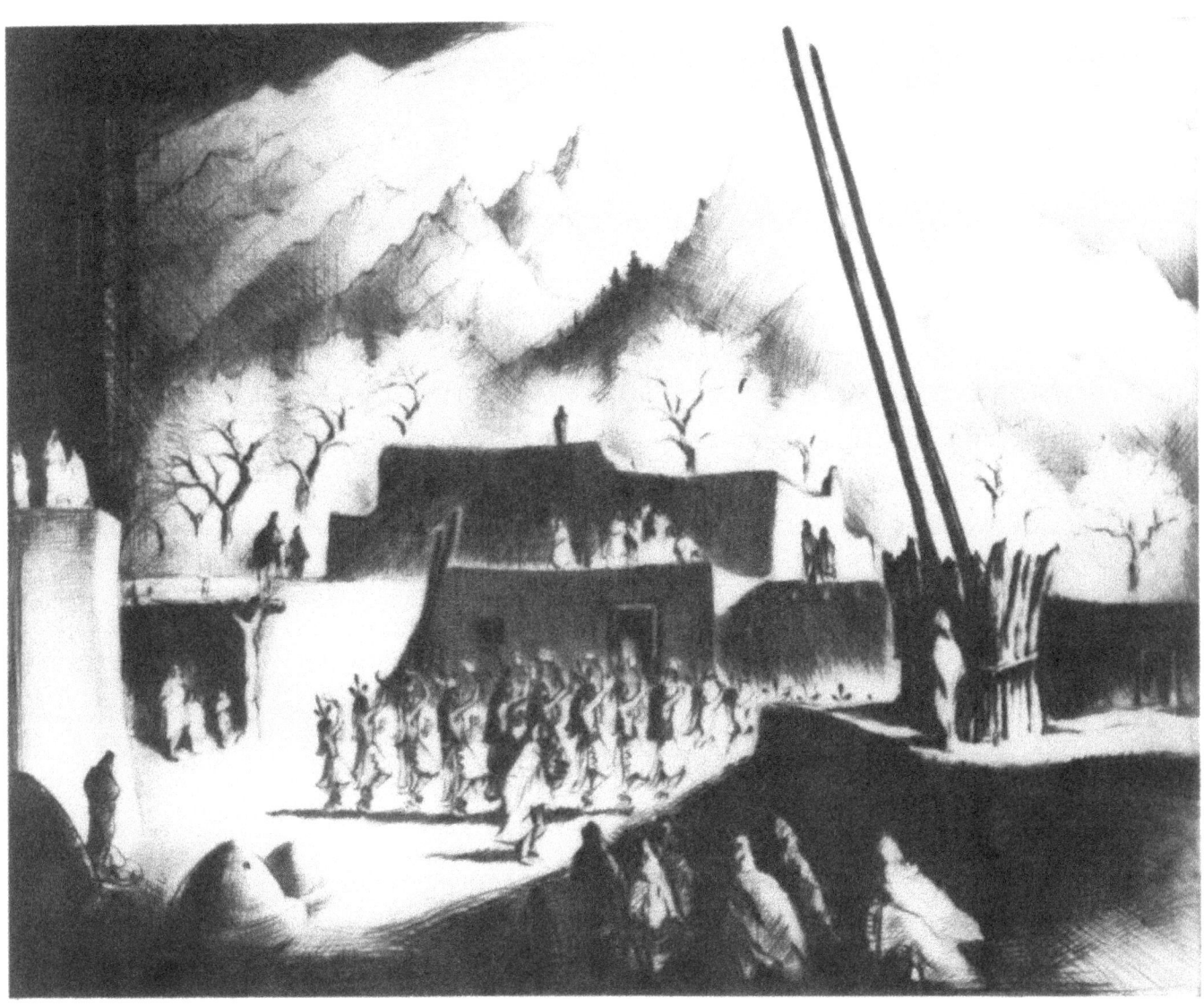

Song of Creation

HERE COME THE SINGERS
390

It was permissible to sketch kivas in the 1920s. The taboo came after Elsie Clews Parsons' book on the Taos Pueblo was published in the 1930s. She obtained the Indian name of every person living in the Pueblo, the names of the kivas, the names of the moieties or societies meeting in them, the marriage, birth and death customs, the structure of the ceremonial dances, et cetera, a great deal of meticulous and accurate information, a great deal of bunk. The book made the Taos Indians furious and all kinds of restrictions were imposed on visitors, including artists. There used to be a feeling of welcome and good will at the Pueblo, and when the singers streamed out of the kivas we knew the show was about to start.

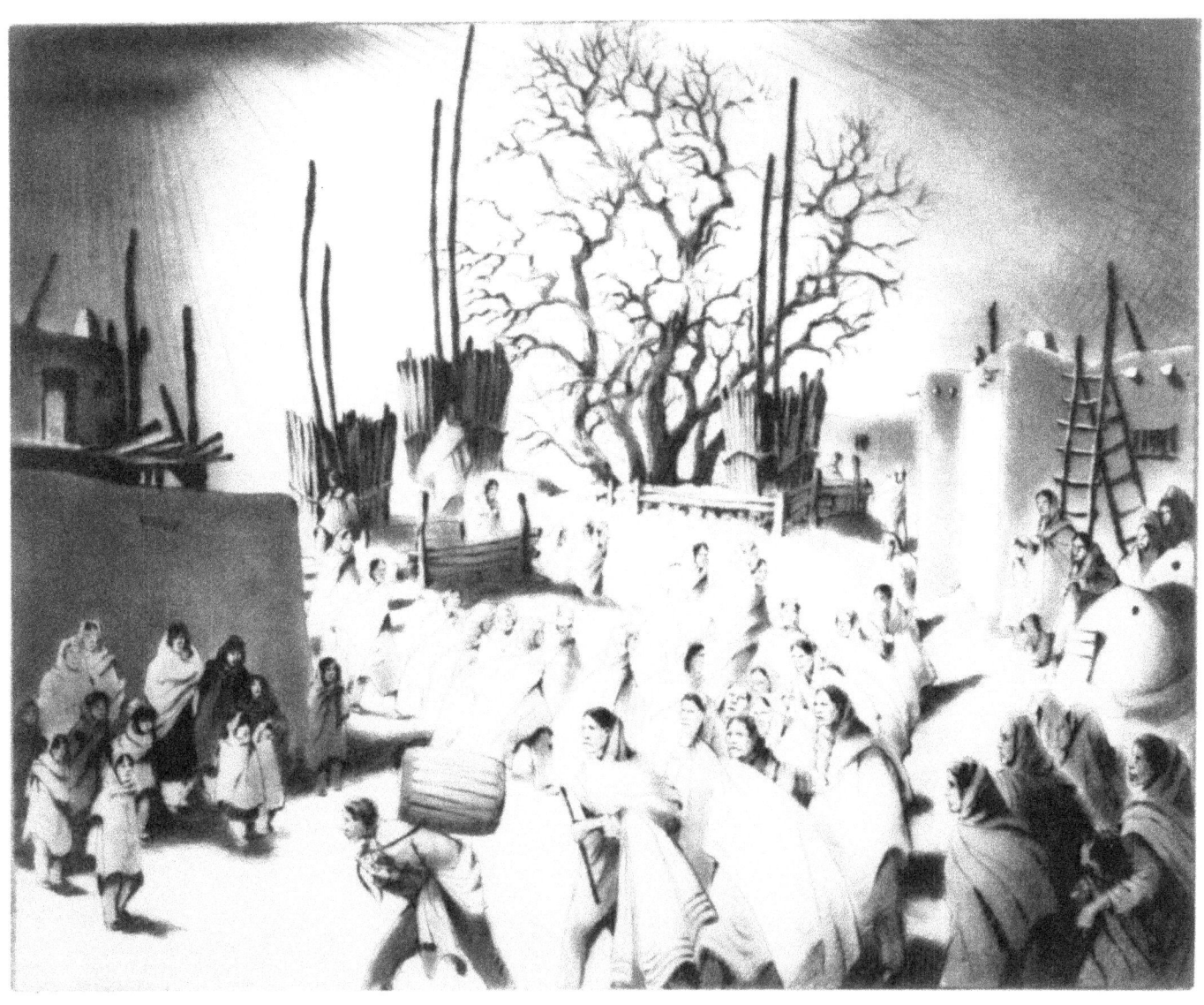

Here Come The Singers

CIRCLE DANCE
357

The Circle Dance is a friendship dance, derived from the Sun Dance. It has a varied and not necessarily sequential song-cycle to go with it. When we had almost finished building our house at the south borderline of the Taos Pueblo Grant, Red Deer and his wife Marie came to construct a real Indian fireplace for us. A fireplace is a woman's work. Red Deer carried the adobe bricks and mixed the plaster, then sang Circle Dance songs while Marie did the job. He taught us one. When we sang it in unison with him to his satisfaction he said, "Good! This song is your song. This song belongs to this house." We still sing it though we have a new house.

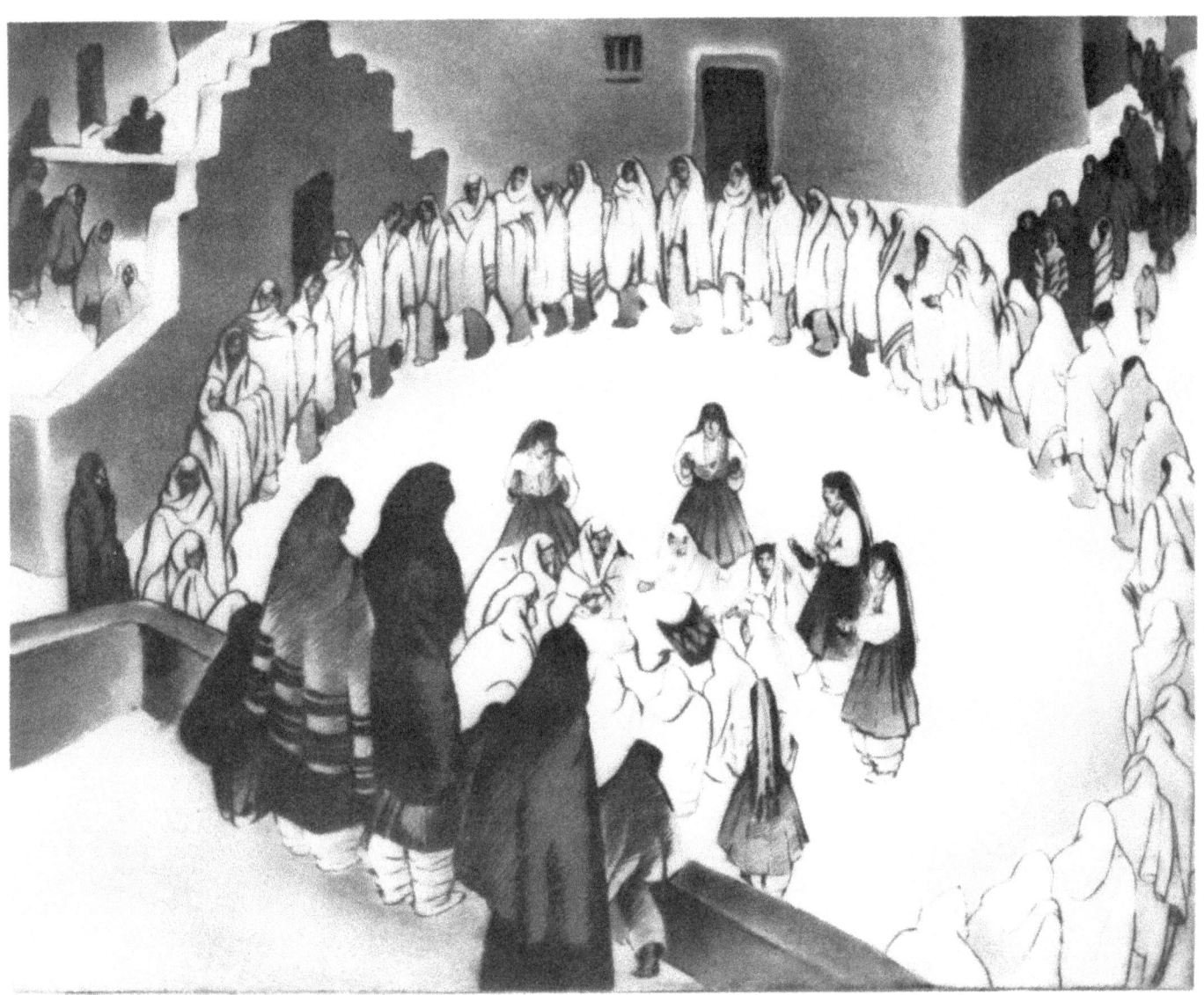

Circle Dance

MOONLIT KIVA
452

Nature arranged dramatic effects, mystic effects with a wave of her magic wand in the old days. You stood back and pondered over your sensations.

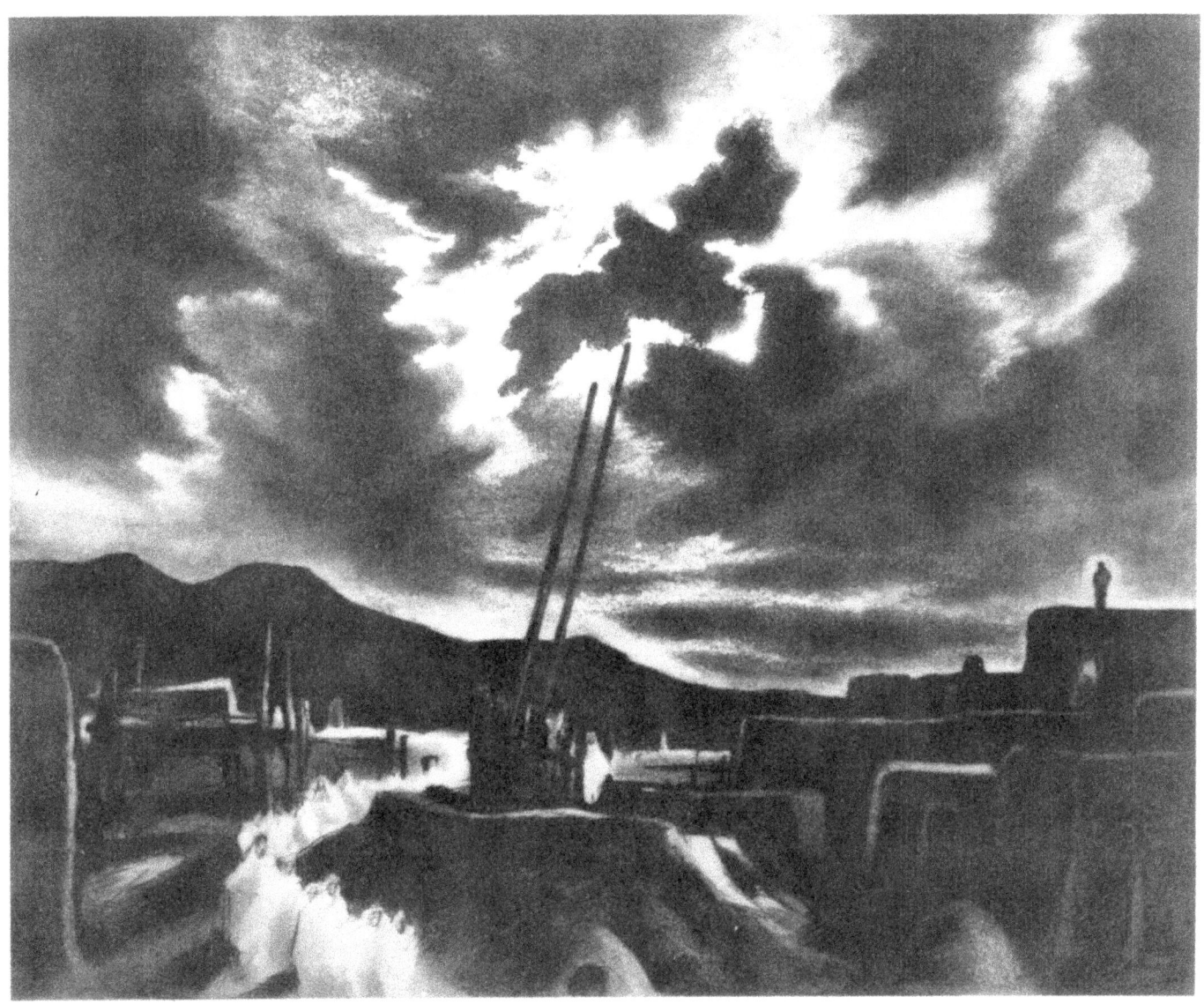

Moonlit Kiva

FIESTA AFTERNOON
497

Viva la fiesta! Spanish, Indian and Anglo lineages meet and make merry. Pottery for sale, silver and turquoise jewelry, terrible trinkets, excellent Navajo rugs, native wood carvings, native food. If you can buy a loaf of Indian bread baked in an outdoor adobe beehive oven, buy it! You will never eat etiolated fluff again. There will be clownish pranks, there will be a dizzy pole-climbing, there will be lively entertainment dances, watermelons, hot dogs, soda pop. And parasols for shade on a blistering day.

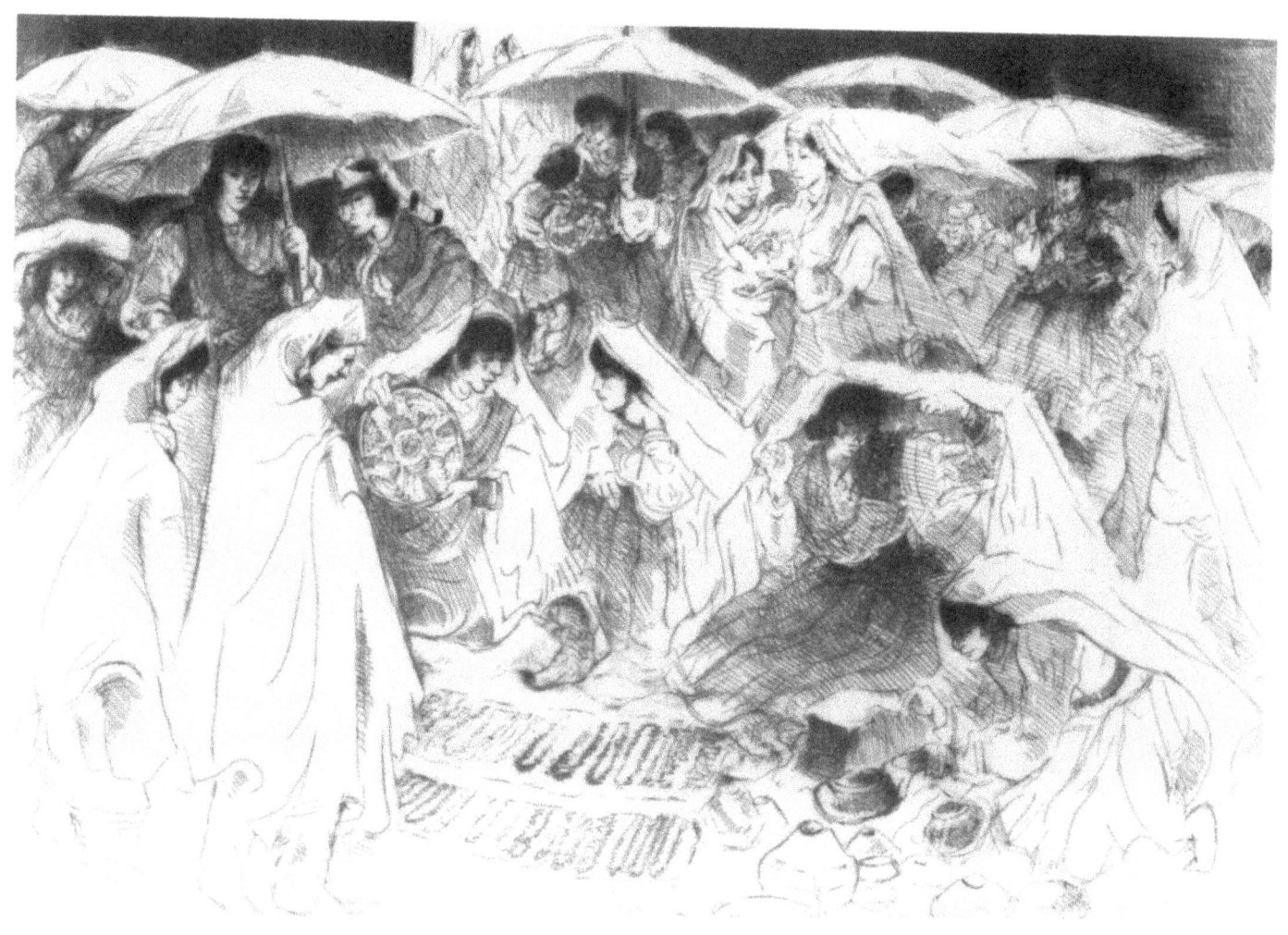

Fiesta Afternoon

PUEBLO LEADER
506

He had the special qualities of Indian virility, a good farmer, fast runner, good dancer, full-throated singer, staunch character. He was captured by the Germans in the Battle of the Bulge and was treated fairly well by his captors because of his Indian songs. Serious and consecrated after the war he tried to improve conditions for his people. He was elected governor one year. He had shrewd discernment and a sardonic sense of humor.

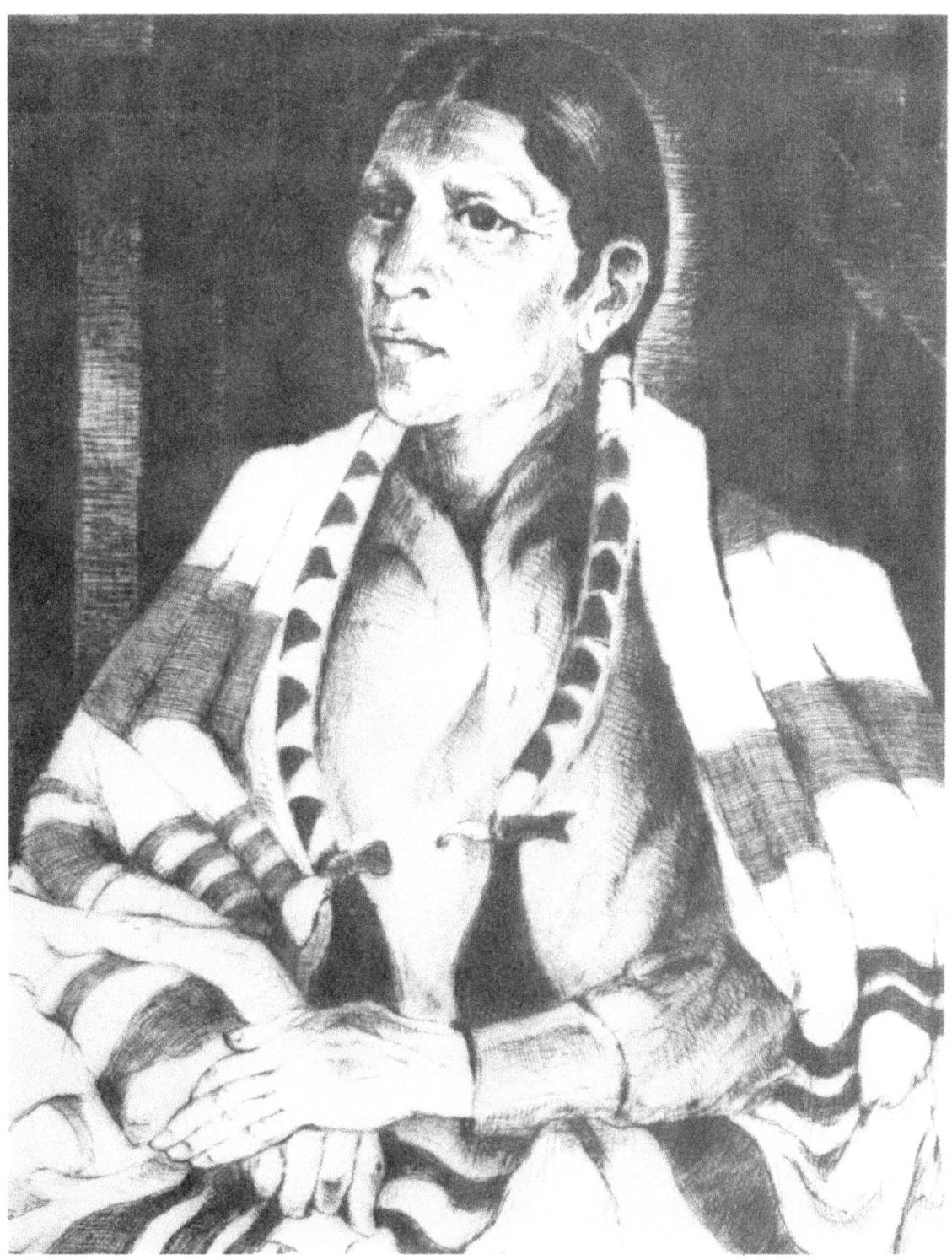

Pueblo Leader

INDIAN SINGER
504

The Taos voice is baritone, rich and strong, the songs all melodic. The singer here spoke English with difficulty and regretted he had had such a scanty education. He resolved his one and only son should have a good education even though his Indian name translated in English was Coming-From-Blue-Lake-Singing.

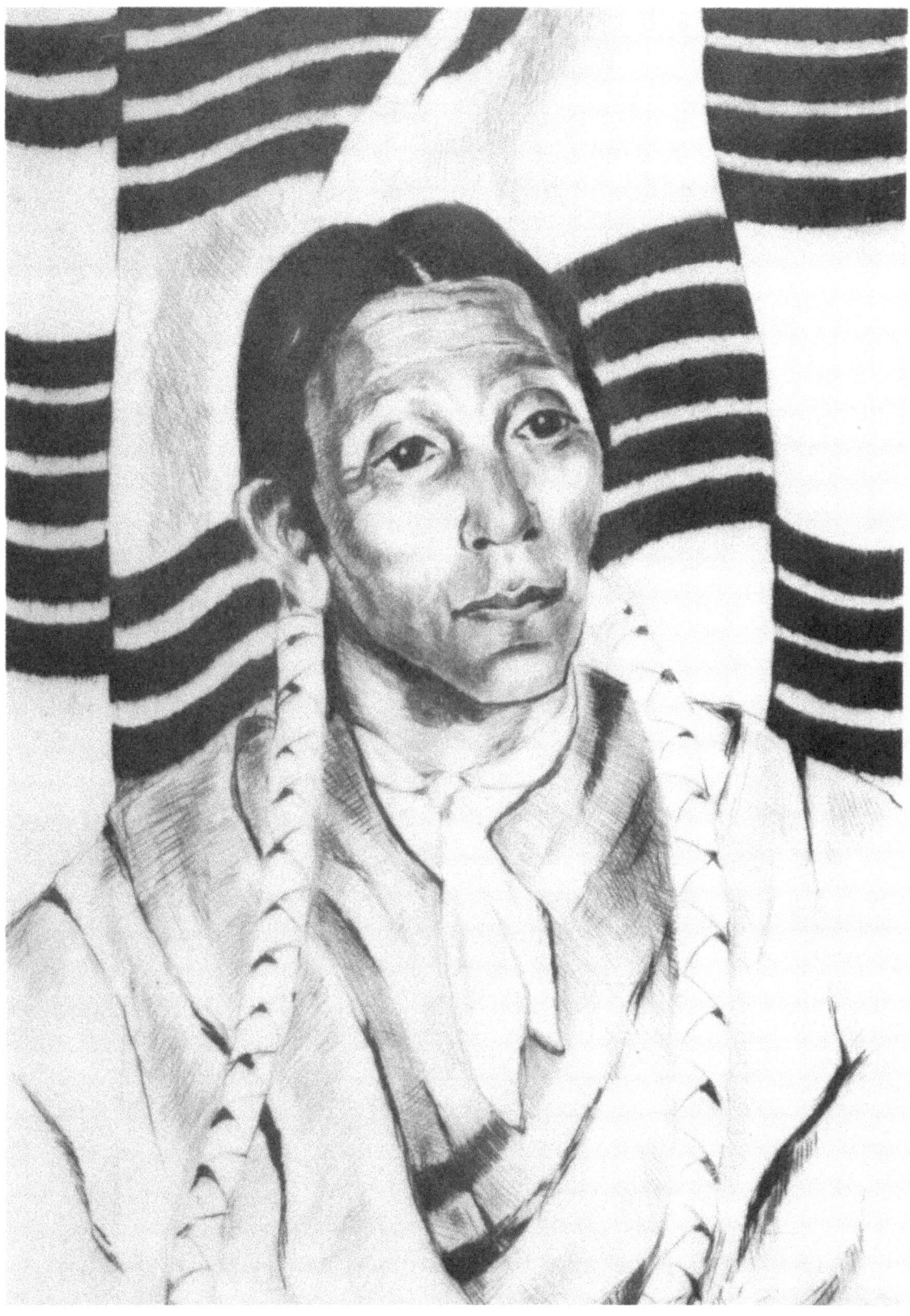

Indian Singer

OLD INDIAN CHIEF
279

He spoke no Spanish, no English, just Tiwa, a mysterious old man, friendly but uncommunicative. I could give his Indian name but I feel he would prefer, if he were living, that I didn't. All the Taos Indians deferred to his quietness.

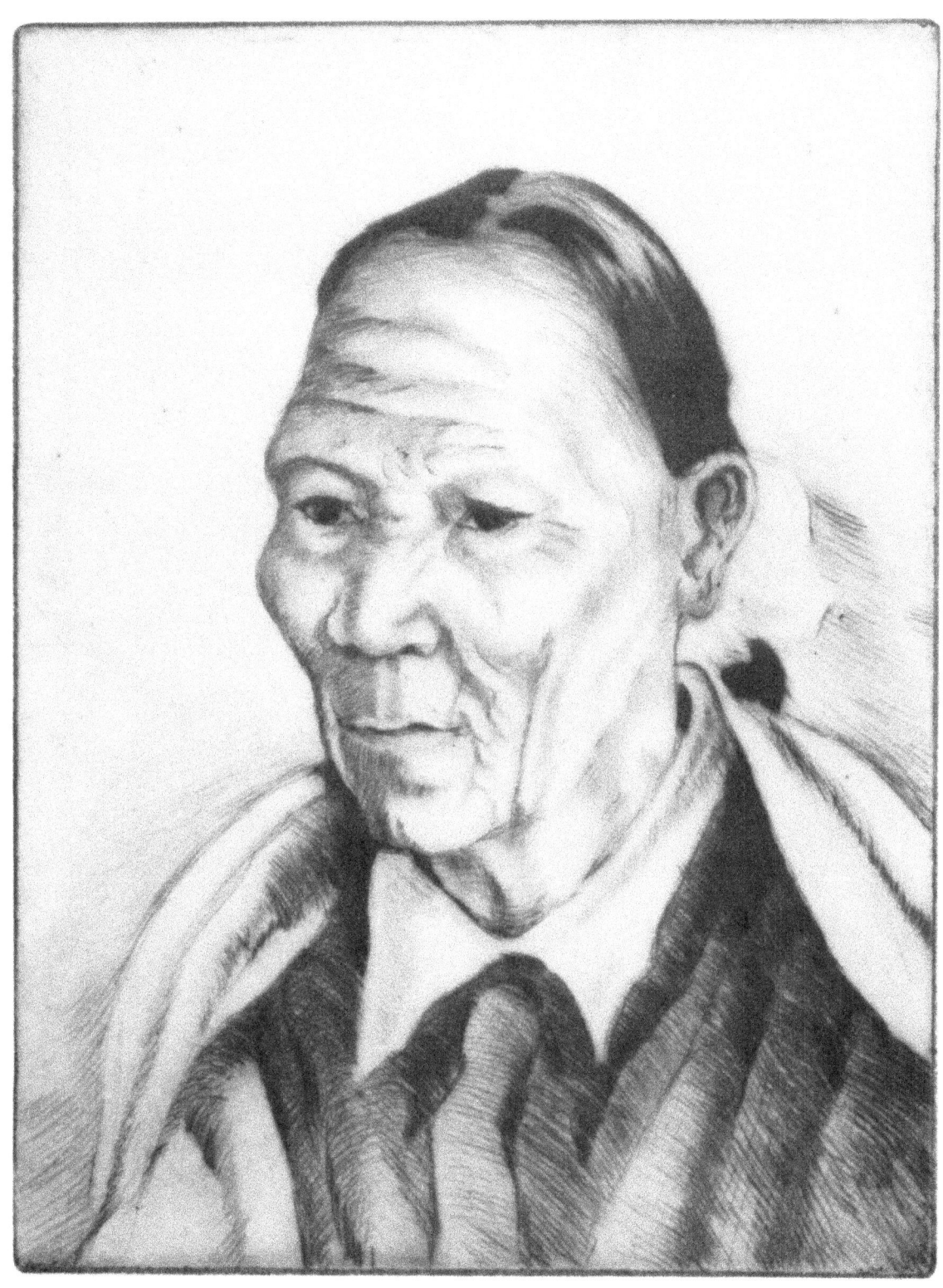

Old Indian Chief

SANTIAGO
271

Santiago was the best shot with bow-and-arrow in the Pueblo, a gentle, likable, somehow courteous man though he spoke no English and was unacquainted with English etiquette. The Spanish name Santiago was a mask for his real Indian name. He was Red Deer's grandfather. When he posed for this etching Red Deer came with him to act as interpreter. During the rest period he demonstrated his uncanny prowess with his bow-and-arrow. He stood forty feet away from the house while Red Deer tongued a finger and drew a wet target mark on the adobe wall. Santiago shot an arrow straight to the mark just as Red Deer drew his hand away. Red Deer shook his nearly nipped finger and said Gee whiz! The last time we saw old Santiago he was riding his horse on the trail to the Picurís pueblo for the doings there on August 10th, and he was chanting a tune in a cracked voice as happy as a youngster.

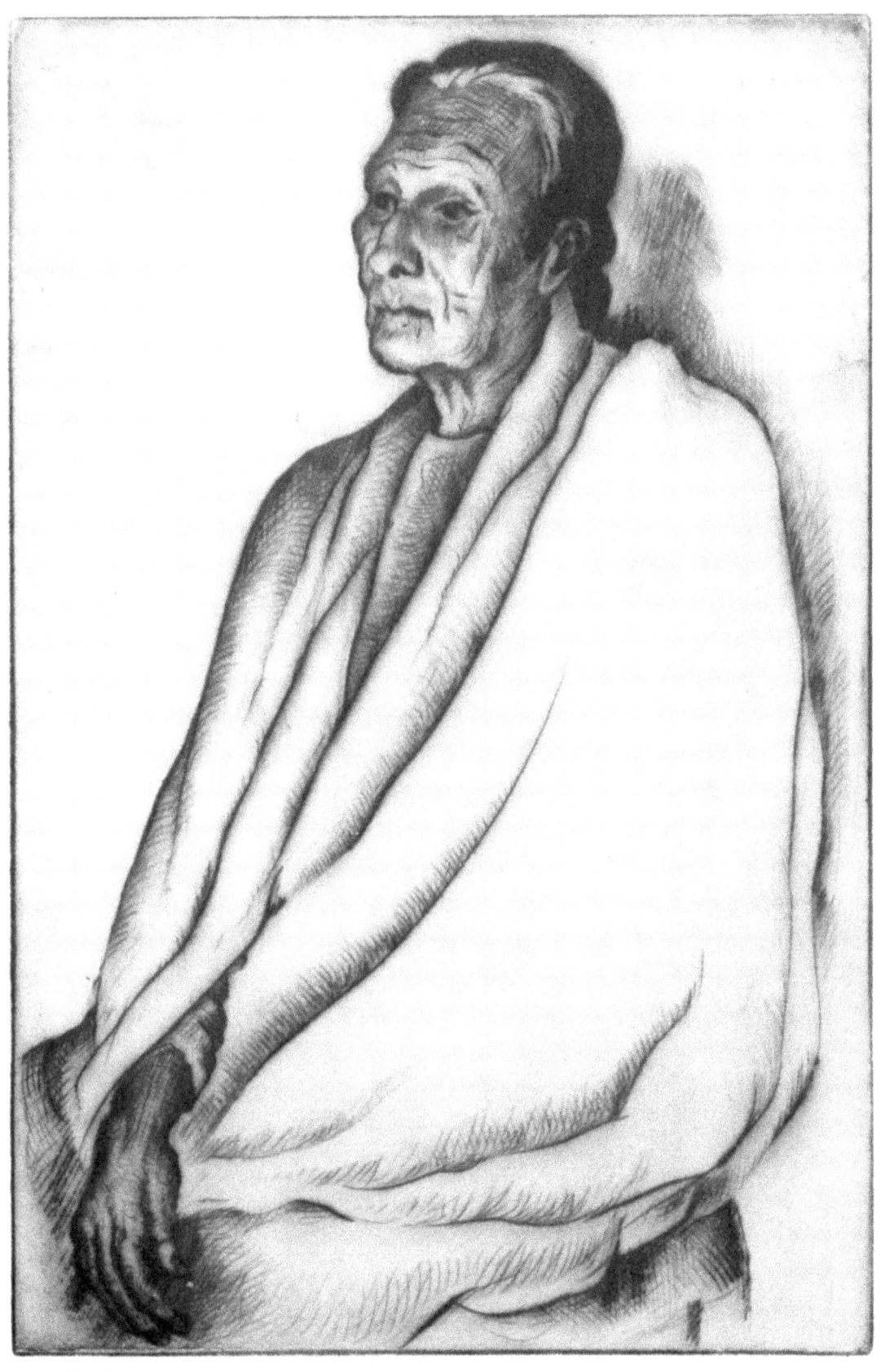

Santiago

MANUELITA
470

Manuelita was assistant nurse in a private rest home in Taos, very kind to my ninety-five year old mother who had been rendered helpless by a stroke at eighty-five and had suffered subconscious torment for ten years. I couldn't stand her final days gasping for breath and asked Manuelita to say an Indian prayer for her release. Manuelita did, and my mother was released, coincidentally if not miraculously. The tribal ceremony at Blue Lake high up in the mountains in August is a prayer for all living creatures, all humanity, for the Indian people, the Black White Man, the Quonsyna White Man, the Ponsyna White Man impartially.

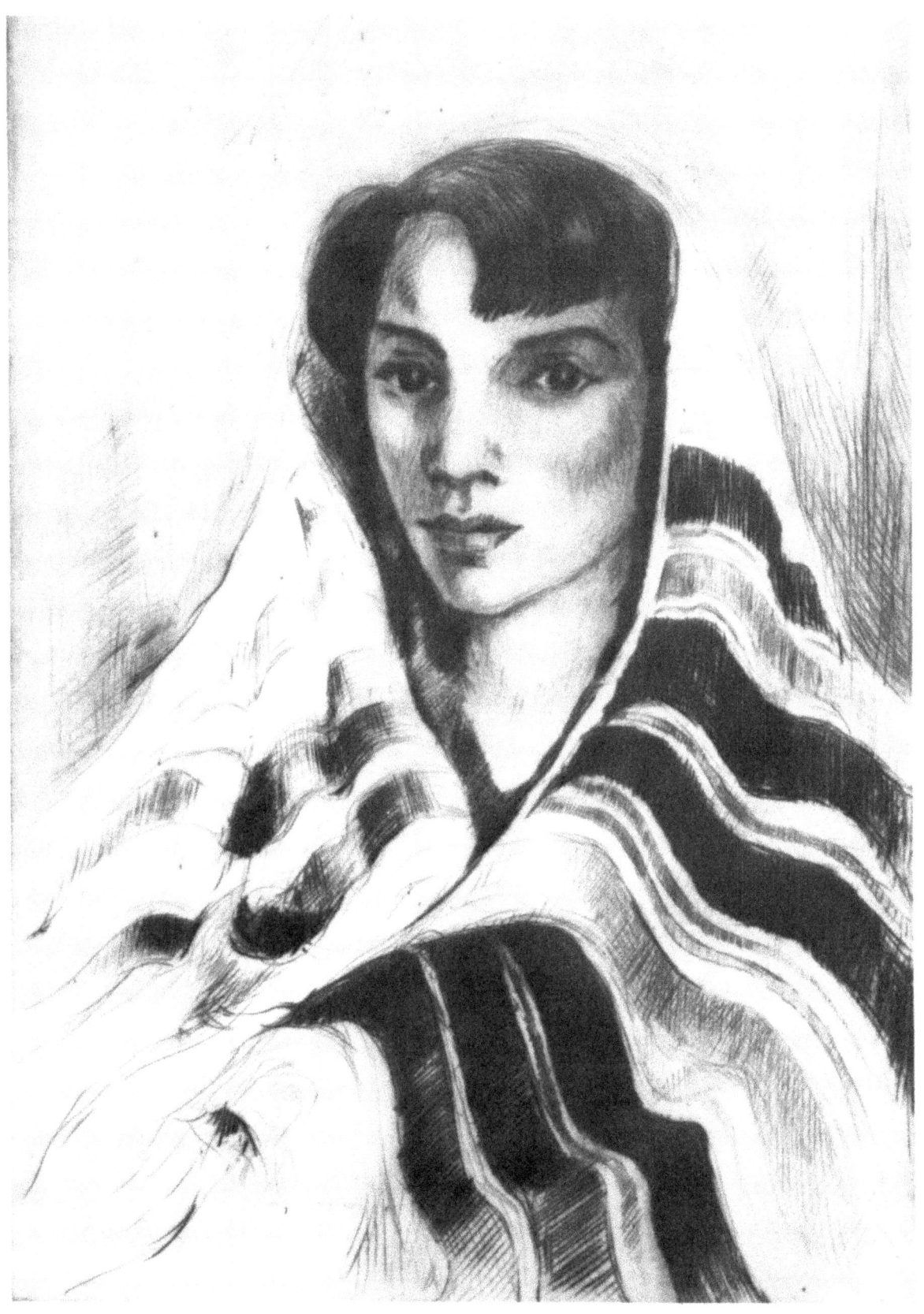
Manuelita

CORN DANCE MAIDEN
555

She was in the know, this girl. Her father was chief of a secret society and she was too intelligent to be denied confidential information, which she divulged to nobody but you were aware she had knowledge. She took part in the Corn Dance and other Indian doings. She married an Oklahoma Indian artist, who was rather rough when drunk, so she took town jobs, managerial jobs, very capable and efficient. She posed for Gene several times and they gossiped about town affairs, Indian affairs, never esoteric affairs.

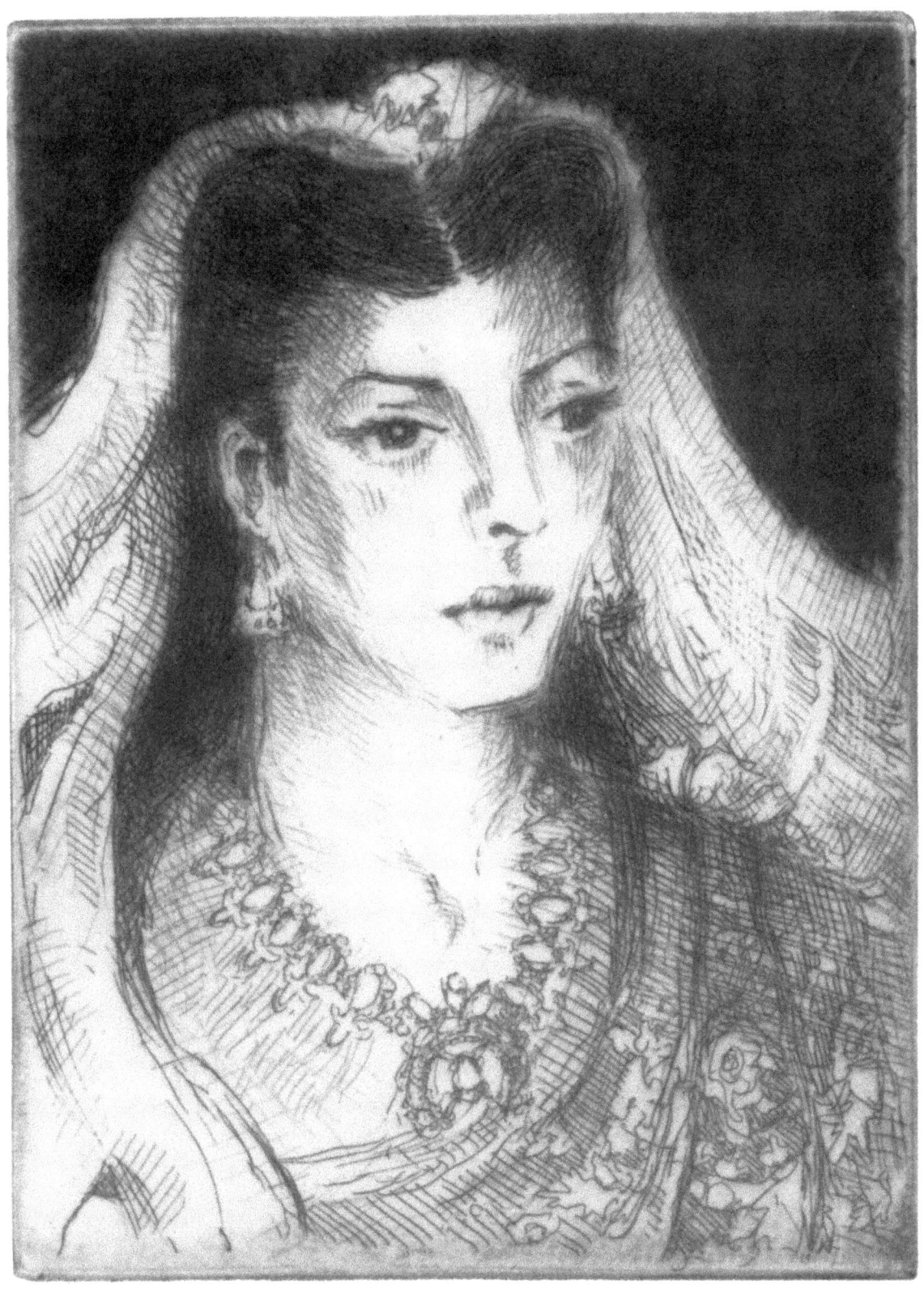

Corn Dance Maiden

CRUSITA
505

Daughter in a cacique-related family, one of thirteen children, all good-looking, Crusita was a patient model but impatiently ambitious to make something of her life other than raise thirteen more children. One of her pretty sisters, Gene's watercolor model, went to Chicago, became involved in the Pan-Indian movement, married an Eastern Indian and lives atop a skyscraper.

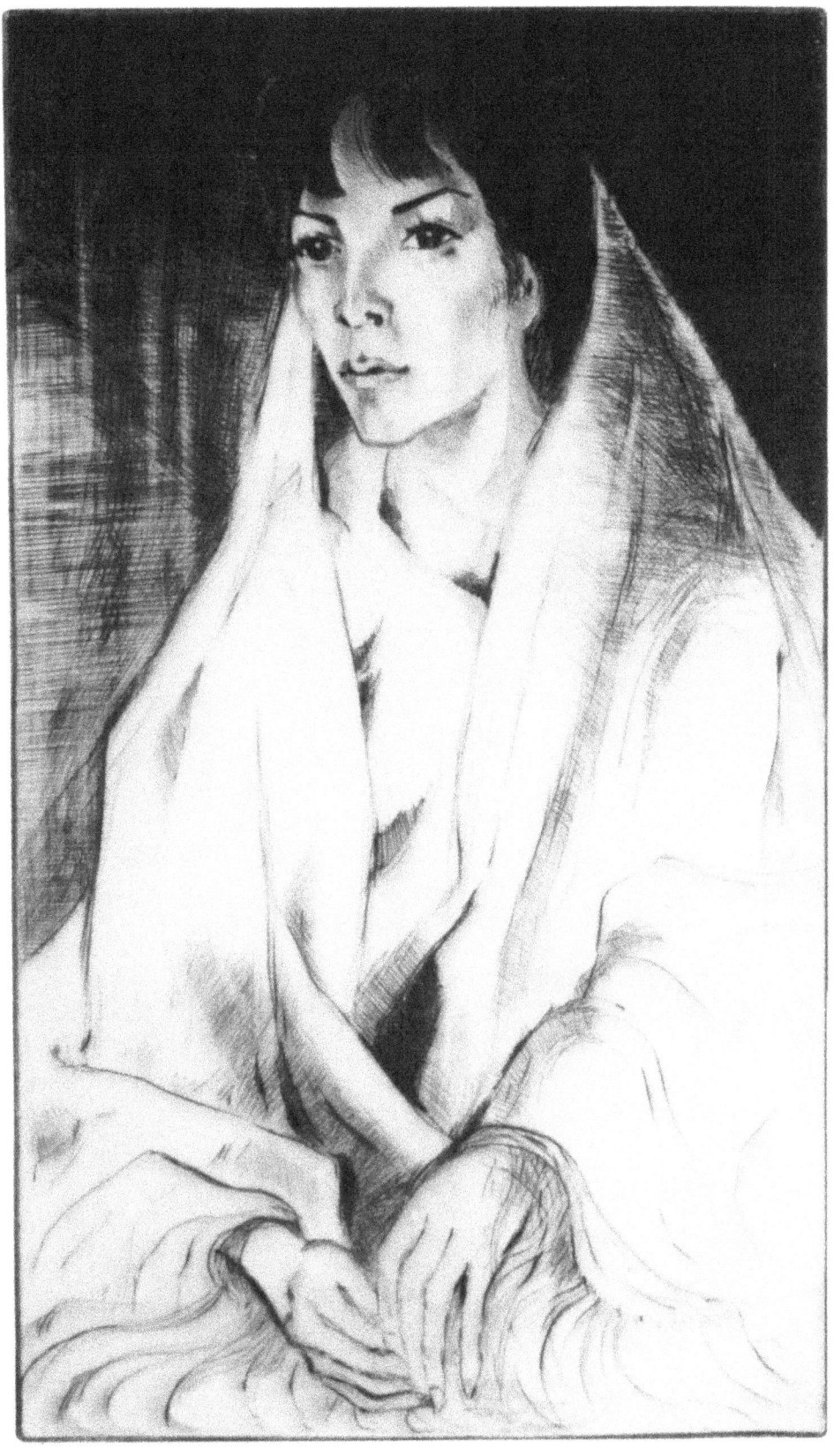
Crusita

REFLECTION
527

During rest periods Indian models, men, would often go to the window and look at the view from our elevated mesa across country. It was their ancient Indian domain, the boundary marks the crest of the Picurís Mountains south, the truncated triangle of Pedernal on the west horizon, the curve of San Antonio Mountain north, the unseeable baseline at Ute Park east. They liked the farness of the view, reflected on the places they had been and what had happened there. Posing again they introspected as well as reflected, their eyes showing it, reminding us of Paul Radin's paraphrase — Let me see, is this real? Let me see, is this real? This life that I am living?

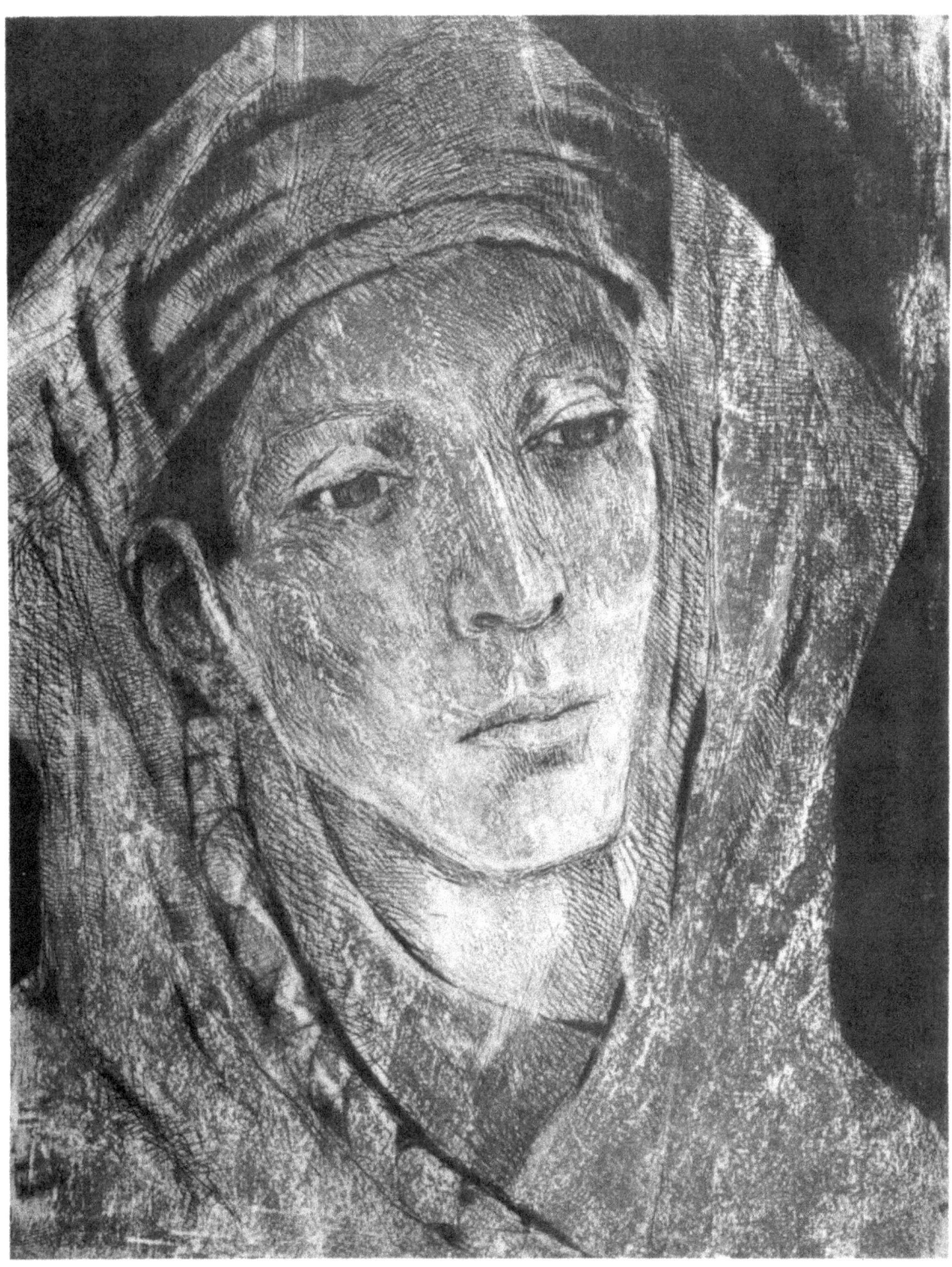

Reflection

THE VISITOR'S TALE
538

Keresan Indians, Osage, Pawnee, outsiders from near and afar often visited the Taos pueblo and had a tale to tell. The teller here, judging by his hairband, is from the Keresan pueblo of Kihwa (Santo Domingo). The attentive face is that of the Taos Head Man, one of the strongest characters and purest minds we have ever known. He would be a gracious host to an important visitor.

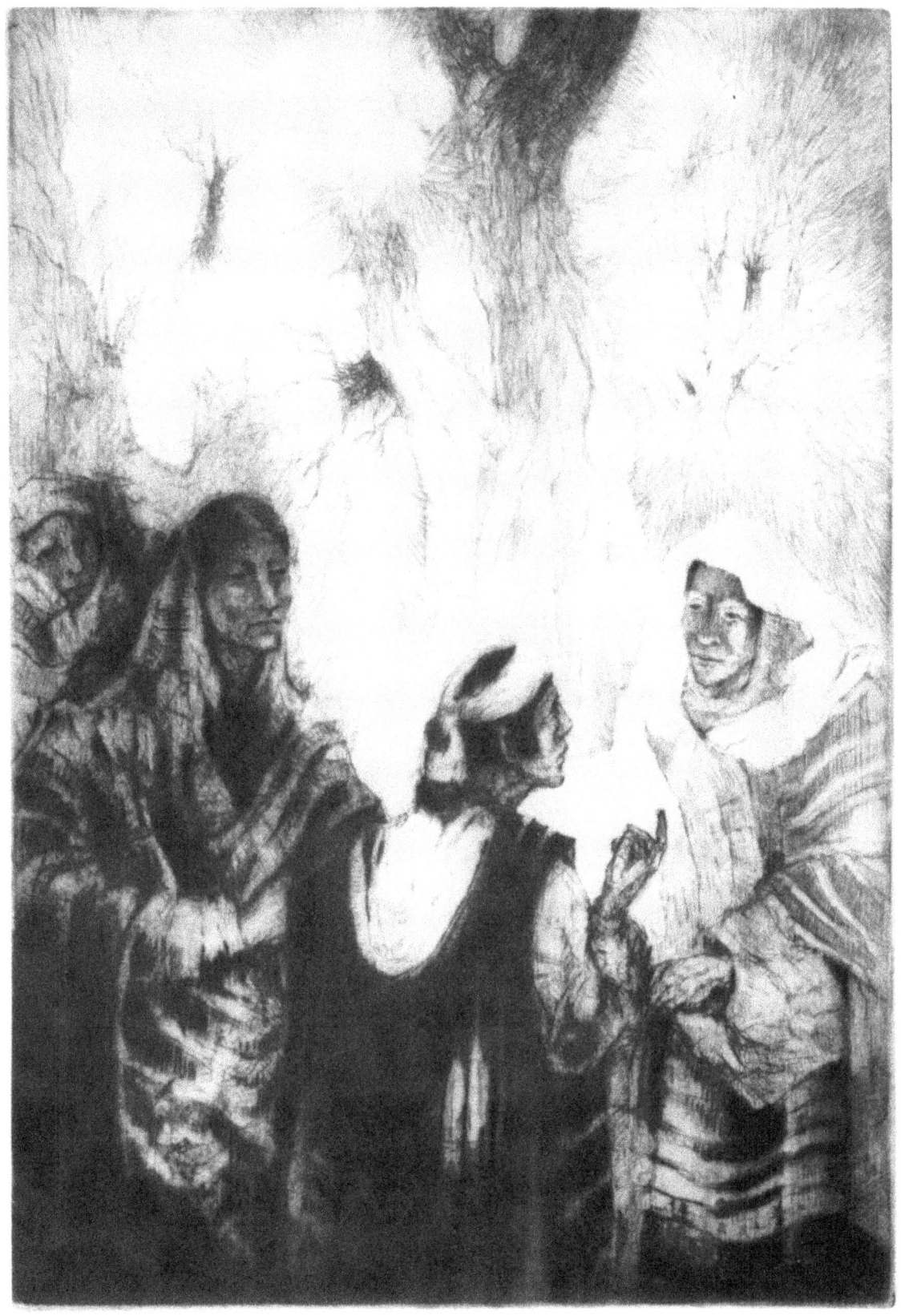

The Visitor's Tale

DEER DANCE
531

Now the two lines of Deer Dancers reach the upper end of the
 danceground and the Corn Dancers stand back.
Now two women appear and take their place at the head of the
 two lines,
Two women wearing white robes and white moccasin boots, head-
 dresses a fan-spread of eagle and macaw feathers.
They are the Deer Mothers. They raise their arms sidewise
 shoulder-level, crook their elbows, forearms vertical,
They hold two eagle feathers in each hand, a gentle wrist motion
 keeping time with the drumbeat.
Now they lead their lines down the danceground to make a circle,
 one to the right, one to the left,
Now they turn back in opposite rotation, meet at the top of the
 danceground, closing the circle.
The Deer Dancers kneel, forming the circle, and nod their antlered
 heads up and down to the drumbeat.
Now the Deer Mothers dance inside the circle, one to the right,
 one to the left, graceful, swaying, pulsing steps,
They swerve and shake the eagle feathers with both hands over
 each kneeling deer they pass,
A maternal benediction for the spirits of the dead deer, a
 blessing for their sacrifice of life.
We are the Deer Mothers, we watch over you, ye shall arise and
 live again,
Shall run through the woods, leap over rocks, drink from the
 streams, browse the green leaves,
No arrow shall touch you, we shall watch over you, ye shall
 arise and live forever.

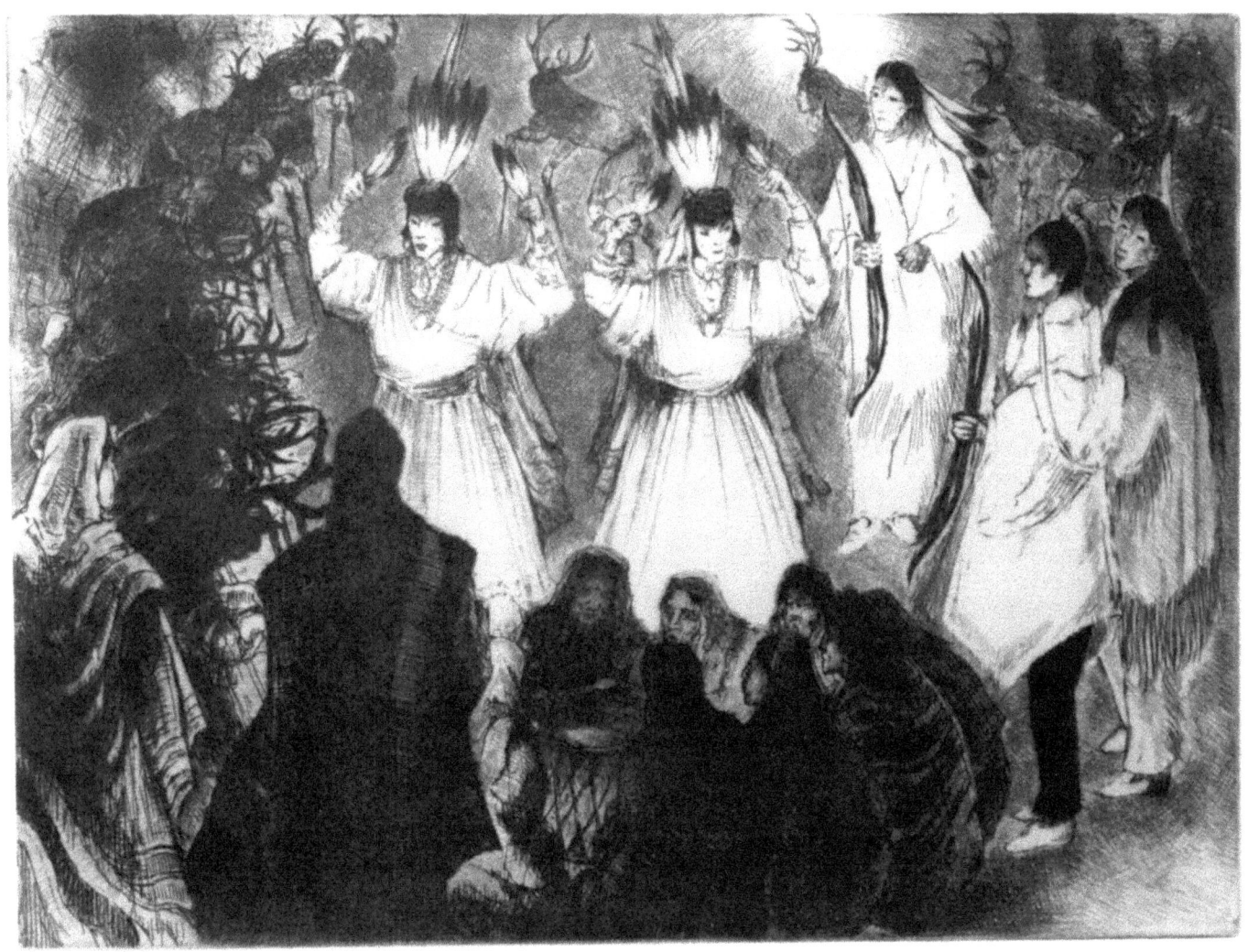

Deer Dance

RABBIT HUNTERS ON THE WAY
545

The Rabbit Hunt is an exciting spectacle, no guns or bows-and-arrows allowed, just the throwing stick, a knob-headed club that can be thrown with surprising accuracy. Horses are allowed so that the riders can make a big arc and roust the rabbits toward men on foot armed with throwing sticks. Formerly rabbit hunts ranged over the open country all around Taos, few fences to obstruct the hunters. Now the hunts are limited to the Indian reservation and several adjoining ranches.

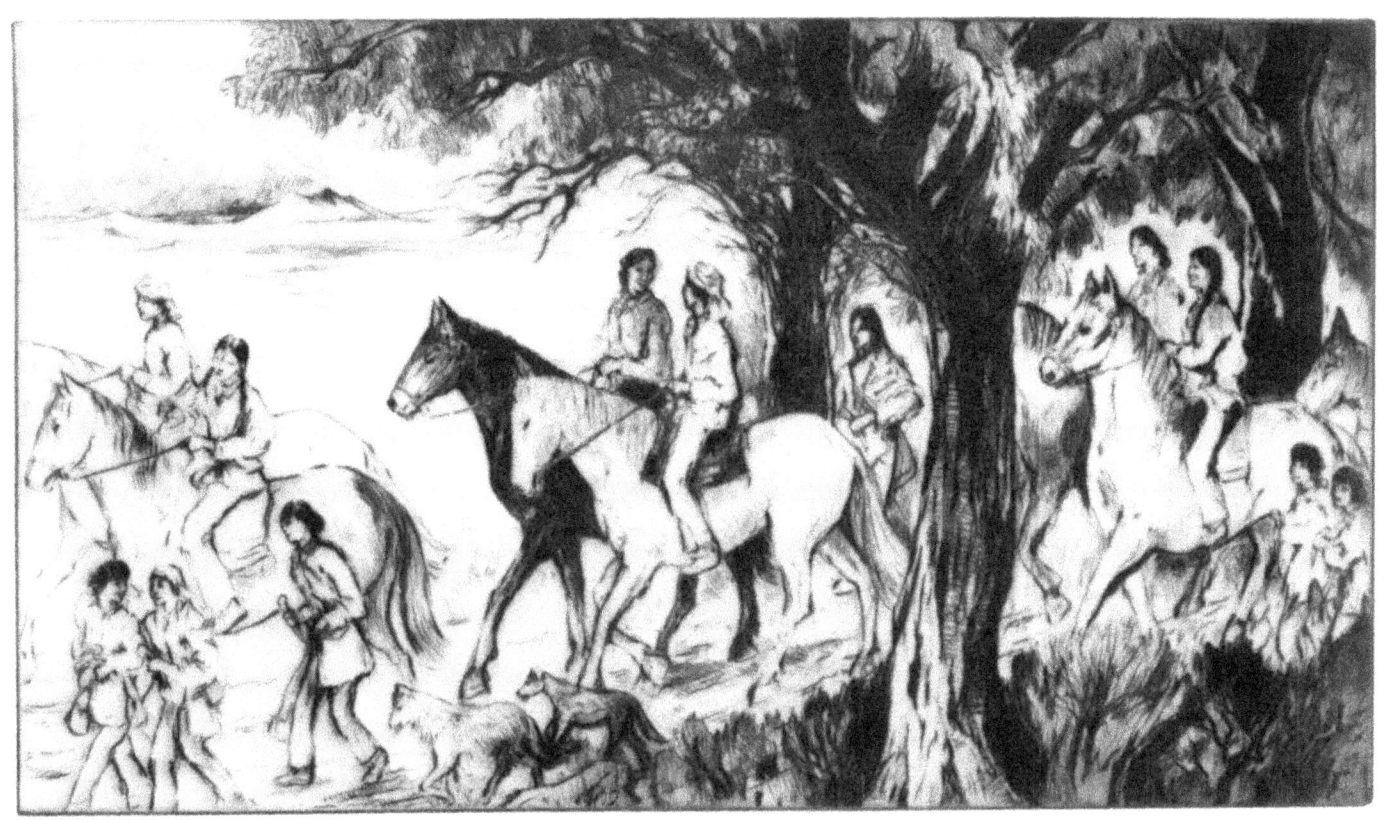

Rabbit Hunters On The Way

THE OLD ROAD TO TAOS
428

The basaltic Taos river gorge drops into the basaltic Rio Grande Gorge, a ledge road hanging over a precipice once the main road between Santa Fe and Taos. You went up in low gear and down in low gear. You hugged the inside rut when the road was icy hoping your car wouldn't decide to make a ski slide out of it. Long John Dunn drove his Studebaker stage daily over this road summer and winter to get the mail and passengers at the narrowgauge railroad station at Taos Junction. He was a lank Texan, six-foot-two, with a nasal Texan drawl and tobacco-stained walrus mustache. He considerately loaded his passengers on the mail bags instead of loading the mail bags on the passengers. Once when taking three Eastern ladies from Taos to meet the train for Santa Fe at Taos Junction he kindly let the grey-haired one sit beside him on the front seat. She nervously looked down the precipice as they bumped along, apprehensively inquired: "Oh Mr. Dunn, do people fall over here often?" He tugged his tobacco tips and replied in his nasal Texan drawl: "No ma'am, not often. Just once."

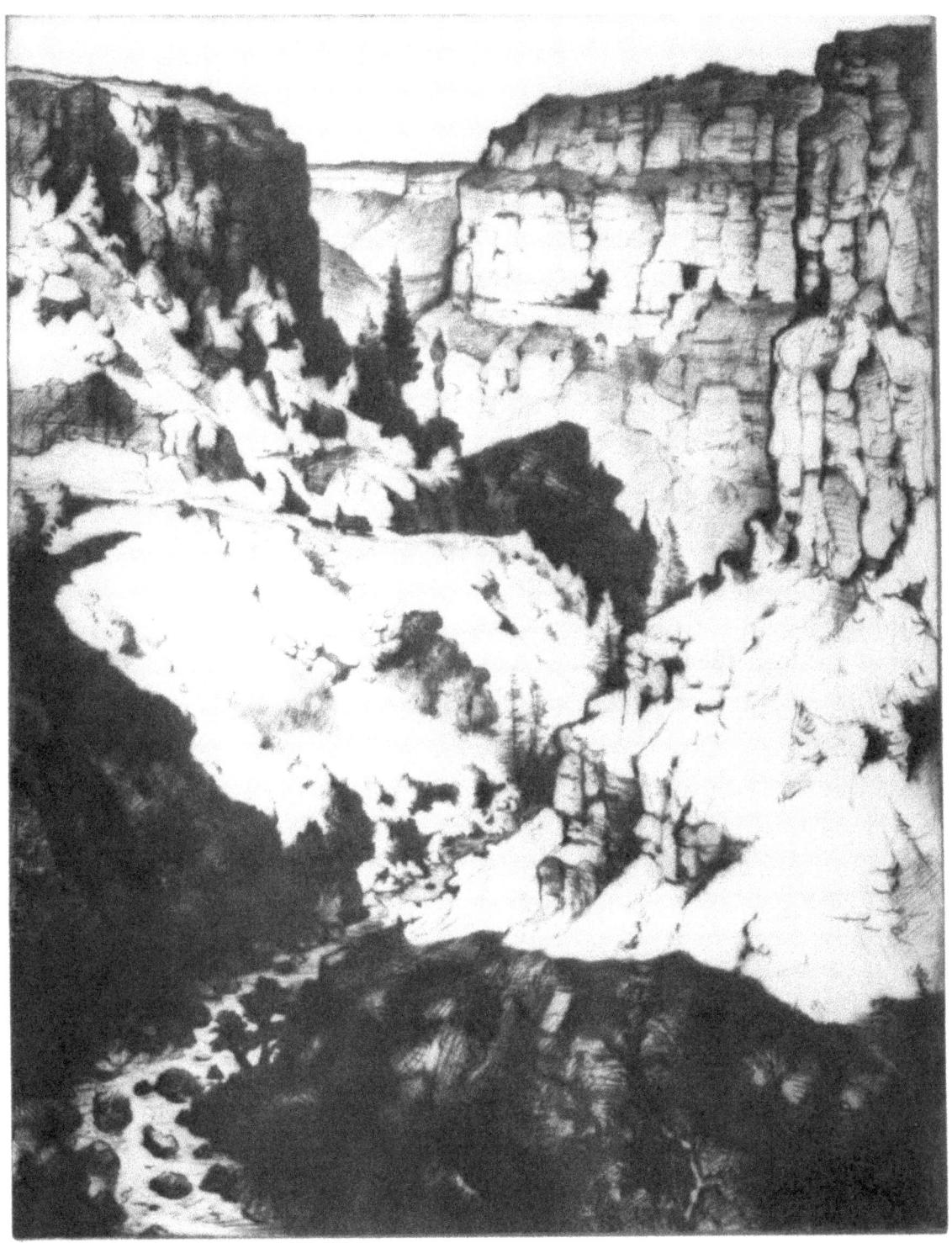

The Old Road To Taos

YESTERYEAR IN TALPA
558

Talpa was an arresting and restful composition in the old days, built on a low spur at the confluence of two mountain streams, a lush, tangled, almost tropical valley below. We shouldn't bewail changes that keep changing. Talpa was once the center of a large Indian population, pithouses, pueblos, the so-called Dwarf Pueblo across the main stream. We can't glorify the past, present or future. We can retain pleasant aspects.

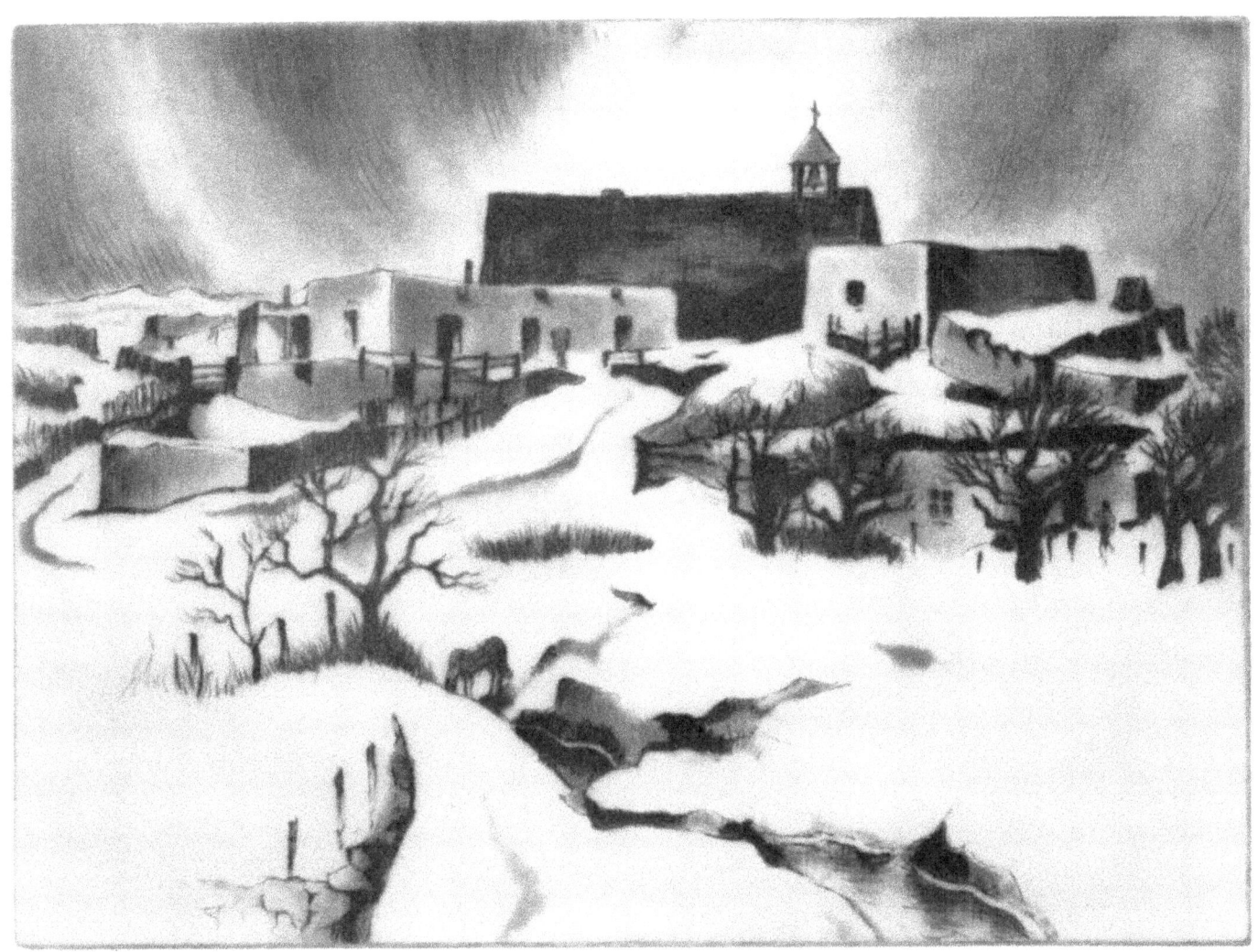
Yesteryear In Talpa

THE VALLEY OF VALDEZ
553

Pre-pueblo pithouses line the mesas of the lovely valley of Valdez, the circular depressions scarcely discernible. The Hondo River runs through the valley, and the village of Valdez itself, once a house-squared stockade, retains its rurality.

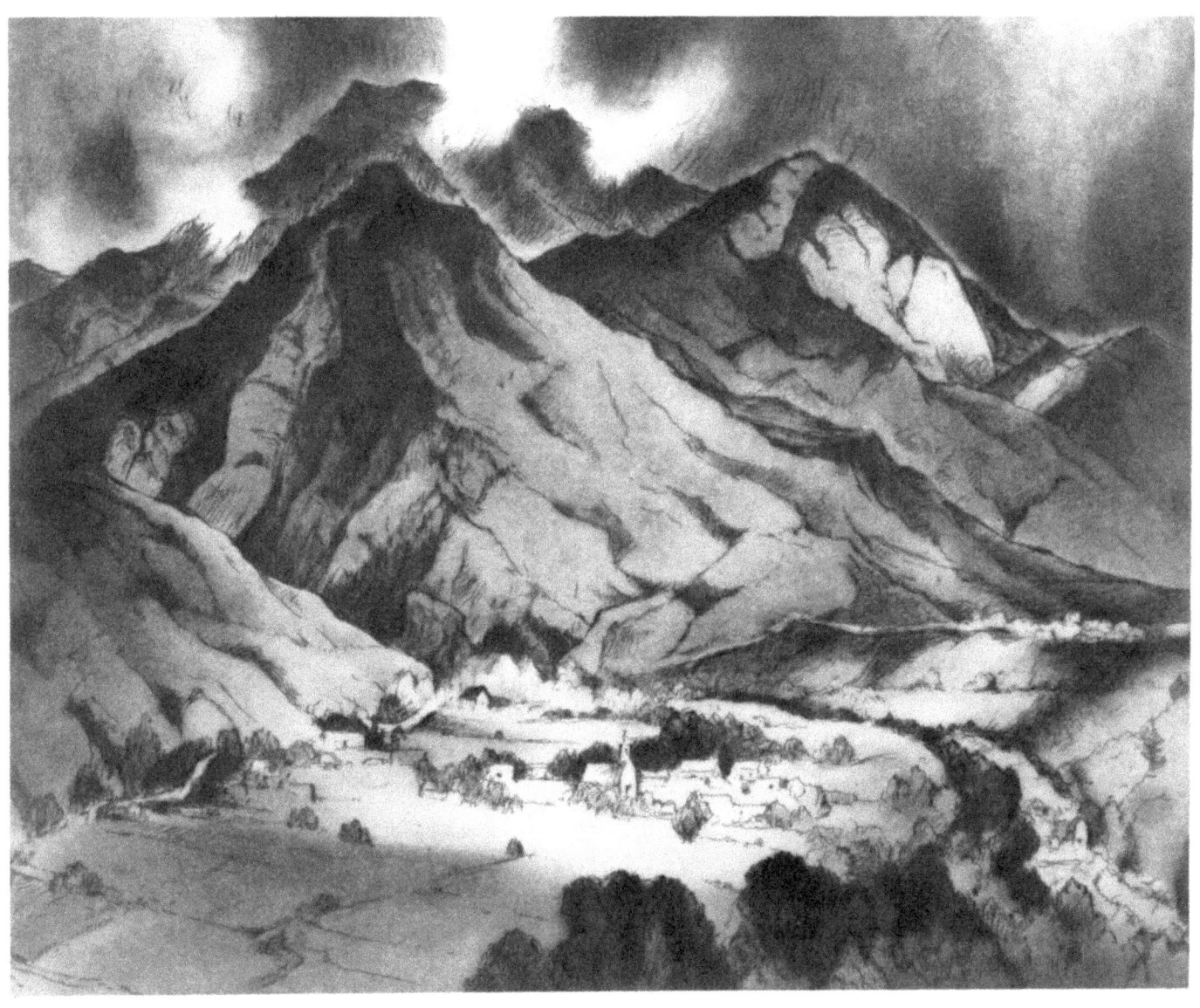

The Valley of Valdez

TAOS VALLEY IN WINTER
548

Our native-shaped oblong adobe house on the mesa was windowed on four sides, and in summer Gene would sometimes set up watercolor boards in two or three directions and paint the chameleonic cloud-effects dually or triply, dashing and splashing from one to the other. In winter the effects were steadier, except in a snowstorm, and she could draw meticulously. This view of the valley out the window is one of my favorites. It is etched on my memory, a psychic incision.

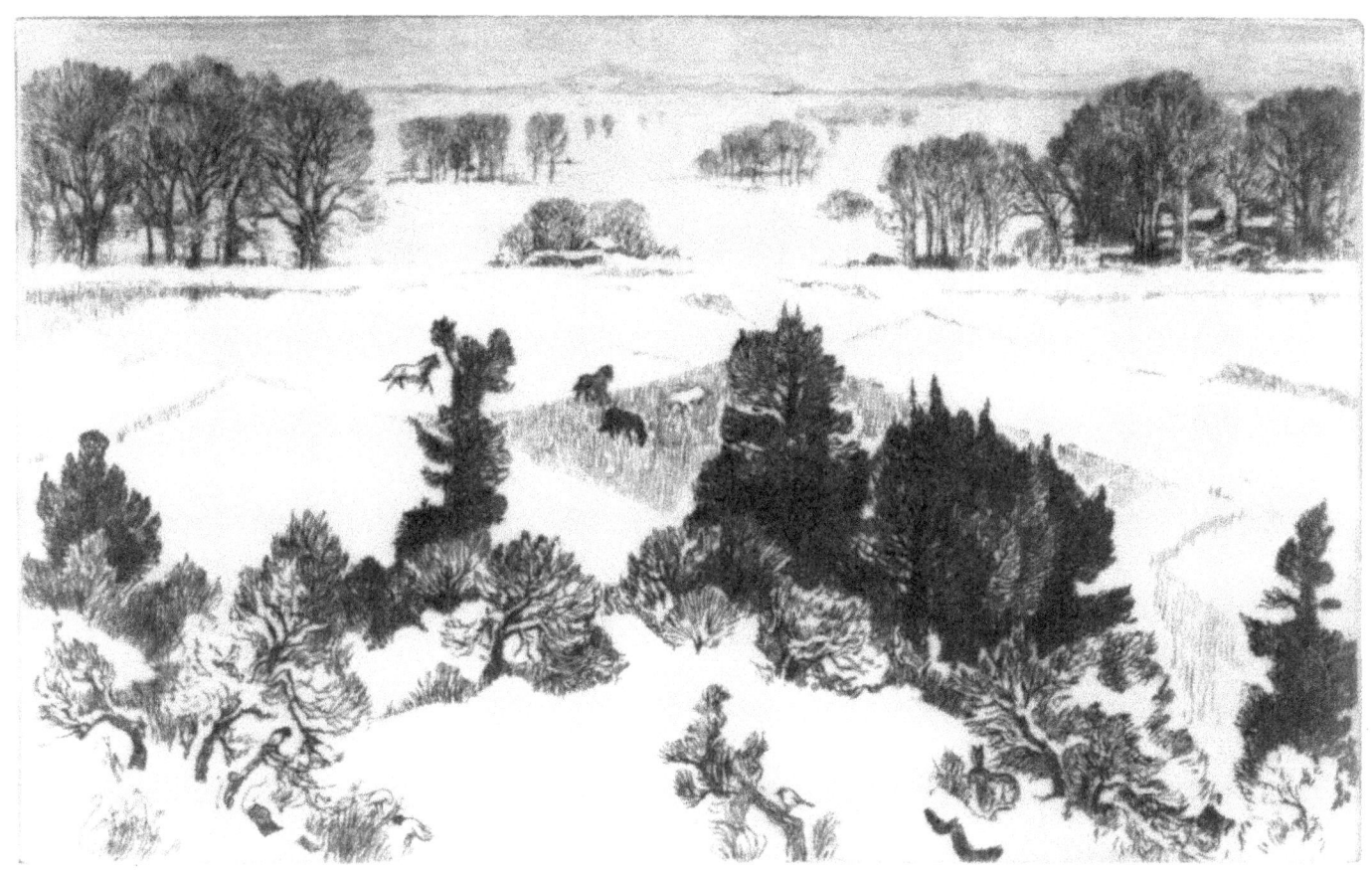

Taos Valley In Winter

WINTER SUNRISE
576

The woods are lush, broad-leafed cottonwoods, narrow-leafed cottonwoods, gnarled boxelders, chokecherry trees, red-stemmed dogwood bushes, ponderosa pine, balsam fir, douglas spruce, blue spruce, limber pine, on up the canyon. The seasons enchant the woods. Sunrise restores the tang of living.

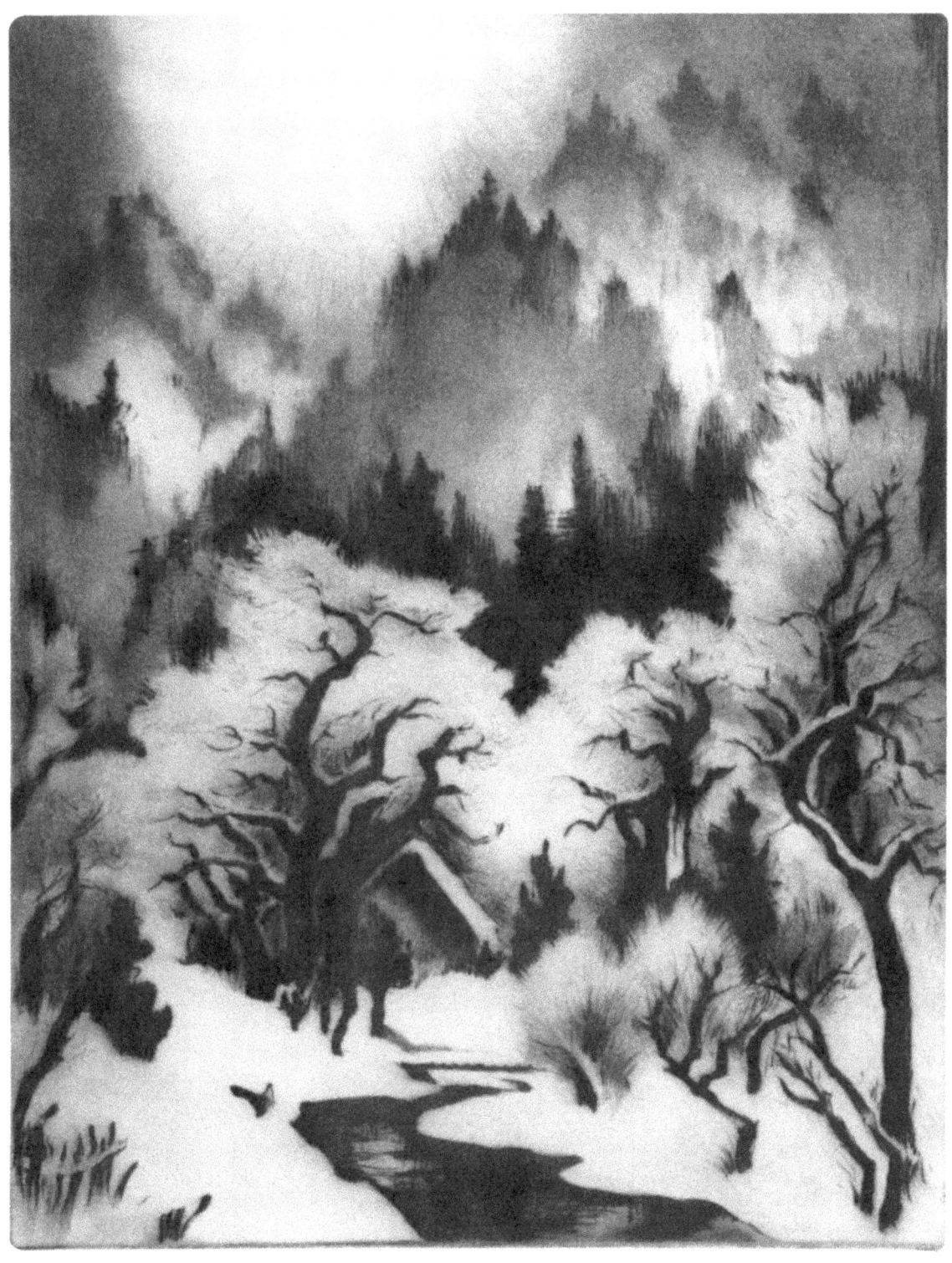

Winter Sunrise

HONDO VALLEY WESTWARD
571

The Hondo Valley continues the Valdez Valley down to the Rio Grande, and you look across the Rio Grande Gorge to the sagebrush plains and vast panorama of the San Juan range, the view that D.H. Lawrence declared the most beautiful landscape in the world.

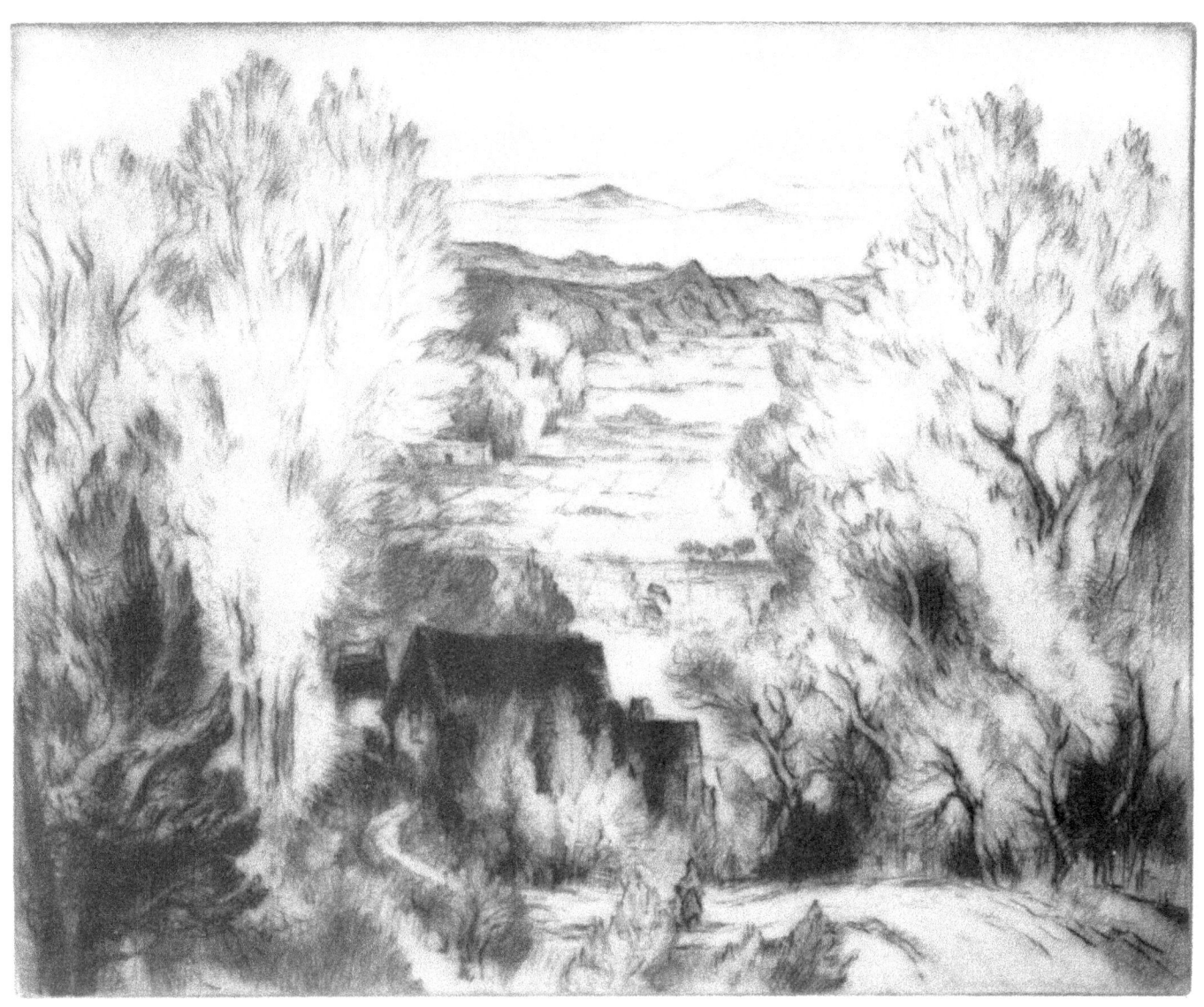

Hondo Valley Westward

"QUOTH THE RAVEN, NEVERMORE"
559

The sketch of this scene was made over forty-five years ago, the etching from the sketch recently. The place is unplaceable today. The ravens were in the original sketch and to have them quoth Nevermore as the title for the etching was irresistible.

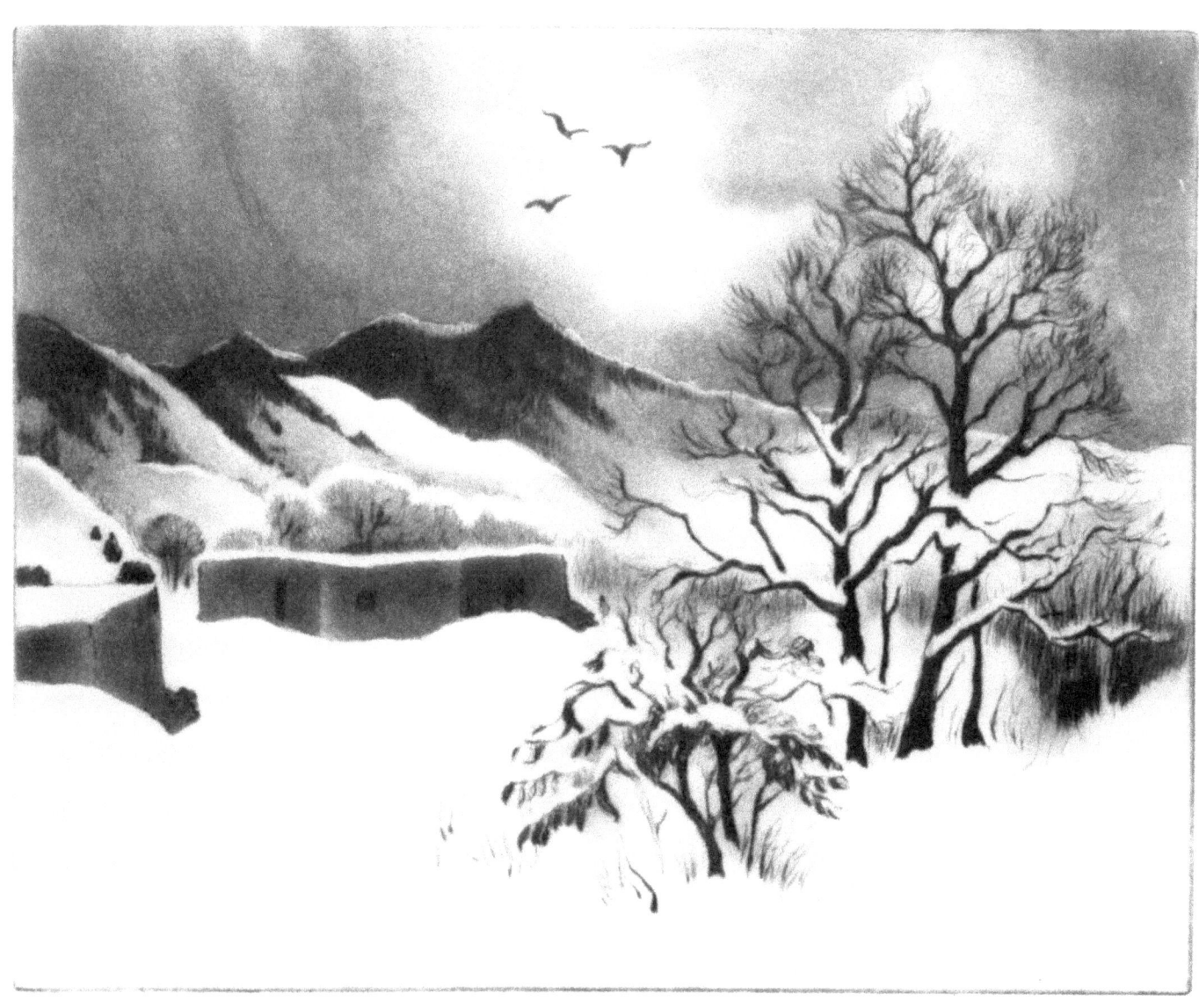

"Quoth The Raven, Nevermore"

EVE OF THE GREEN CORN CEREMONY
306

The Corn Dance at the Keresan pueblo of Santo Domingo, Kihwa, on the Fourth of August is a fervent, meaningful, powerful event, a prayer for rain, prayer for growing corn, prayer for life. It is said to be the greatest native dance of any people anywhere in the world. It consists of two long lines of dancers, a huge male chorus, a lone drummer, and a ceremonial wand-bearer. Woman is matched with man in the dance, following his footsteps, girl with boy. The various intricate dance patterns are perfectly performed. The duality principle is carried further with a Winter People's group of dancers alternating with a Summer People's group all day, joining in a tremendous finale toward sundown. In this etching a Koshairi, or so-called Delight Maker, Ancestor Spirit, stands on top of the Turquoise Kiva giving instructions to the Winter People the evening before the great dance.

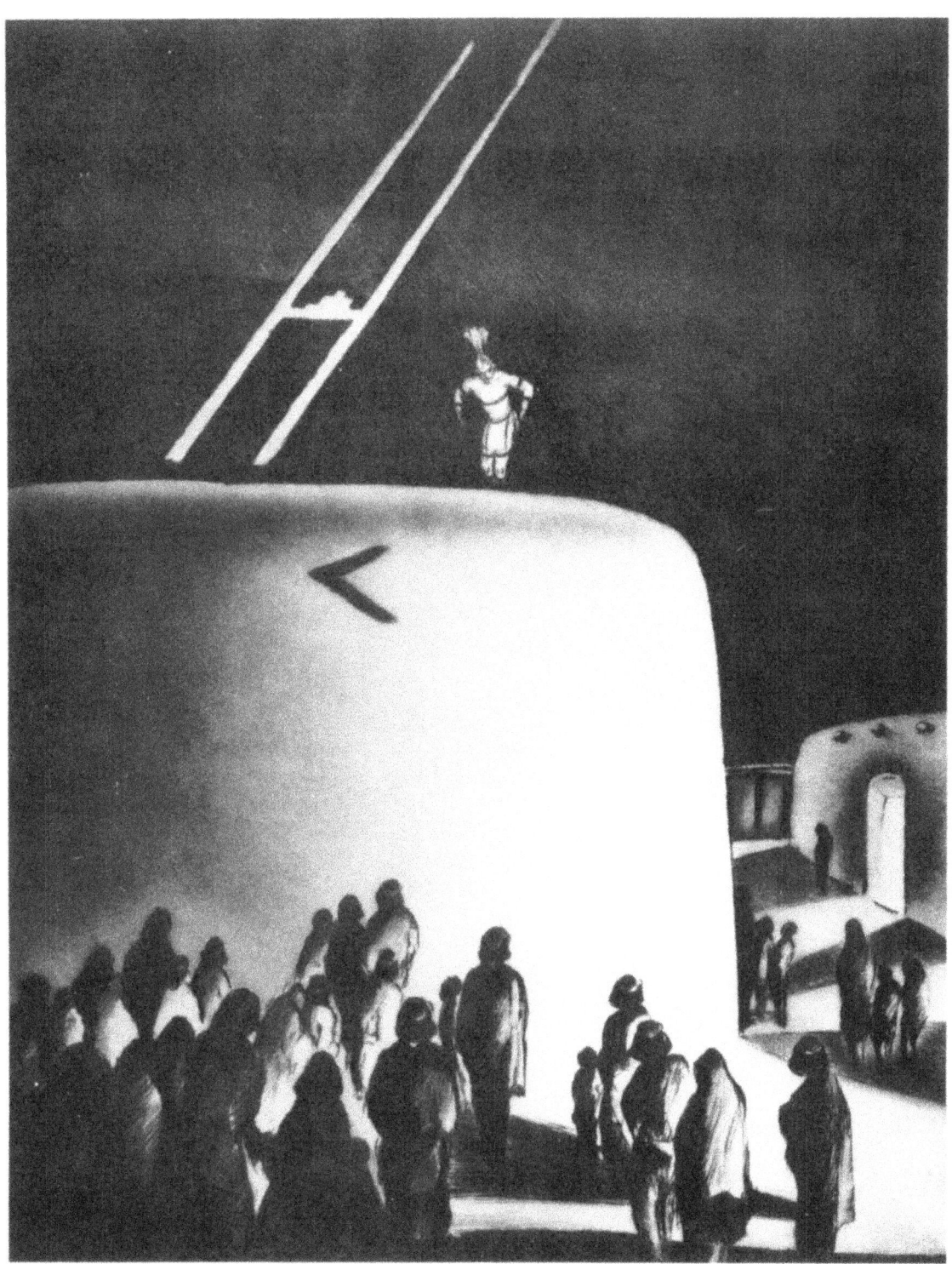

Eve Of The Green Corn Ceremony

DOMINGO BASKET DANCE
562

This is strictly an entertainment dance, said to be a parody of the Hopi Basket Dance. A respectful parody. Indians are rarely contemptuous in their imitation or burlesque of other people's mannerisms and customs. A clown Koshairi will imitate a classic-type Negro mammy with affectionate exaggeration, black face, rolling eyes, bandana headdress, stuffed bosom, purple dress, white gloves, Southern dialect, all abodd, evrybody, peanuts, popcahn, chewin gum, howya doin, honeychile, is yo-all got ovah yo bellyache. The Basket Dance is a fastidious performance, no Koshairi, the words of the song the chorus sings unknowable.

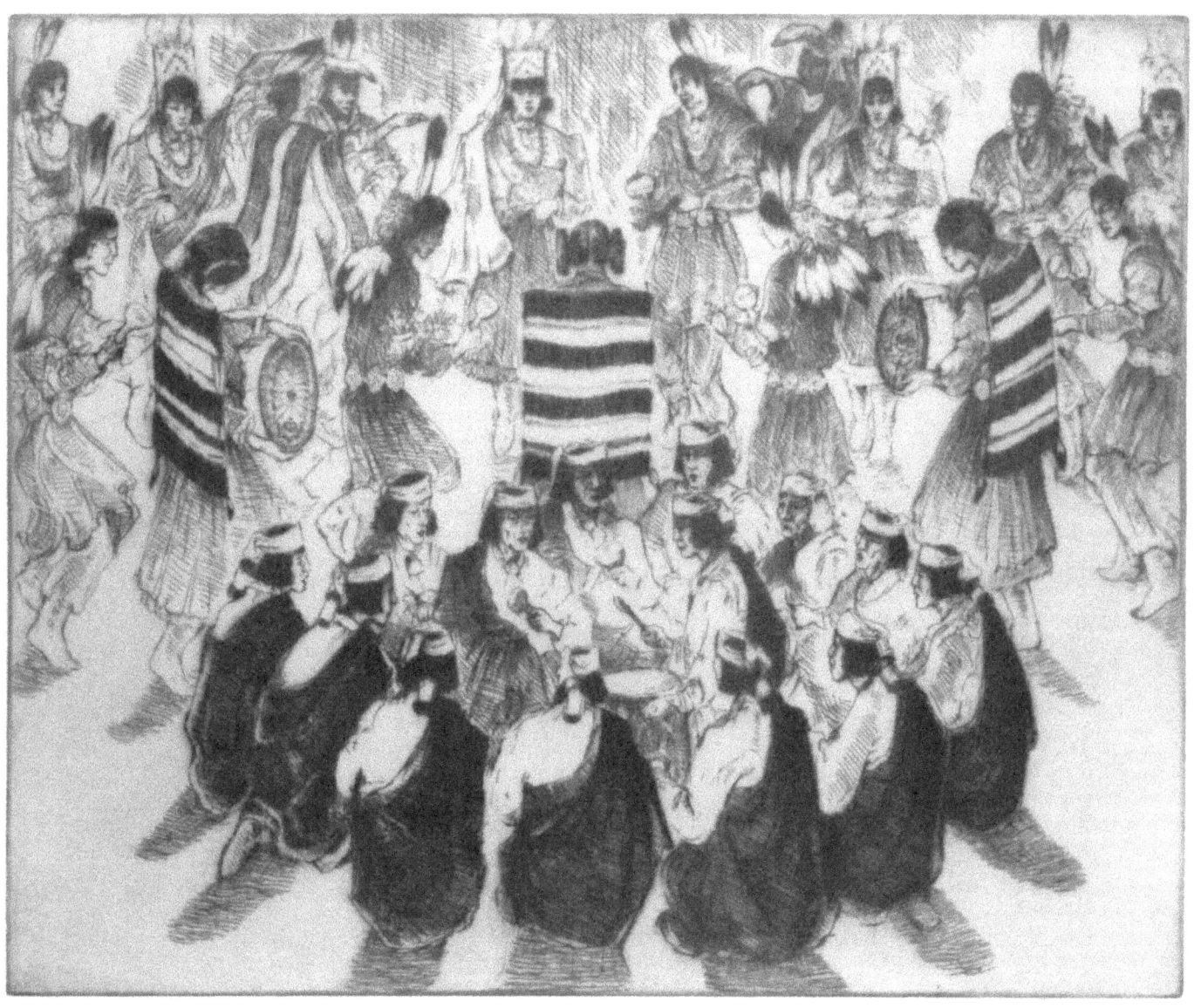

Domingo Basket Dance

ON CHRISTMAS DAY
581

One of the two entertainment dances on Christmas Day, the whorl motif accentuated. The costumes are stunning, the men wearing bright red velveteen blouses, white cotton ceremonial trousers, silver concho belts, the women wearing stiff white deerskin capes, dark coarse cotton skirts. The dance patterns reiterate the whorl motif, diagonal tangents accentuate it, a significance we don't fathom. Mysterious, intriguing, flawless.

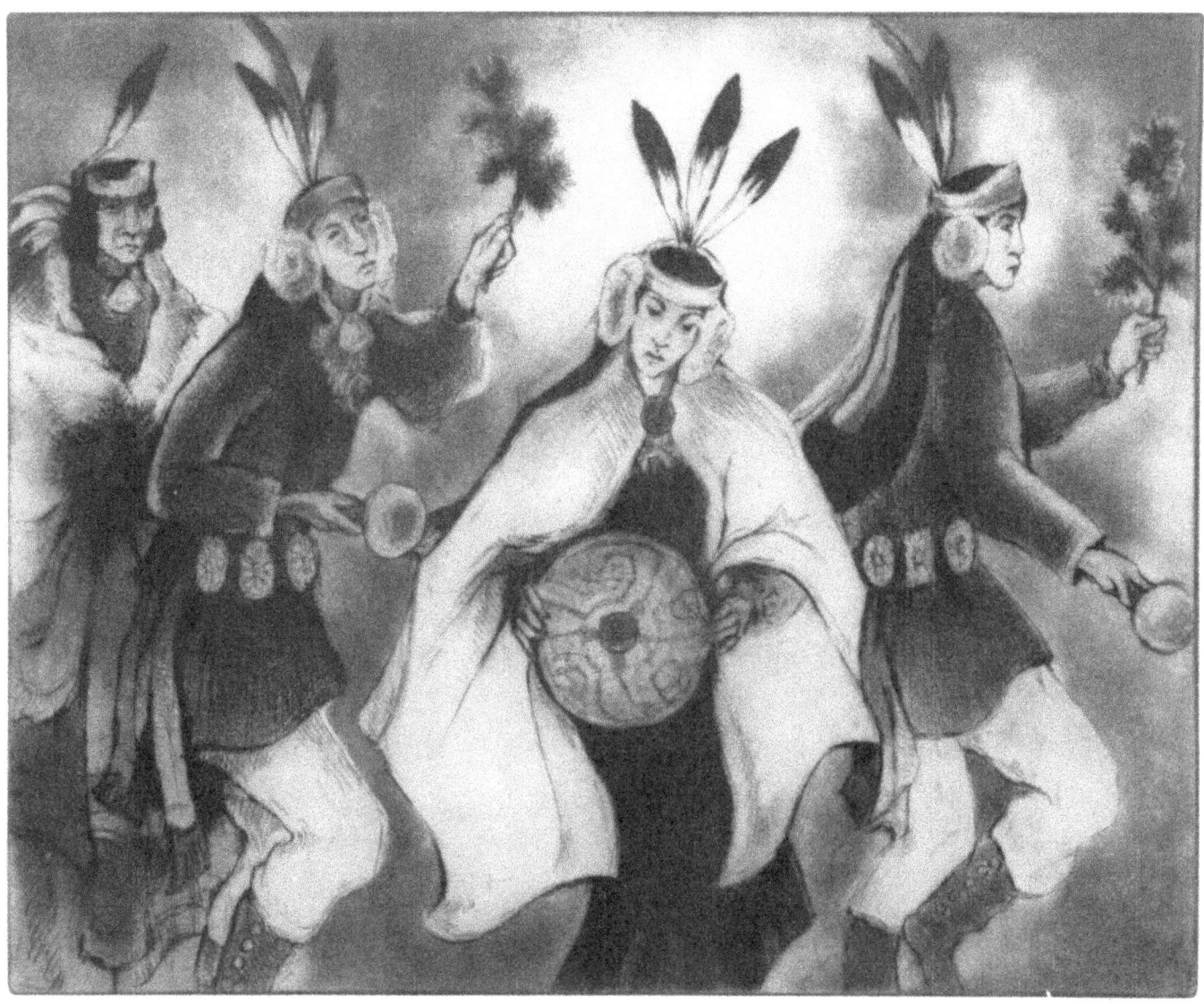

On Christmas Day

WINTER SOLSTICE DANCE
491

Though given on Christmas Day as a celebration of festivities, this is a serious dance equivalent to the Taos Turtle Dance which is given on New Year's Day. The sun has turned back to the north. Celebrate the birth of Christ and re-birth of the earth. The days will grow longer and brighter, the sun will grow warmer. It is an indescribable dance. Like a Beethoven sonata it transcends its key, the implications and inferences beyond language.

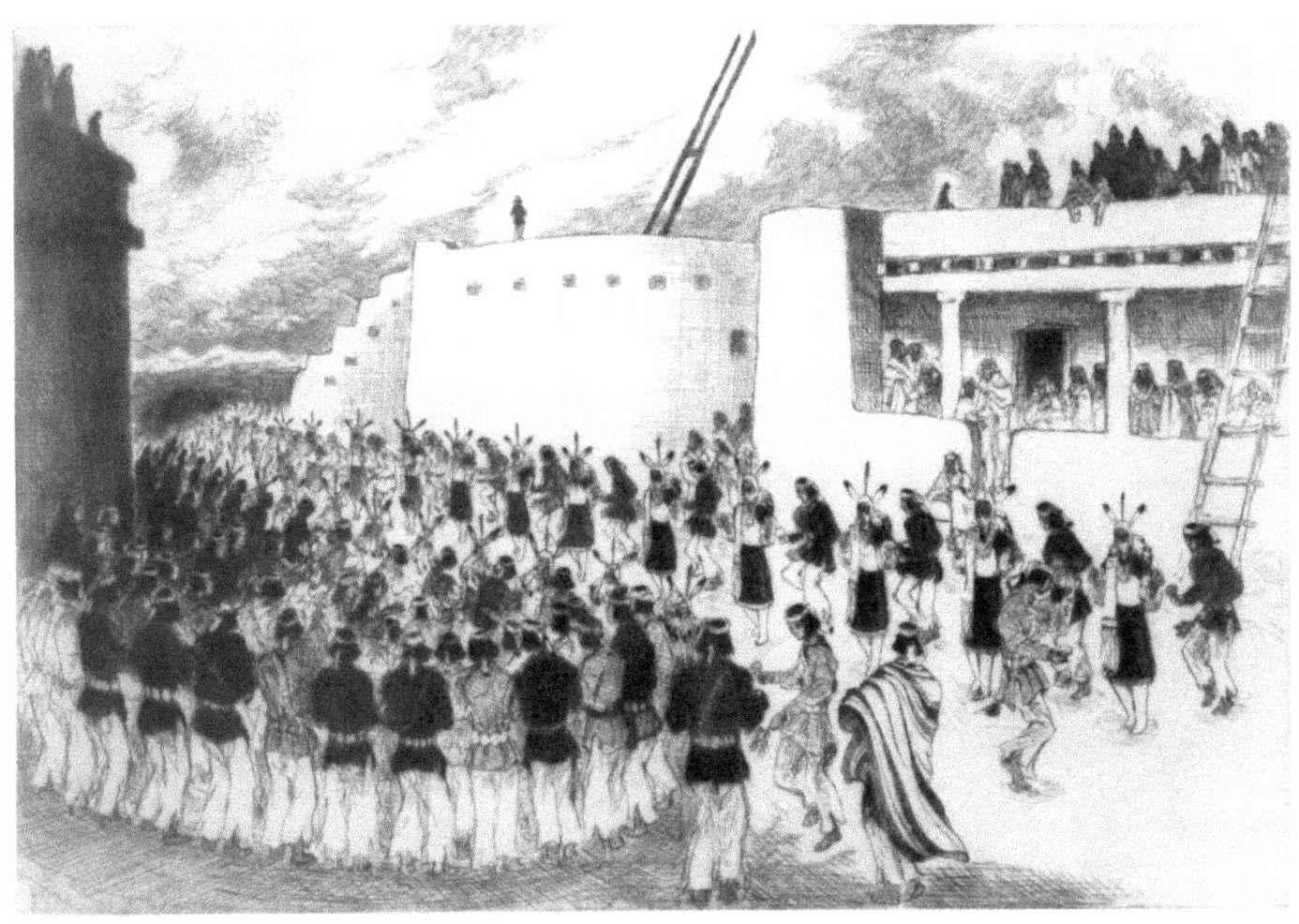
Winter Solstice Dance

PUEBLO FEATHER DANCE
543

Not a fanciful model, a transposed one, facial features often unrecallable in a memory sketch of a dance. These are typical Indian faces nonetheless. Intermixture with Spanish blood can bring out startling genetic results, but Indian traits persist. Demure downcast eyes can open wide and glitter like obsidian. The Feather Dance is a peace dance.

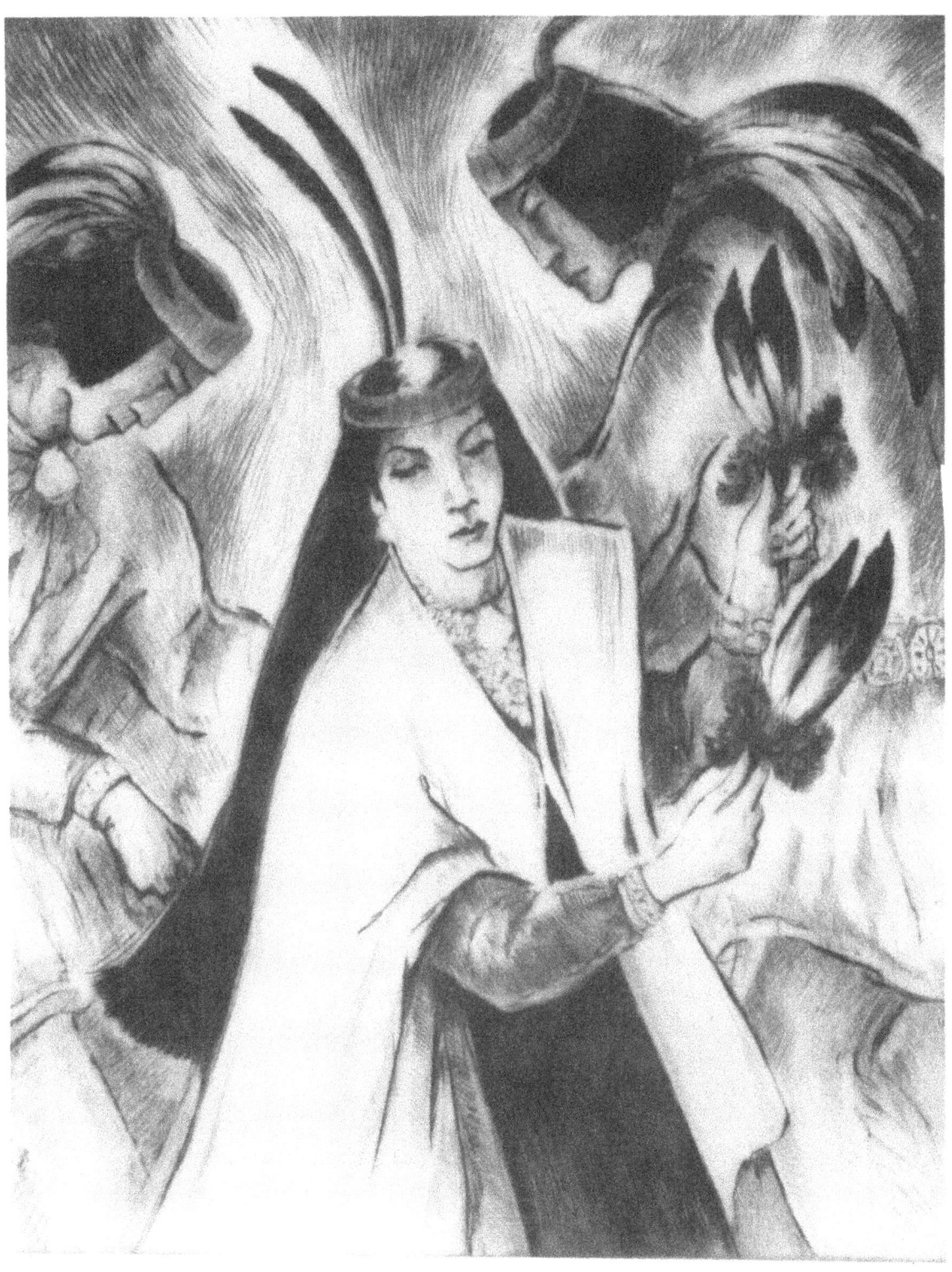

Pueblo Feather Dance

AGE-OLD RHYTHM
539

Full scope here, two long lines of dancers with Koshairi dancing between them like grey ghosts, supposedly invisible, exhaling and inhaling the Koshairi cry Ha-ah-ha, Ha-ah-ha, Ha-ah-ha! A loud continuous song from the huge male chorus interspersed with coyote yelps. Fast tempo to the dance, incessant drumbeat, pounding footsteps, wonderful shifts of pattern, diagonals, circles, single-file dual lines, opposing lines, energy taken from the earth given back to the earth.

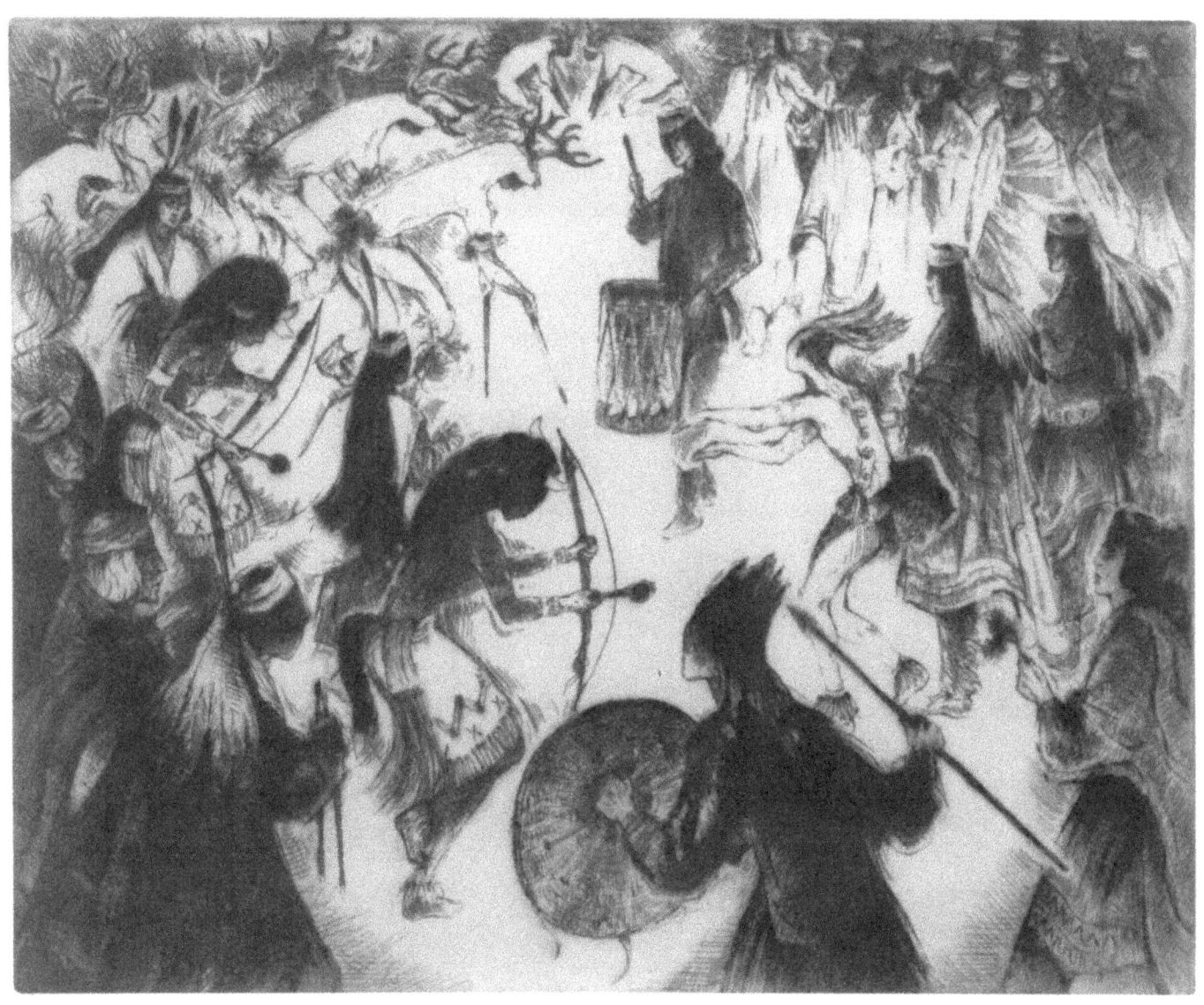

Age-Old Rhythm

SAN FELIPE BUFFALO DANCE
493

The animal dances at the different Keresan pueblos are all different. This one at San Felipe on their fiesta day February 2nd was an incisive dance, the faces were incisive, faces we had never seen before at any of the Keresan pueblos. A young Taos Indian friend of ours, a Gallup intertribal prizewinner himself, watched it profoundly impressed. He wondered why the Taos Indians couldn't put on a group dance as precise as it was. "I think we don't practice enough," he analyzed, and resolved to emulate. He organized a dance troupe of his own but had no influence whatsoever on the ceremonial dances at Taos. Their dances are scraggly and we like them scraggly. We like the differences at each pueblo, and this Buffalo Dance at San Felipe was very very different.

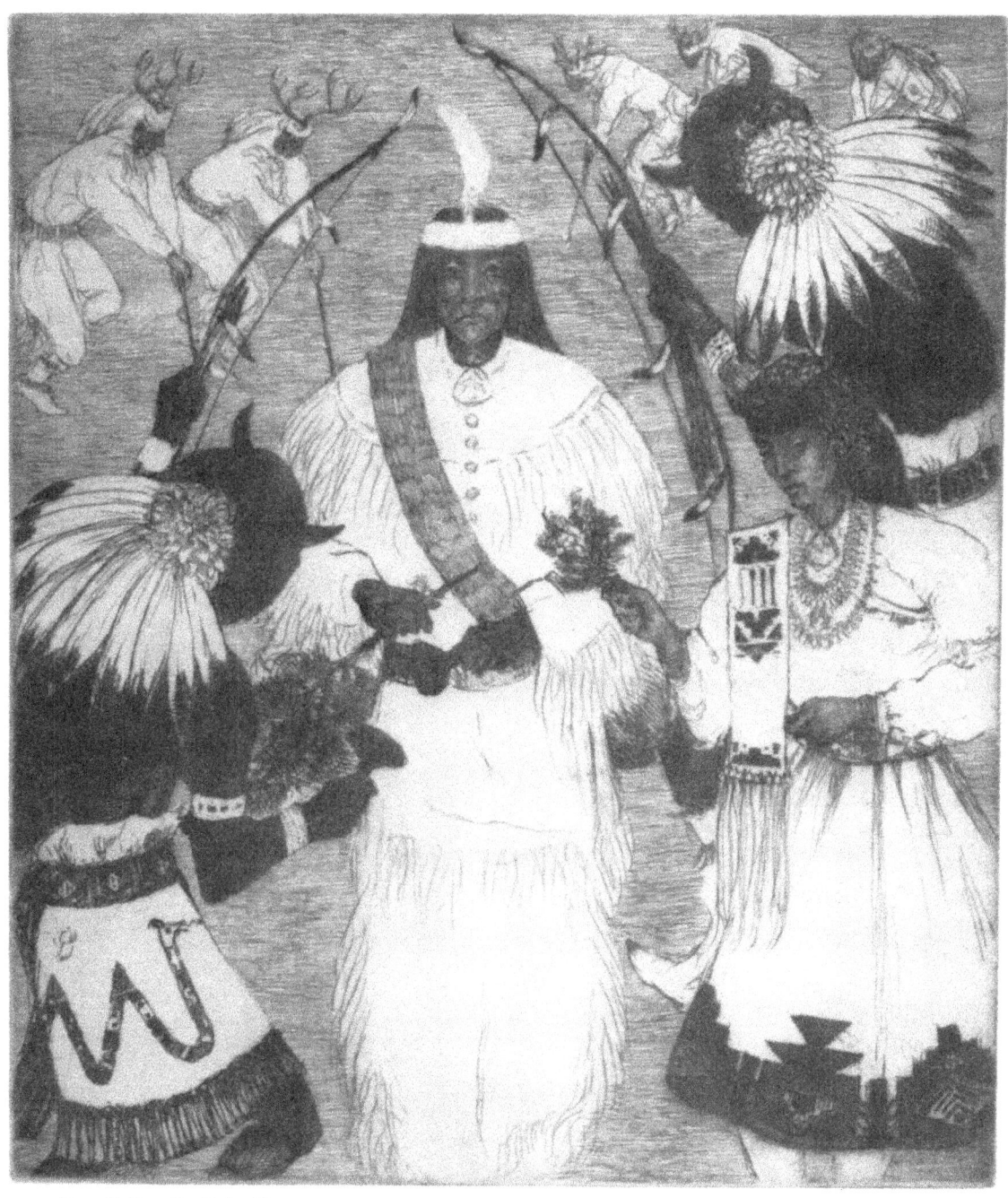

San Felipe Buffalo Dance

SONG OF THE BUFFALO HUNT
584

A small, pretty, but predatory woman from Zia was the star of this dance, a veritable cave woman, quick eager up-down steps dancing in one position between two Buffalo Hunter-Dancers as they framed their bows over her head, a long crouching stride when they drew apart and she danced from one to the other. Get meat. Men dressed in buckskin formed a short line in perfect juxtaposition to the dancers and chanted the hunting song.

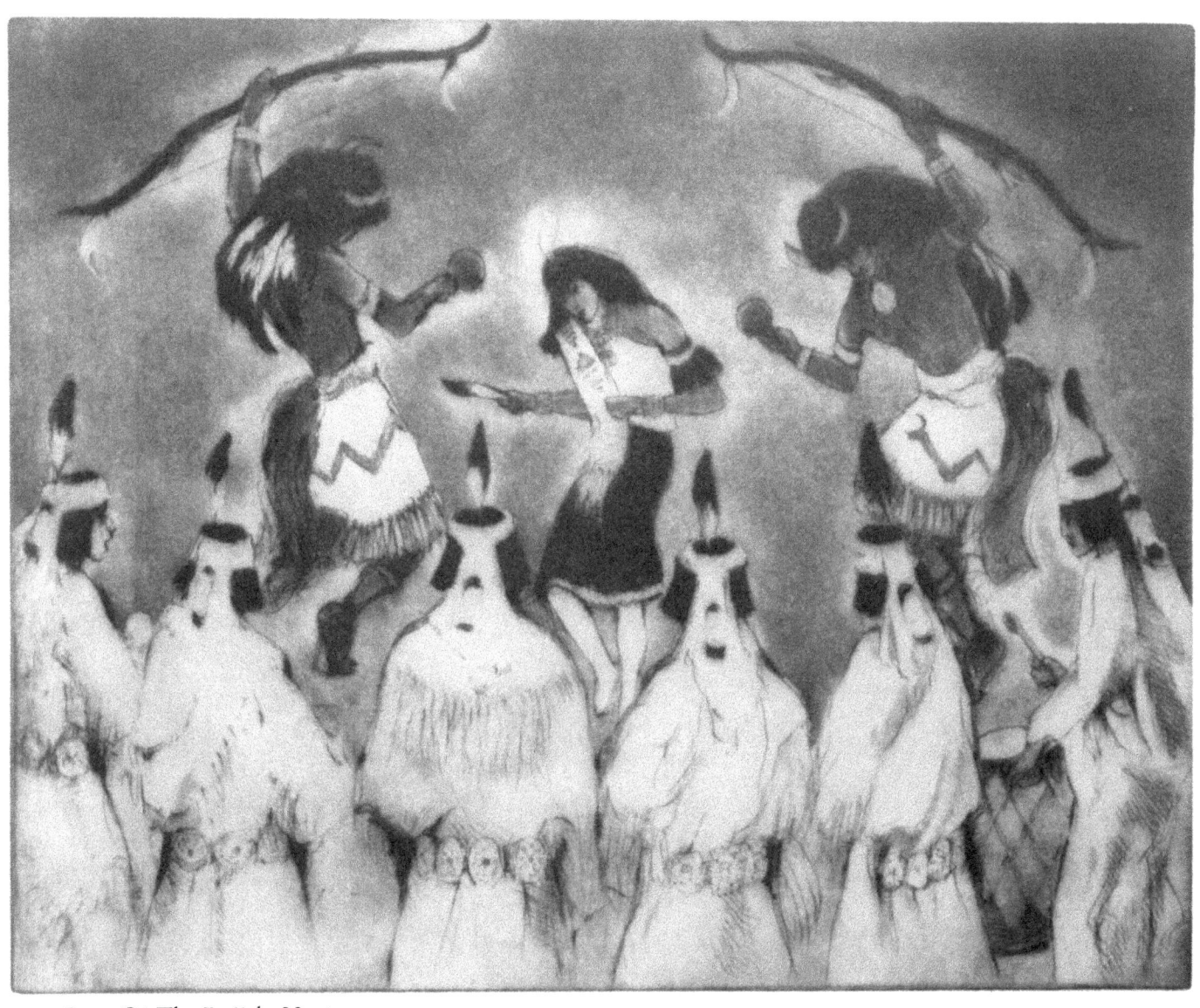
Song Of The Buffalo Hunt

YOUNG APACHE WIFE
457

Indian men usually precede their wives afoot, ready for combat of any kind, a snake, a bear, an ambush foe. There were several Apache families at Santa Ana that day. The wife looked back at Gene as she passed and Gene registered the flowing grace of her fringed shawl and long skirt, the Apacheness of her face.

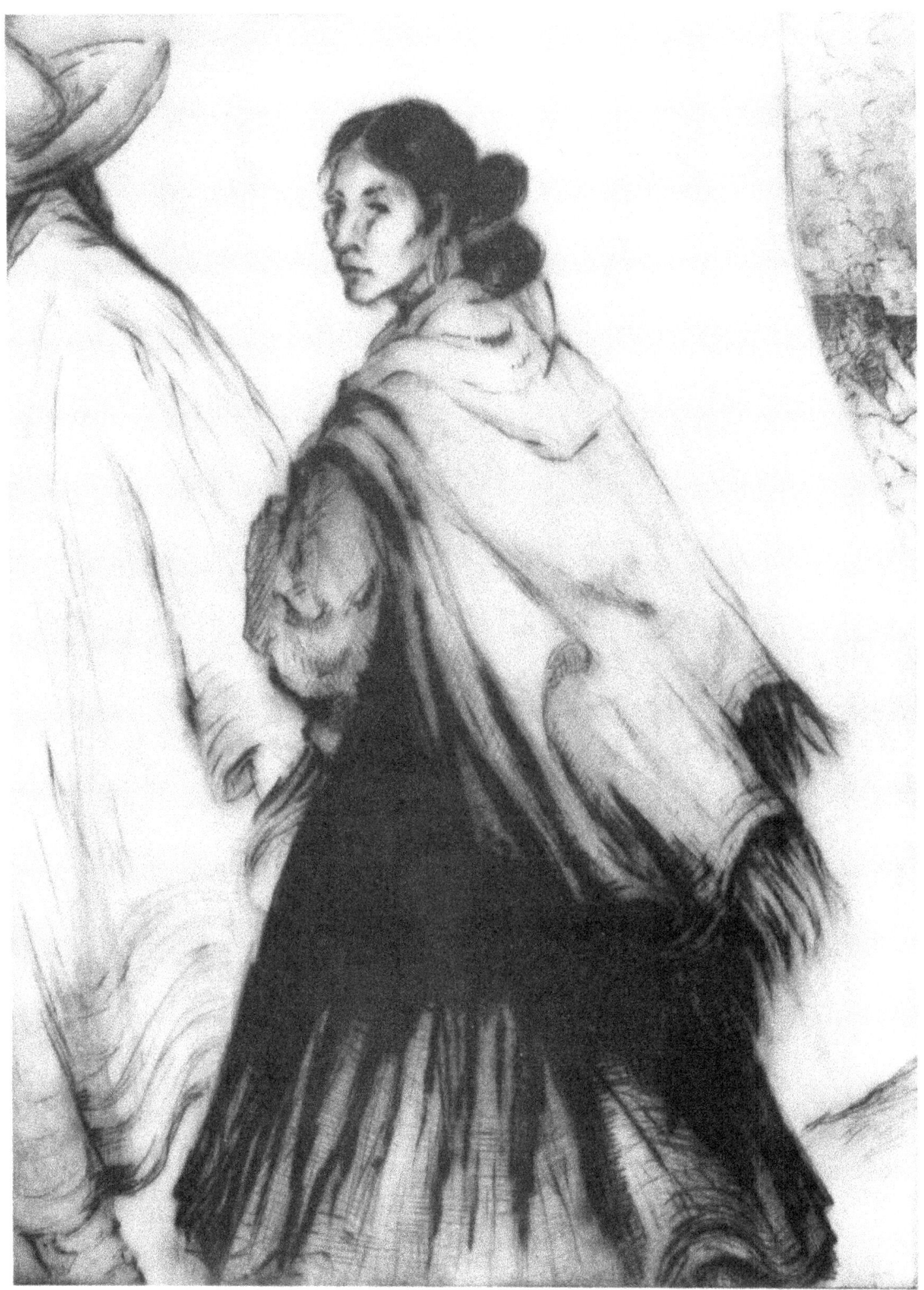

Young Apache Wife

WINTERTIME DANCE–COCHITÍ
579

Antelope Dancers bent forward using short sticks for forelegs taking tableau positions kicking their hind feet up and down to the beat of the drum, antlered Deer Dancers, two Buffalo Dancers wearing hollowed buffalo head hides with horns, their naked torsos painted red-brown, plumed serpent kilts, and between them a beautiful young Buffalo Maiden. She wore a slim white ceremonial robe embroidered at the hem, dark hair hanging down her back, a narrow red headband with three eagle feathers and two macaw feathers fastened rear, white deerskin moccasin boots, exquisite grace in every movement she made. She focused the dance around her, a subtle syncopated foot rhythm at times, one foot suspended gliding slowly back and forth, the other pulsing up and down to the drumbeat. And repeated in the dance a superb symbolic arm gesture, right hand upraised invoking the sky, swooping down like a rush of rain, pulling up the growth from the earth to the ear of blue corn held in her left hand at her waist, the fertility of life. For fifty years had we seen the various animal dances at the various pueblos, Santa Clara, San Ildefonso, Santo Domingo, San Felipe, Santa Ana, Jemez, Taos, Tortugas, none comparable to this at Cochití that clear warm Christmas Day. The chorus was poor, the song muffed, and the drummer missed a beat now and then. Not the Buffalo Maiden! She gave verve to the other dancers, her young loveliness infusing them with the spirit of their ancient heritage.

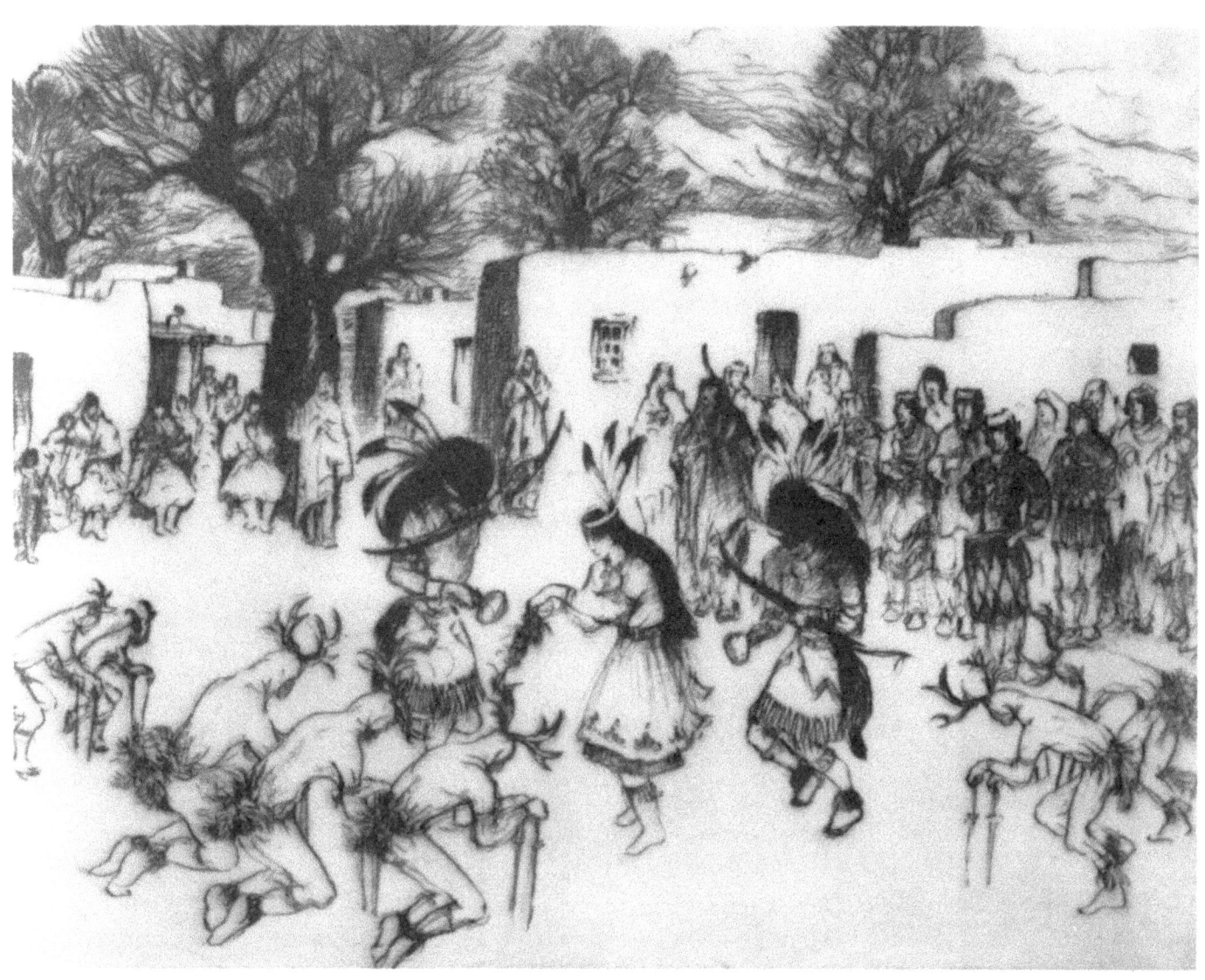

Wintertime Dance – Cochiti

END OF THE DANCE–COCHITÍ
578

But a gigantic dirt dam had just been completed at Cochití impounding the waters of the Rio Grande for a recreation lake, fishing, boating, swimming. A housing project on the west side of the lake, the land on long-term lease from the Indians, smears the background of the Jemez Mountains and cliffcave canyons. On the east side, northeast, a horserace track called The Santa Fe Downs has proved a fiasco. As an irrigation project the dam is a fiasco. Water seeps under it up into the Indian fields with capillary surfacing of alkali. The dam spells doom for oldtime Cochití. The second group of dancers and singers that same Christmas Day seemed to sense it. The chorus sang a sad little song as they filed off the old old plaza danceground back to the kiva house. The end of the dance, end of Cochití.
Gene took mental notes for a memory sketch, hoping for a possible revival there.

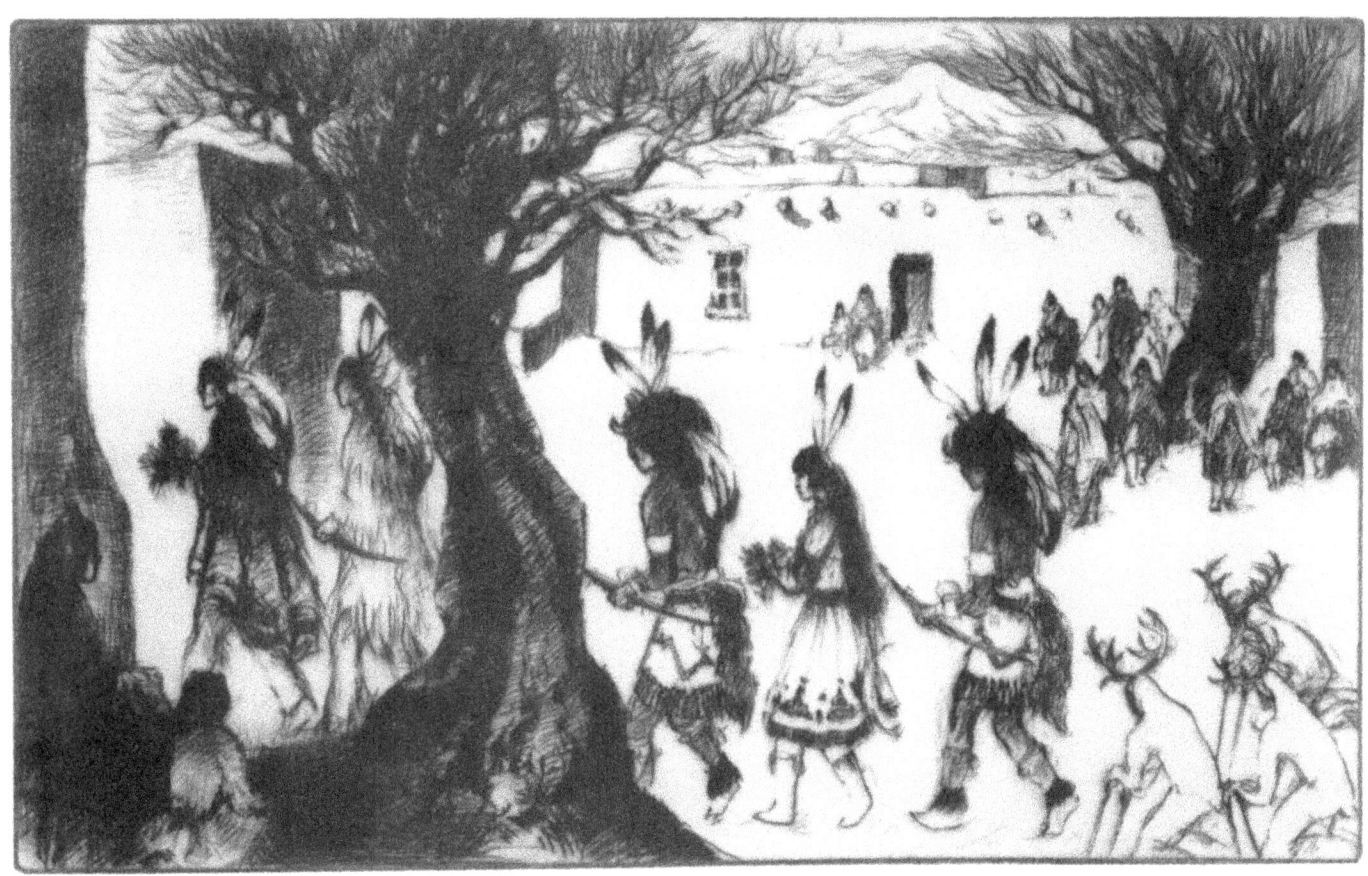

End Of Dance – Cochiti

BLESSINGS ON SAN FELIPE DAY
570

The cacique is a Catholic officer at all pueblos. He is sometimes the same man as the Indian Head Man, apparently always so at Santo Domingo and San Felipe. At Taos the Indian Head Man is distinct. He can also be a cacique as a condescension or a camouflage. Decoy words and decoy offices conceal the real Indian religion. At San Felipe the cacique represents both religions and gives blessings the day of the patron saint. Merged with the Indian surroundings, the Indian atmosphere. Merged with the Great Rock guarding the Pueblo century after century long before the Christians came.

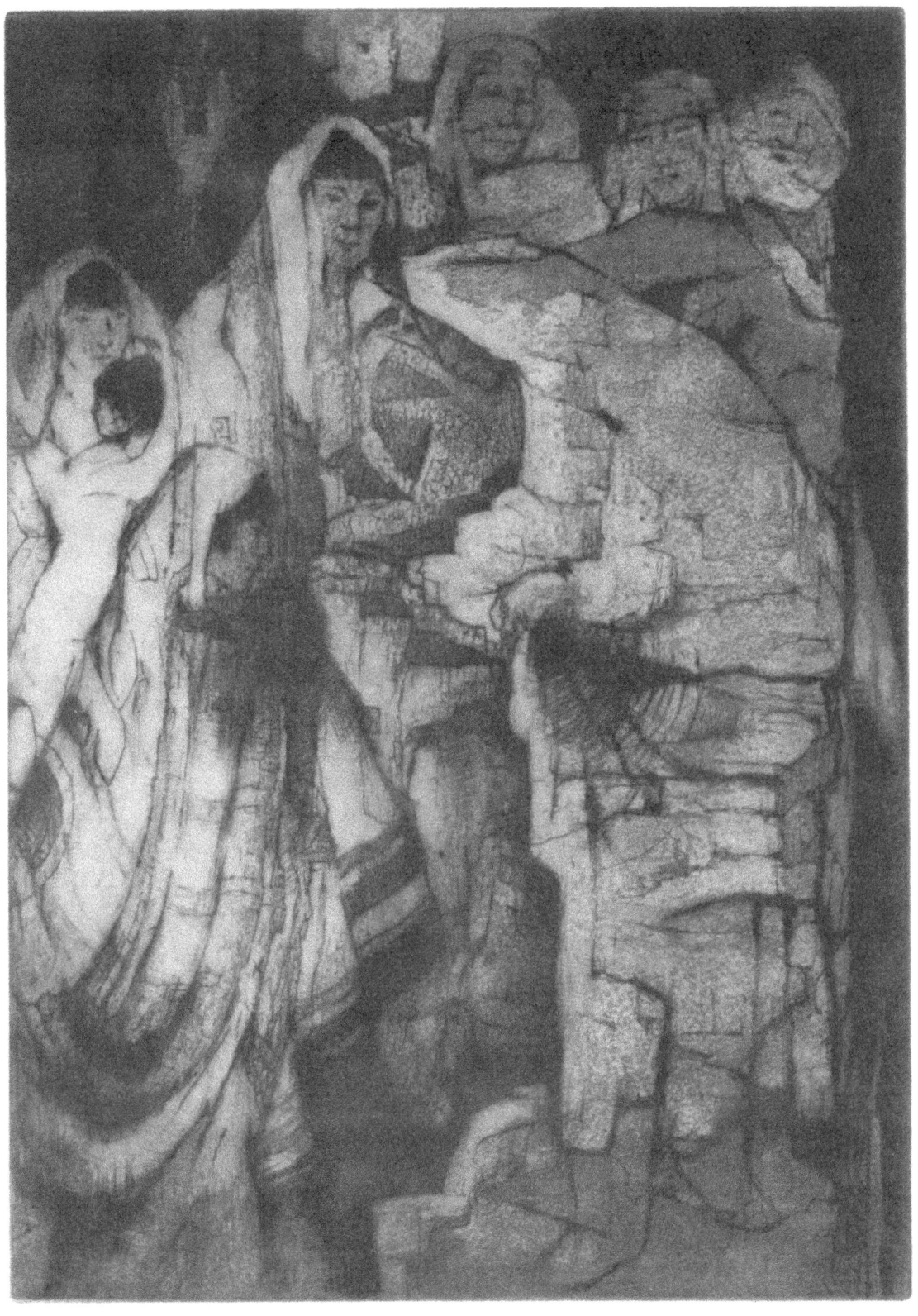

Blessings On San Felipe Day

SHADOWED BUTTES
595

Monument Valley does not belong to the land-grabbing Navajos or indigenous Utes, not to the Mormon settlers of Utah, not to artists, poets, exploiters, promoters. It belongs to itself. Absorb its sublimity at dawn, at dusk, in storm or sunlight, and pass on.

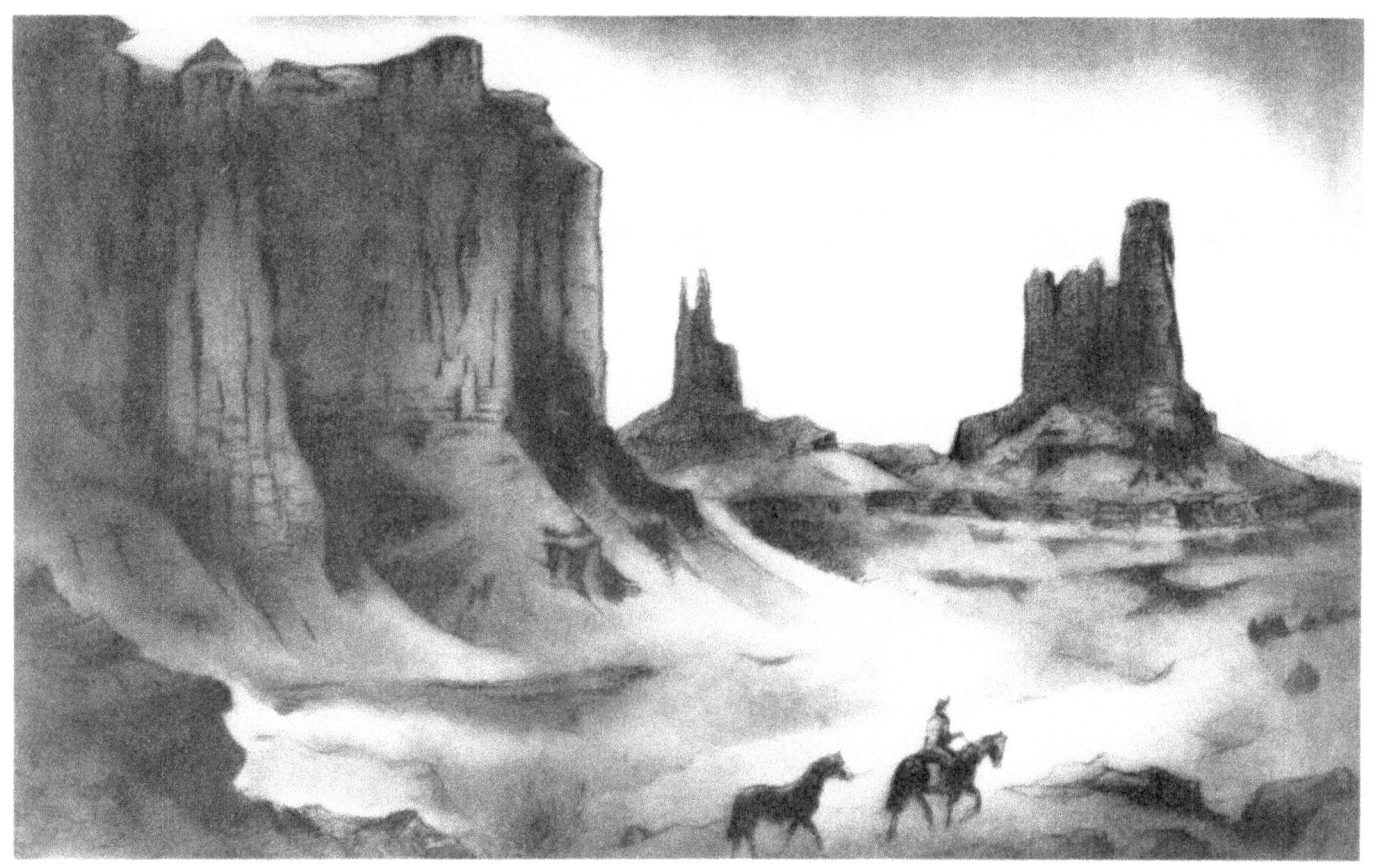

Shadowed Buttes

ROADSIDE POTTERY VENDORS
591

The highway from Albuquerque to Santa Fe was gravel, the speed limit reduced according to circumstances, and you stopped at Indian brush shelters along the way and bought pottery. This etching recaptures, for me at least, the bygone charm.

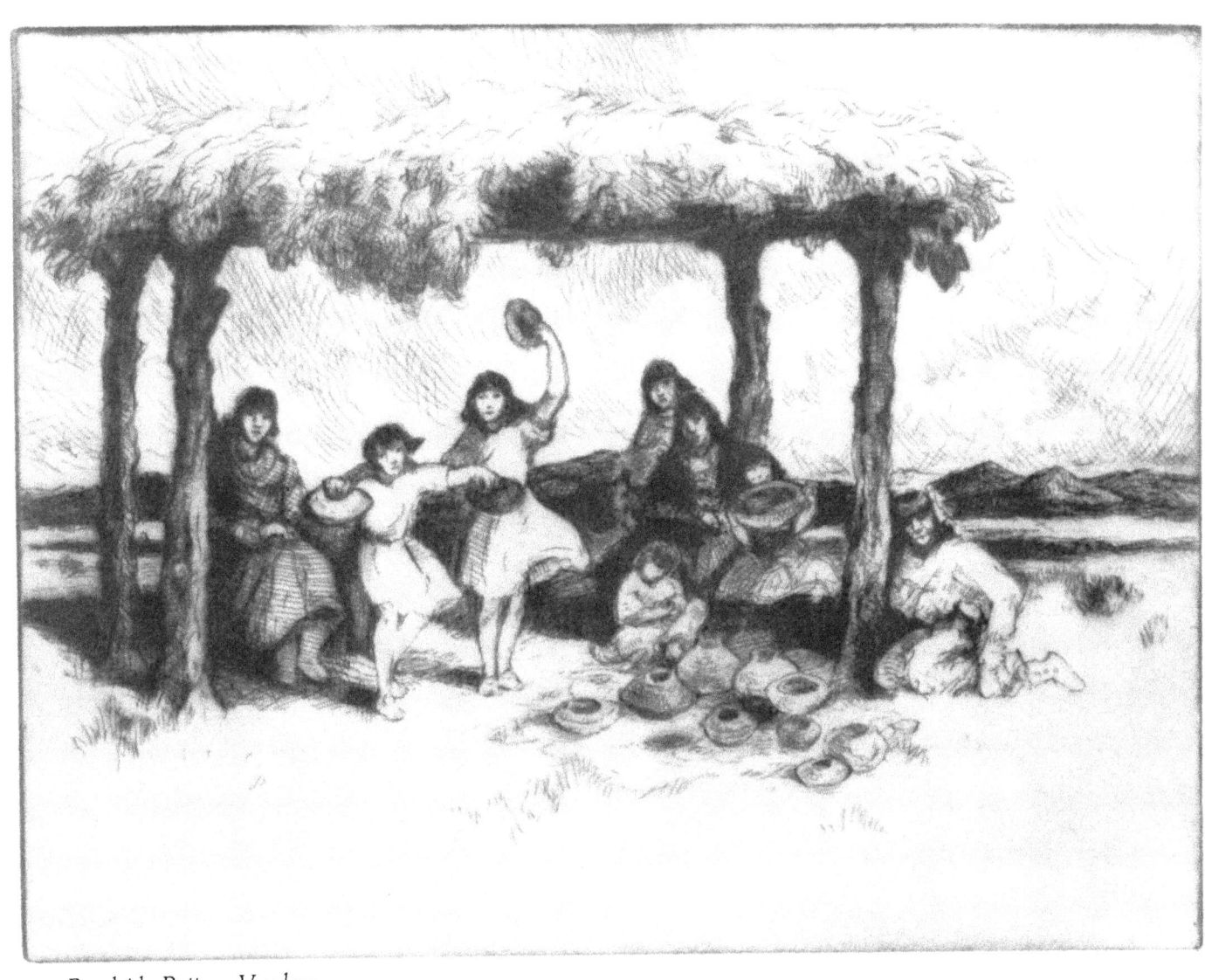

Roadside Pottery Vendors

OLD PUEBLO ROAD
566

The overarching branches of great cottonwood trees framed the perspective on Taos Mountain, heightened the contour, deepened the color. Irrigation ditches on both sides of the road kept the roots well watered. Strangely enough, the trees were planted by an Englishman, Arthur Manby, a dendrologist rumored of having royal Warwick connections. He trained his Indian helpers to select for transplanting only saplings with male catkins, which produce no bothersome allergenic "cotton." The Indians who worked with him liked him, his Spanish and Anglo associates mistrusted him. He mysteriously disappeared from Taos after nefariously winning title to the Martinez Grant which practically embraced the whole valley. Whatever his sins the great trees were his legacy to Taos. Alas no longer! Stores, art galleries, motels, condominiums, churches, gas stations render the street a suburb of Los Angeles.

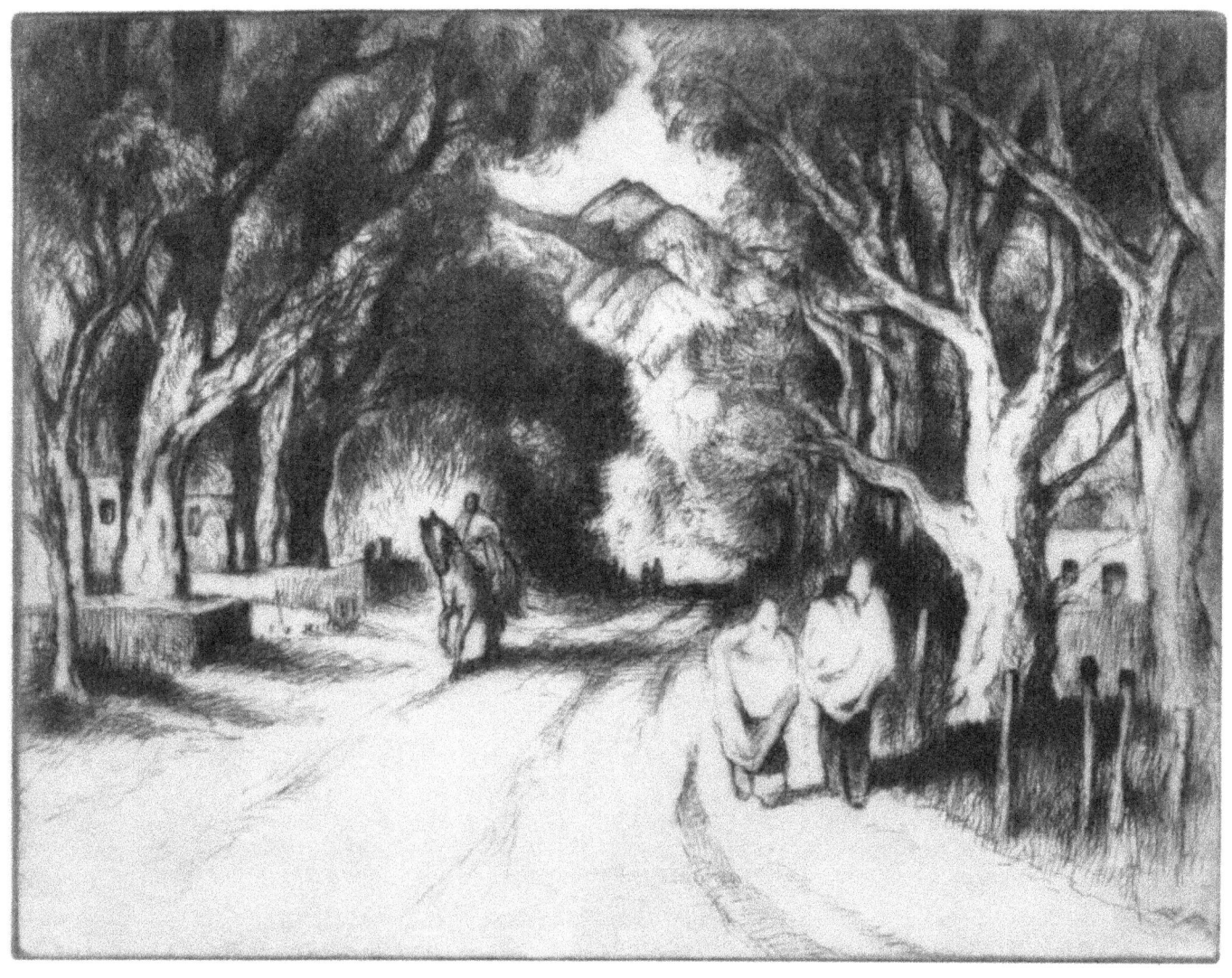

Old Pueblo Road

TRIP TO TOWN
592

In the 1920s the Taos Indians lived chiefly by raising their own wheat and corn, shooting wild game for meat. Deer, elk, antelope, bear, turkeys, rabbits. Some raised a few head of cattle. Most of them owned a team of horses for ploughing and a wagon for trips to town. They made their own moccasins but bought clothing from the general merchandise stores, the white sheets and colored blankets with which the men draped themselves sheik-like from the J.C. Penney Company. Formerly they wove their own blankets. I found fragments with rare designs similar to Peruvian textiles in a blowhole years ago and tried to scoop them up. They disintegrated in my hands. I should have sprayed them with a fixative first. The 1920 Indians took jobs in town for pin money, posed for artists, sold drums, flutes, moccasins, bread, strings of Indian corn. They had their wheat ground at the steam-powered grist mill in Taos, a one-cylinder behemoth with an enormous flywheel that reverberated thunderously when in action. At its demise the Indians took their wheat sixty miles to the grist mill at San Luis, Colorado, or fifty miles over the hills to the waterwheel mill at Mora. They got lush sacks of flour in exchange for the bran the miller kept as payment. It was a tough life but they all seemed contented. You often heard them singing on their treks.

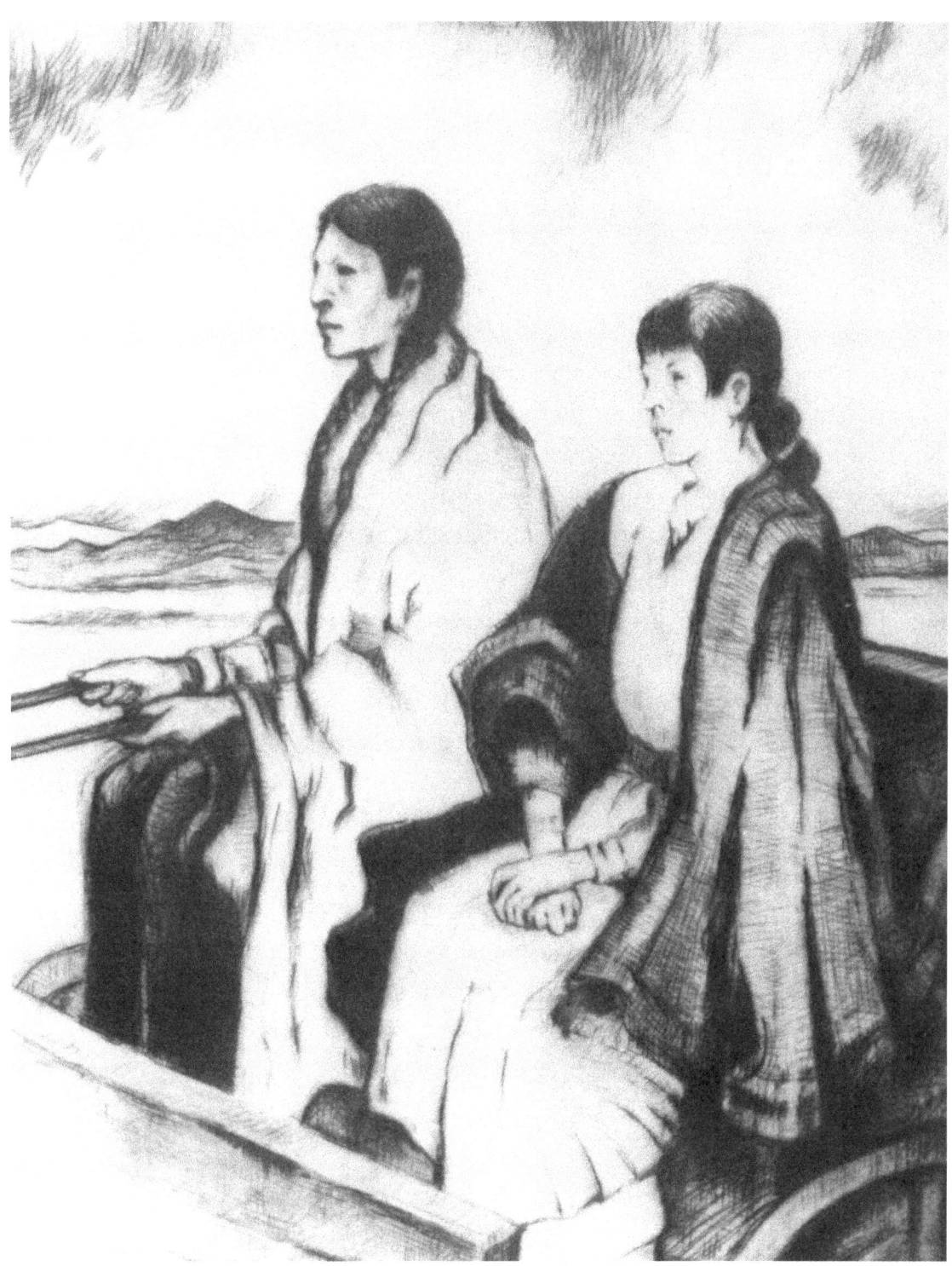

Trip To Town

CENTURIES OLD
583

The Ranchos Church is a shrine for Catholics and Protestants alike. It has stood for two centuries and will stand for two centuries more, unless an atomic war destroys contemporary civilization and a new-world religion is formulated. It is a beautiful church. There were architects among the early Fathers. The slabstone church at the Quarai ruins, a pueblo settled by dissidents from Taos and Picurís in the domain of their Piro cousins, was a majestic cathedral built by a genius. The church at Jemez Springs likewise.

Is religion a detriment or asset to the welfare of humanity? Certainly the ancient Greek religion was a detriment and should be expunged from literary reference as has the Mother Goose nonsense. The Inca, Maya and Aztec religions were bloodthirsty and hideous, regardless of their stupendous architecture. Fray Diego de Landa was justified in destroying Maya records and practices. Hernando Cortez was justified in destroying the Aztec empire and putting a stop to the heart-ripping human sacrifices to the silly sungod Huitzilopochtli. Pizarro was justified in destroying the Inca and his syphilitic harem of sun-maidens. The Pueblo Indian religions are egalitarian and relatively humane but lack the broad compassion which is the essence of Christianity. The Indians had and have a torture-trait in them, the Church has had its Torquemadas and cruel compulsions, but it still stands as a refuge and consolation for the suffering soul.

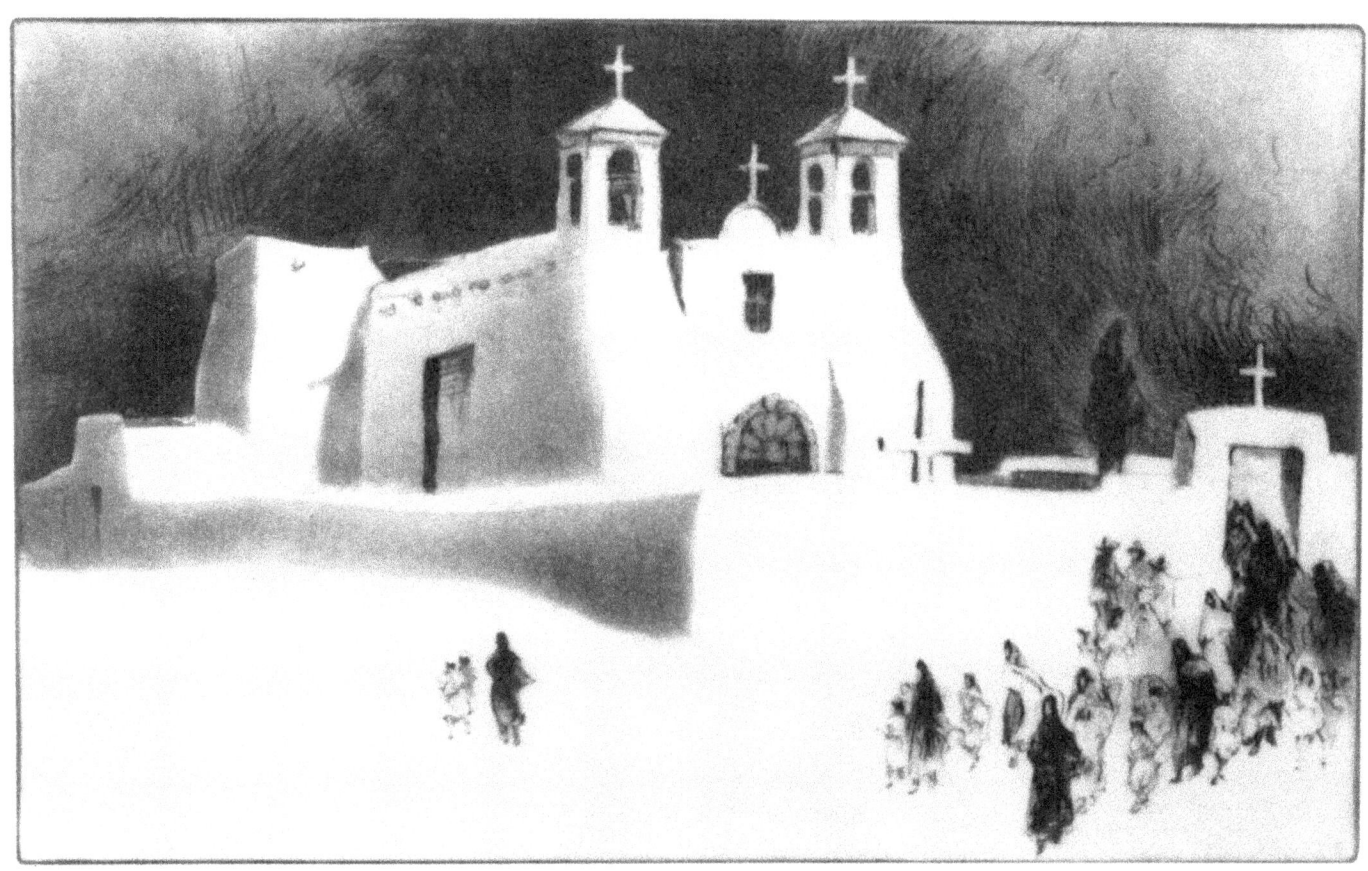

Centuries Old

FORSAKEN CHURCH AT THE EDGE OF THE GREAT PLAINS
590

Of late date, a Muscovite bell tower, stalwart forsaken against a haunting background, untouched by vandals, it simply had to be sketched. We didn't inquire its history. It is a sermon to space.

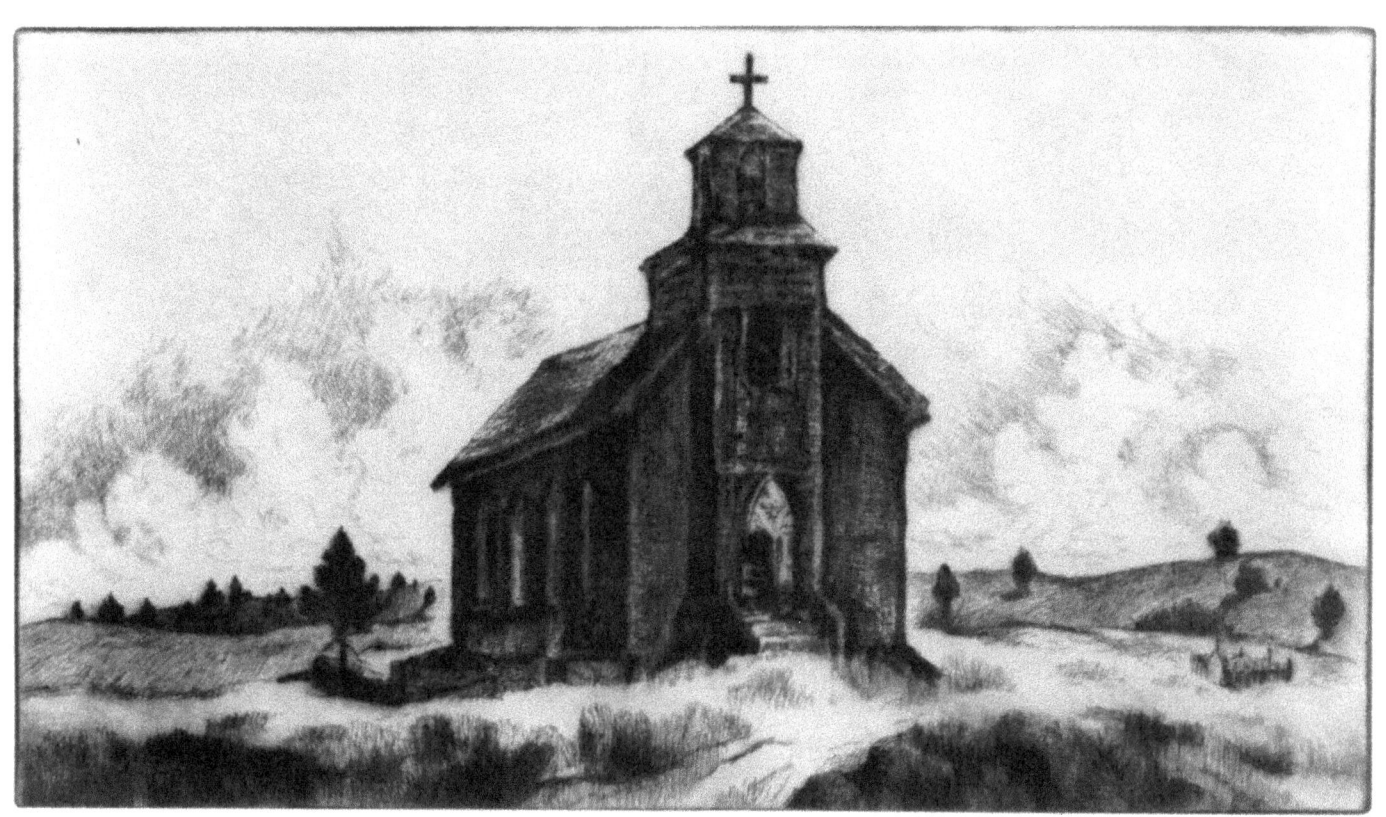

Forsaken Church At The Edge Of The Great Plains

TIMSY SLEEPING
407

Timsy was a little mongrel shepherd dog who adopted us in Taos in 1934, climbed the mountains with us, went with us to California and back every year, died in 1948, and is buried under a eucalyptus tree on a hillside in Berkeley. We called her Timsy because her tail looked like a plume of timothy grass when she was a tiny pup. She had no pedigree, but when Gene won both first and second prizes for her work at the State Fair in Albuquerque, we filled in her name and breed on the blank labels of the blue and red ribbons, attached them to her halter, and proclaimed her a Rocky Mountain Goatdog, first and second prize. She had many cute tricks of her own, one a game of creeping toward me foot by foot, head low and menacing as if ready to spring and bite, and I would go at her the same way, both of us leaping and romping as we met. She tried the trick on a great big dog down on the street. He watched her creeping toward him first with amazement, then with apprehension, then with panic, and he turned tail and ran.

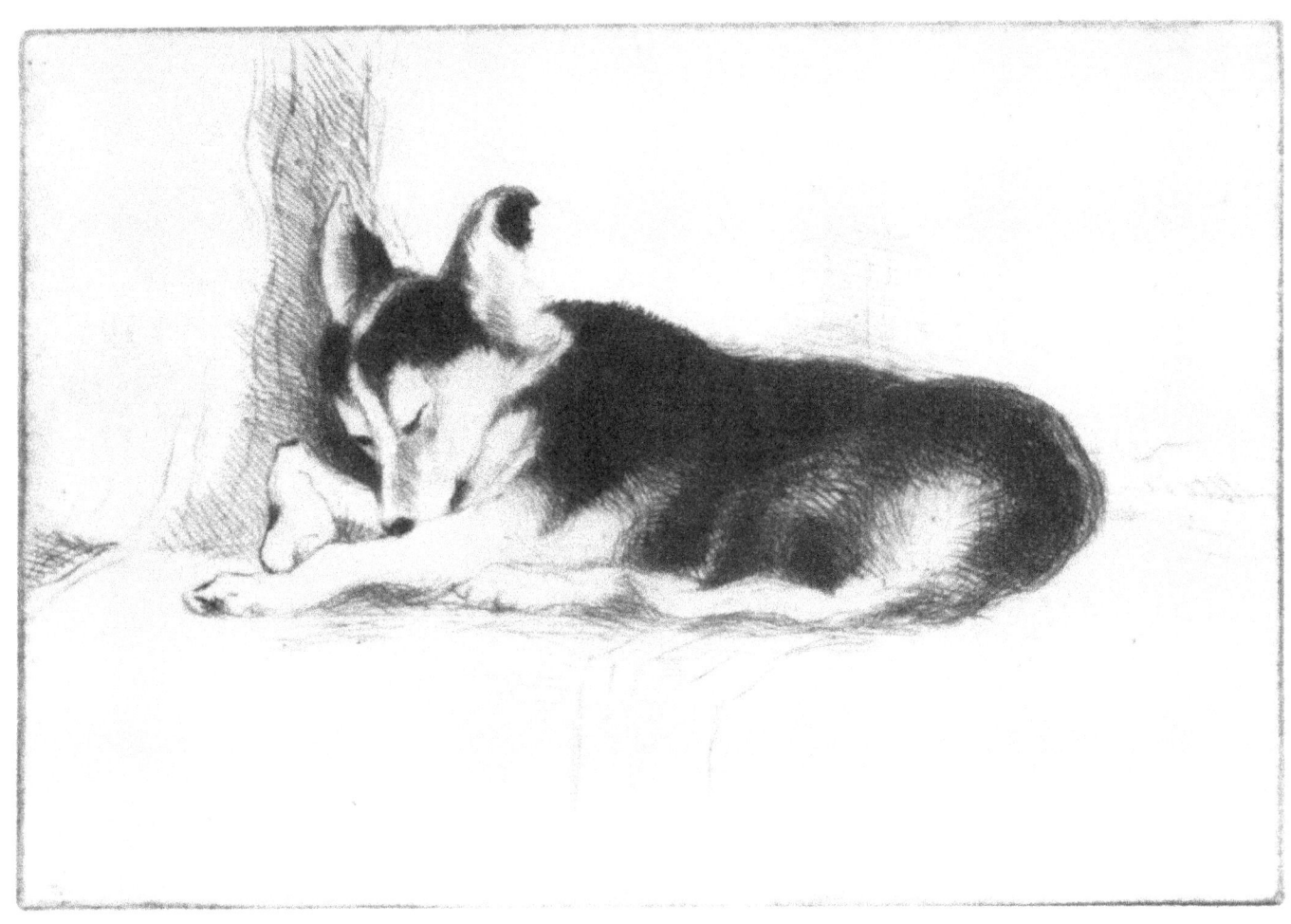

Timsy Sleeping

MAGPIES AND RED-TAILED HAWK
492

For some ornithological reason unbeknownst to us a flock of magpies resented a Red-tailed hawk perched in one of the season-bare cottonwood trees in the glade below our mesa. They ganged up on him, yak yak yacked at him for trespassing on their territory. He regarded them with imperturbable disdain. Handsome birds, black and white and iridescent green, they made lively patterns in the stark trees.

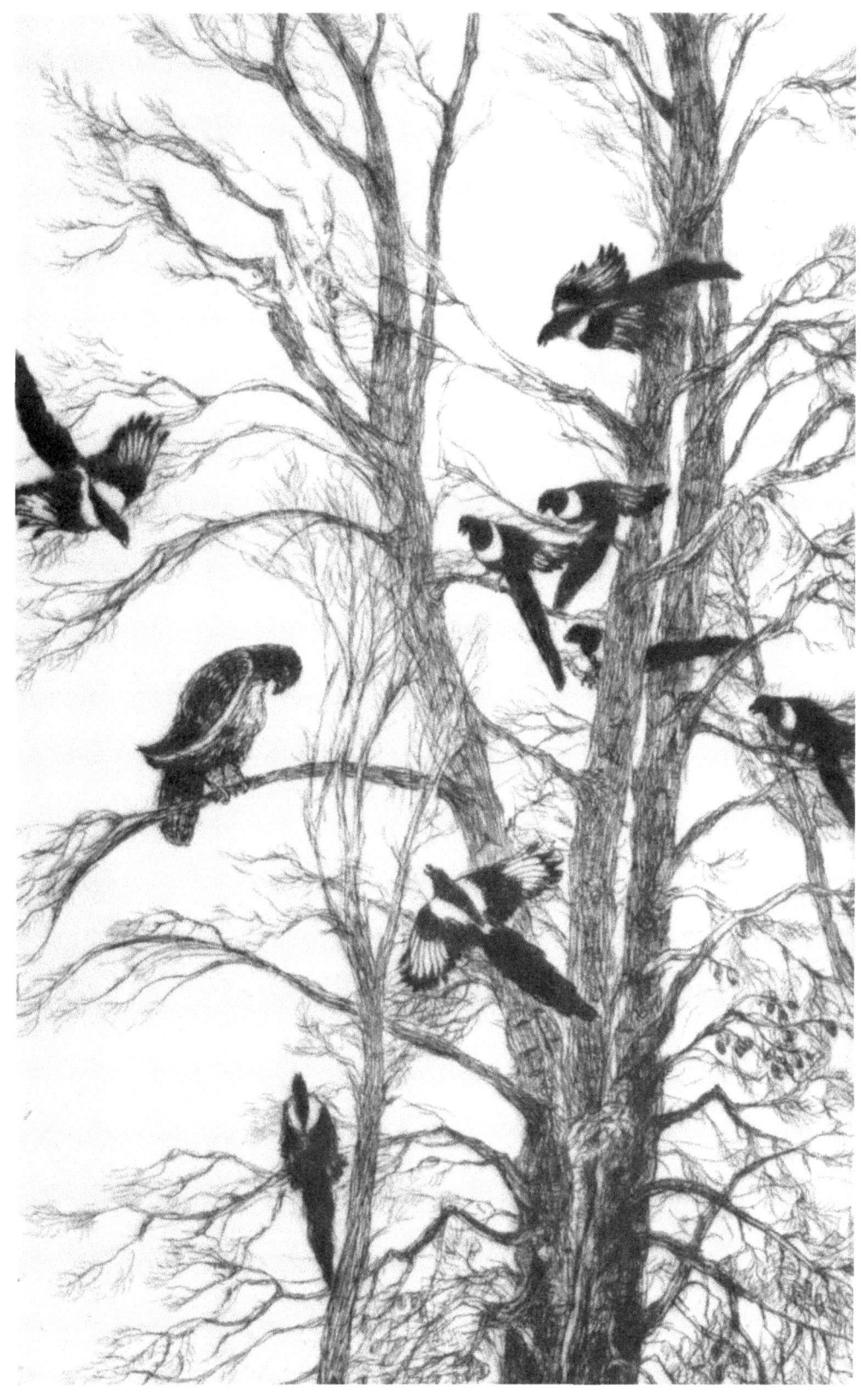

Magpies And Red-Tailed Hawk

FORCE AND FATE
501

Saffron sunsets blent with rose,
Music held while music flows,
The lilac lift of desert dawns,
The vast smooth rolling cabochons
Of emerald plains and emerald seas,
The majesty of redwood trees,
Winter nights with stars aglint
Like fires of faith, like flakes of flint—
Count your blessings free from fate,
The timeless treasures which elate.

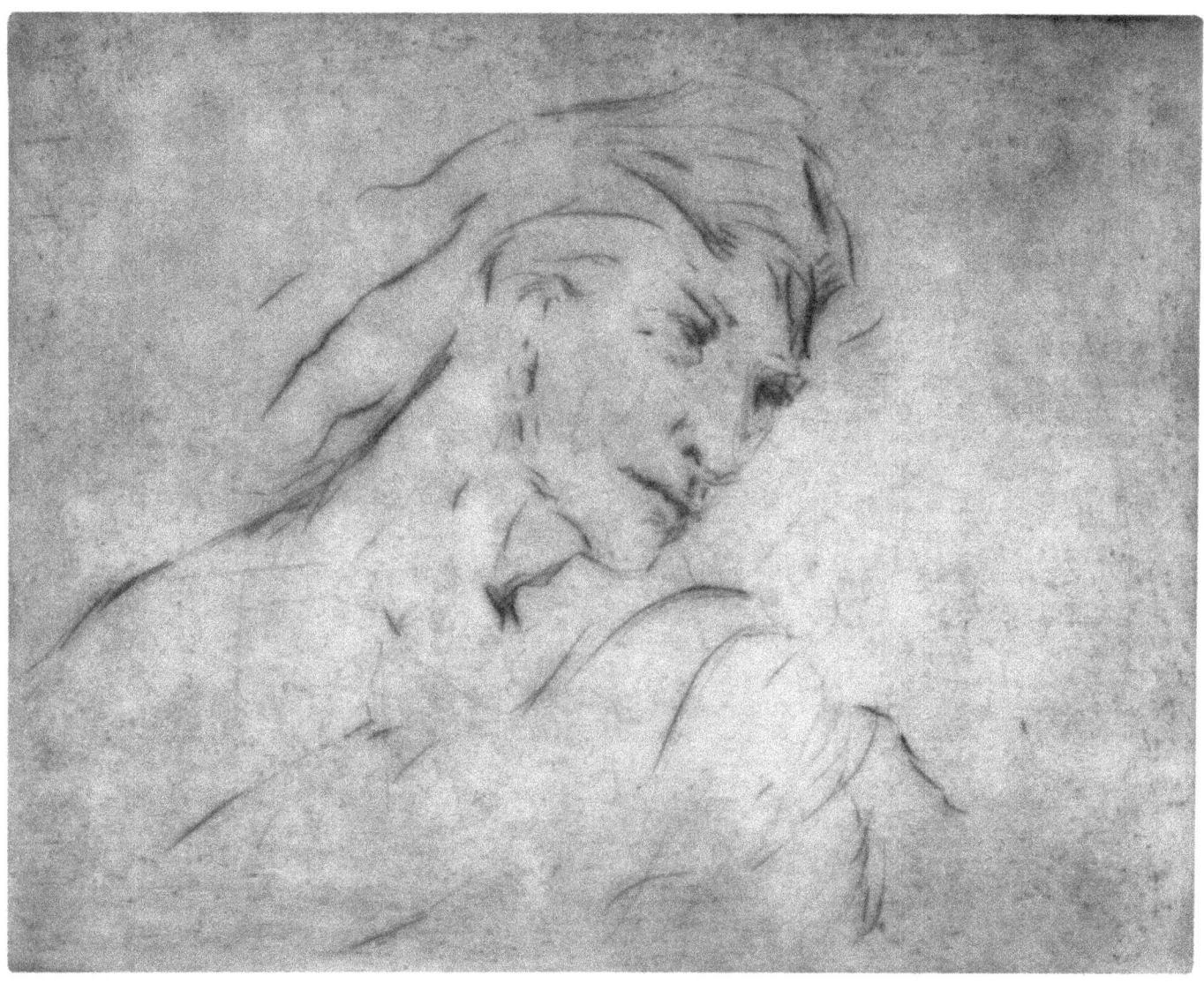

Force And Fate

INDIAN INFUSION
508

They have infused us with respect for nature, with their aesthetic spirit, with their religious sense of our relation with the sun and earth, making a god of neither. They taught us how to use indigenous foods, they gave us poetic place-names for our towns and localities, their music lilts in our blood more compatibly than jazz or Bach. What have we given them in return? Mechanical inventions mainly. Medical and surgical salvation. Peace instead of constant warfare with other Indian tribes. Then too we have given them the precedent for intellectual inquiry and for ideals of womanhood and manhood above mere physical functions.

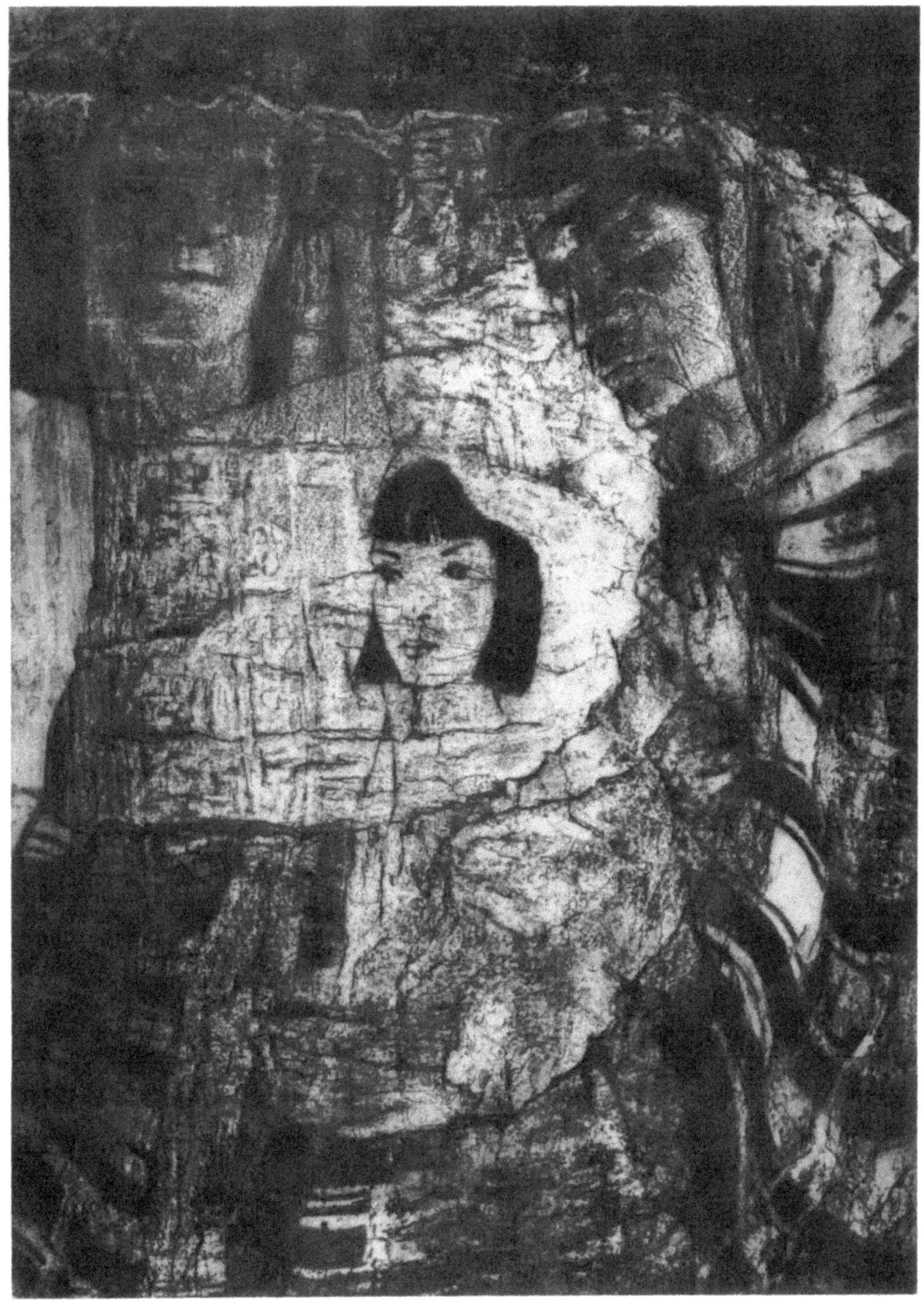

Indian Infusion

TURTLE DANCE–TAOS PUEBLO
348

A snowy New Year's Day, the Turtle Dance performed at sunrise no matter how cold, at first in front of the mission church, repeated on the danceground in front of the North House, repeated on the danceground east of the South House, and the rounds repeated later in the morning. It is the most meaningful of the Taos dances. We like the legendary feel of it and have shivered many a New Year's sunrise watching it. Our Indian friends criticize us when we don't appear. We sort of belong to it.

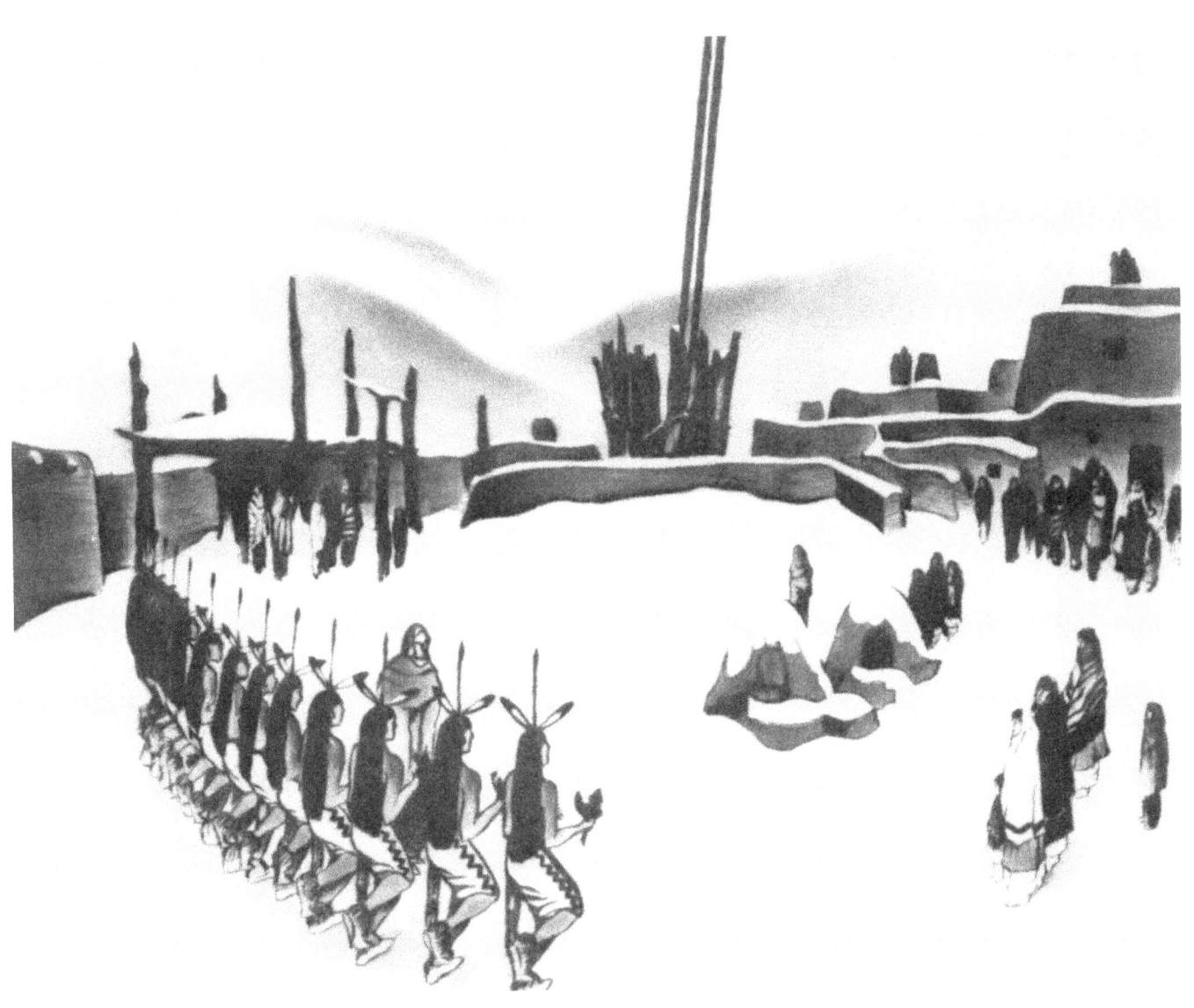

Turtle Dance – Taos Pueblo

TRIBUTE TO THE EARTH
542

Born of the earth, sustained by the earth, give back to the earth, sing, dance, pray for mutual well-being, man and woman interconnected with the creatures of the earth, with all living things, birds, flowers, trees, ants, deer, bear, buffalo, blades of growing corn. The earth is benign if treated benign, give tribute to the earth, the miracle of life is sufficient heaven.

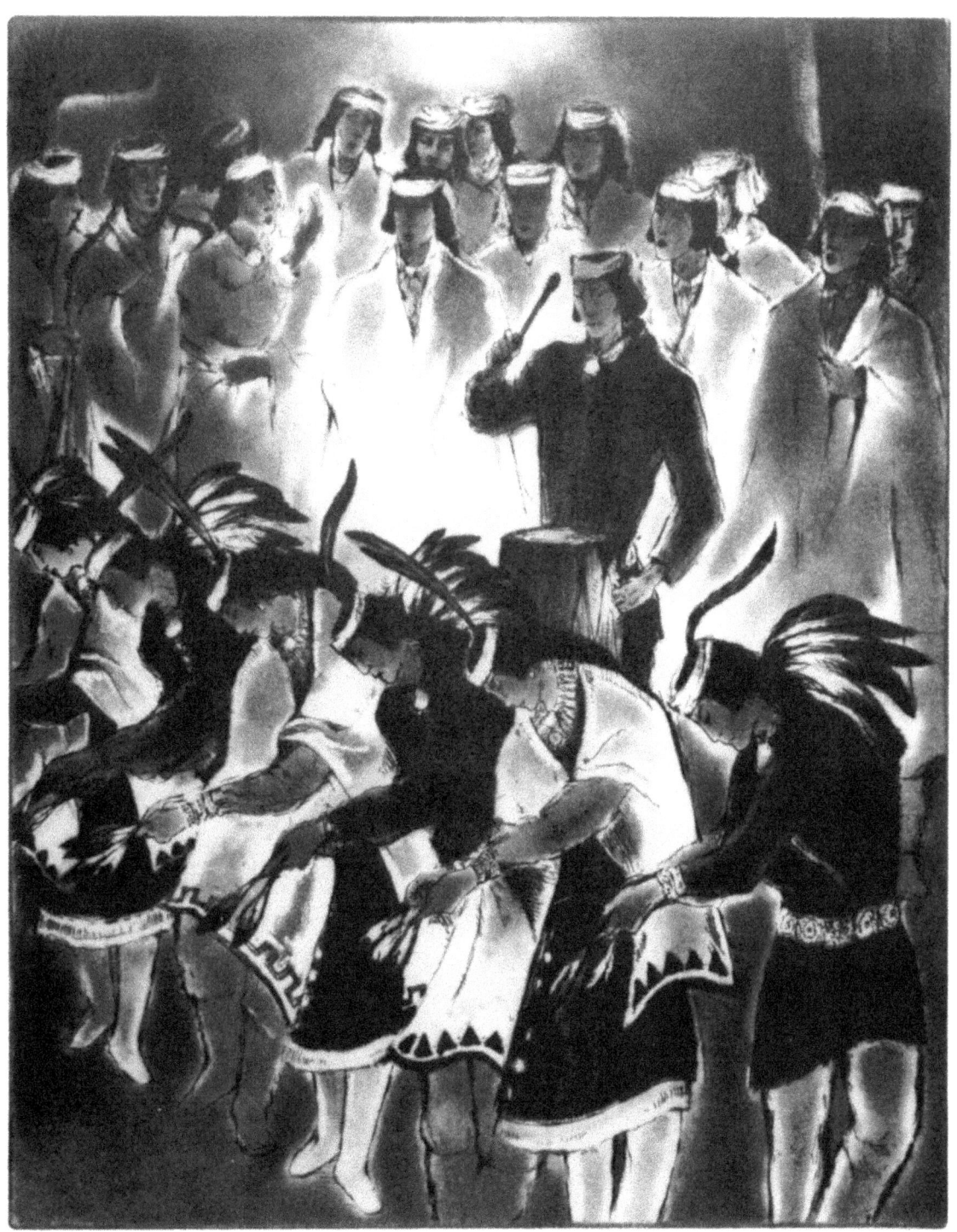

Tribute To The Earth

CATALOGUE RAISONNÉ

	TITLE	MEDIUM	SIZE	EDITION	DATE
1	THE OLD BRIDGE	E	3½ x 4½	—	1924
2	REFLECTIONS	E	3½ x 4½	—	1924
3	THE STEEL FACTORY	E	4 x 5	—	1924
4	TEA GARDEN GATE	E	3½ x 4½	—	1924
5	THE BLACK SCARF	E	4 x 5	—	1924
6	JAPANESE BRIDGE	E	4 x 5	—	1924
7	THE ALLEY	E	4 x 6	—	1924
8	THE SKY SWEEPER'S HOUSE	E	6 x 8	—	1924
9	THE DESERTED FARM	E	8 x 10	—	1924
10	MORGAN HILL ROAD	E	7 x 8	—	1924
11	MORAGA ROAD	E	9 x 12	—	1924
12	SUNDAY ON THE ESTUARY	E	9 x 12	—	1924
13	THE BAND CONCERT	E	9 x 12	—	1924
14	REDWOOD CABIN	E	4 x 6	—	1925
15	THE CAMPANILE	E	4 x 7	—	1925
16	INGLESIDE	D	4 x 5	—	1925
17	OFF CONTRA COSTA ROAD	E	5 x 6½	—	1925
18	CAMPUS CORNER	E	5 x 6½	—	1925
19	LAND'S END	E	5 x 6½	—	1925
20	CARMEL-BY-THE-SEA	E	5 x 6½	—	1925
21	HILLS OF CONTRA COSTA	E	4 x 5	—	1925
22	NEAR SAN MATEO	D	3½ x 4½	—	1925
23	INDIAN SUMMER	E	5 x 6	—	1925
24	SIMPLICITY	D	3 x 6½	—	1925
25	THE SHORE ROAD	D	4 x 5	—	1925
26	HILLSBOROUGH	E	5 x 6½	—	1925
27	ROCKY SHORE	D	4 x 5	—	1925
28	CANUTILLO	D	4 x 5	—	1925
29	ISLETA	E	3½ x 4½	—	1925
30	AN INDIAN PUEBLO	E	3½ x 4½	—	1925
31	THE CANYON	E	4 x 6	—	1925
32	ROAD TO TAOS	D	4 x 5	—	1925
33	LOS RANCHOS	D	4 x 5	—	1925
34	THE CALLERS	E	3½ x 4½	—	1925
35	IN ZUÑI LAND	E	5 x 6½	—	1925
36	LA HACIENDA	E	5 x 6½	—	1925
37	ON THE WAY TO SOLEDAD	E	4 x 7	—	1925
38	EVENING SONG OF THE ORGANS	E	4 x 7	—	1925
39	ORGAN MOUNTAIN HOUSE	E	4 x 7	—	1925
40	LA RESOLANA	E	5 x 6½	—	1925
41	IN MESILLA VALLEY	E	5 x 6½	—	1925
42	THE PLAZA AT SOCORRO	D	5 x 6½	—	1925

	TITLE	MEDIUM	SIZE	EDITION	DATE
43	DRIPPING SPRINGS	D	5 x 6½	—	1925
44	CHURCH AT ISLETA	E	4 x 7	—	1925
45	TAOS PUEBLO	D	5 x 6½	—	1925
46	NOON SHADOWS	E	5 x 6	—	1925
47	ADOBE WALLS	E	6 x 8	—	1925
48	COTTONWOODS	E	7 x 8	—	1925
49	RIO GRANDE MEADOW	E	7 x 8	—	1925
50	MORNING LIGHT	E	7 x 9	—	1925
51	AN ADOBE SHACK	E	7 x 9	—	1925
52	OLD MESILLA	E	7 x 9	—	1925
53	HILLSIDE IN TAOS	D	7 x 9	—	1925
54	THE SHELTER	E	3½ x 4½	—	1925
55	ADOBE DUSK	E&SG	3½ x 4½	—	1925
56	JANUARY SHADOWS	E	7 x 9	—	1925
57	DESERT RHYTHM	D	5 x 10	—	1925
58	WIND CLOUDS	D	5 x 10	—	1925
59	IN DOÑA ANA	E	4 x 5	—	1925
60	NEW MEXICO MORNING	E	3½ x 4½	—	1925
61	ALONG THE CANAL	E	7 x 9	—	1925
62	MESA HOUSES	E	7 x 9	—	1925
63	WHITE PLASTER	E	5 x 6	—	1925
64	COTTONWOOD SHADOWS	E	7 x 8	—	1925
65	STRAW ROOFS	E	5 x 6	—	1925
66	ARCHED DOORWAYS	E&SG	5 x 6½	—	1925
67	BISBEE, ARIZONA	E	7 x 9	—	1925
68	CATALINA MOUNTAINS, TUCSON	D	5 x 10	—	1926
69	SAN MATEO HILLS	D	5 x 6½	—	1926
70	CALIFORNIA AUTUMN	D	7 x 9	—	1926
71	CYPRESS TREES	D	7 x 8	—	1926
72	CARMEL CASTLE	D	7x9	—	1926
73	MONTEREY CYPRESS	E	8 x 10	—	1926
74	EUCALYPTUS AT SAN CARLOS	E	7 x 9	—	1926
75	LARGO	D	5 x 11	—	1926
76	WINTER HARBOR	E	7 x 9	—	1926
77	THE STADIUM ENTRANCE	E	6 x 8	—	1926
78	GARDEN GATES	E	5 x 6	—	1926
79	ACROSS THE BAY	E	5 x 10	—	1926
80	BRIDGE IN BURLINGAME	E	7 x 9	—	1926
81	A PIEDMONT HOME	E	7 x 9	—	1926
82	CONTRA COSTA HILLS	D	5 x 10	—	1926
83	CLAREMONT HOTEL	E	3½ x 4½	—	1926
84	QUIETUDE	E	3 x 5	—	1926

	TITLE	MEDIUM	SIZE	EDITION	DATE
85	CARMEL EVENING	E&SG	4 x 5	—	1926
86	CYPRESS GROUP	D	5 x 6½	—	1926
87	HOUSE ON THE ROCKS	D	5 x 6½	—	1926
88	THE TOWER OF BABEL	E	4 x 5	—	1926
89	SPANISH SHAWL	D	5 x 7½	—	1926
90	DROOPING SAIL	E	7 x 9	—	1926
91	FROM TELEGRAPH HILL	E	7 x 9	—	1926
92	TREE SKETCH	E	4 x 5	—	1926
93	PASS TO THE HILLS	E	7 x 8	—	1926
94	THE AVENUE	E	6 x 8	—	1926
95	PRESIDIO VIEW	E	5 x 6	—	1926
96	HILLSIDE HOUSES	E	5 x 7½	—	1927
97	STANFORD CHAPEL	E	5 x 6½	—	1927
98	ARCHWAY AT STANFORD	E	7 x 9	—	1927
99	A HOUSE IN SOCORRO	E	3½ x 4½	—	1927
100	THE SMELTER HUT	E	3½ x 4½	—	1927
101	SANTA FE CATHEDRAL	E	7 x 9	—	1927
102	SANTA FE RIVER	E	7 x 9	—	1927
103	ROAD IN TAOS	E	7 x 9	—	1927
104	LOS RANCHOS VILLAGE	D	5 x 6½	—	1927
105	BLOSSOMS IN TAOS	E	5 x 6½	—	1927
106	TAOS MOUNTAIN	E	7 x 9	—	1927
107	BLOSSOMS	E	7 x 9	—	1927
108	ARCHED BRIDGE	E	7 x 9	—	1927
109	IN LAKESIDE PARK	E	5 x 7½	—	1927
110	PIEDMONT HILLS	D	7 x 9	—	1927
111	IN KENWOOD	E	6½ x 7½	—	1927
112	SILENT PINE	D	6 x 12	—	1928
1131	BURLINGAME HILLS	E	3½ x 4½	—	1928
114	NEAR PESCADERO	E	8 x 10	—	1928
115	OLD CYPRESS TREES	E	8 x 10	—	1928
116	NIGHT AT THE GOLDEN BOUGH	E	5 x 7½	—	1928
117	MONTEREY WHARF	E	5 x 7½	—	1928
118	ON "THE DRIVE"	E	4 x 7	—	1928
119	OLD MISSION	E	8 x 10	—	1928
120	CYPRESS AND ROCKS	E	4 x 5	—	1928
121	HOTEL DEL MONTE	E	5½ x 7½	—	1928
122	WHITE FOAM	E&SG	5 x 6½	—	1928
123	FEBRUARY DAY	E	5½ x 7½	—	1928
124	IN OLD MONTEREY	E	5 x 6	—	1928
125	ON POINT LOBOS	E	4 x 7	—	1928

TITLE	MEDIUM	SIZE	EDITION	DATE
126 BENDING TREE	E	4 x 5	—	1928
127 CARMEL VALLEY FARM	E	8 x 10	—	1928
128 SLENDER CYPRESS	E	8 x 10	—	1928
129 TREES BY MOONLIGHT	E&A	5 x 7½	—	1928
130 ON THE CLIFFS	D	5½ x 7½	—	1928
131 MONTEREY BAY	E	8 x 10	—	1928
132 BRIDGE IN GLEN ELLEN	E	4 x 5	—	1928
133 BUCKEYE TREES	E	4 x 6	—	1928
134 RUSTIC BRIDGE	E	4 x 6	—	1928
135 THE TWO BRIDGES	E&A	6½ x 7	—	1928
136 IN SAN MATEO	D	5 x 6½	—	1928
137 THE CLIFF HOUSE	D	5 x 6½	—	1929
138 WINDY DAY	E	5 x 6½	—	1929
139 ON THE BERKELEY CAMPUS	E	5 x 6½	—	1929
140 PARK IN CHINATOWN	E	5 x 6½	—	1929
141 WHITE SAILS	E	6½ x 7	—	1929
142 BERKELEY HOUSETOPS	D	6 x 8	—	1929
143 MT. DIABLO	E	6 x 8	—	1929
144 SPRING VALLEY LAKE	D	5 x 6½	—	1929
145 FROM THE PRESIDIO	E	5 x 6	—	1929
146 BERKELEY HILLS	D	5 x 6	—	1929
147 UNIVERSITY LIBRARY	D	5 x 6½	—	1929
148 IN CLAREMONT HILLS	D	5 x 6	—	1929
149 ACROSS THE CAMPUS	D	5 x 7	—	1929
150 RUSSIAN HILL	D	8 x 10	—	1929
151 HILL GUARDIANS	D	5 x 7	—	1929
152 MARIN TOWN	E	6 x 9	—	1929
153 SANTA BARBARA MISSION	E	5 x 6	—	1929
154 EL PASEO-SANTA BARBARA	E	5 x 7¼	—	1929
155 IN THE SAMARKAND GARDENS	E	5 x 7¼	—	1929
156 COURTHOUSE AT SANTA BARBARA	E	5 x 6	—	1929
157 MOUNTAIN HEMLOCK	D	5 x 7¼	—	1929
158 TIOGA LAKE	E	5 x 6	—	1929
159 SIERRA STREAM	E	3½ x 4½	—	1929
160 AH-WAH-NEE HOTEL	E	5 x 6½	—	1929
161 PINNACLE AND LAKE	E	5 x 7¼	—	1929
162 MIRROR LAKE, YOSEMITE	E	5 x 6	—	1929
163 CATHEDRAL ROCKS	E	6 x 8	25	1930
164 SIERRA LAKE	E	8 x 10	25	1930
165 YOSEMITE VILLAGE	E	6 x 8	25	1930
166 HALF DOME-EVENING	E&A	5 x 7	25	1930
167 EARLY MORNING	A	4 x 5	25	1930

	TITLE	MEDIUM	SIZE	EDITION	DATE
168	IN YOSEMITE VALLEY	E	6 x 7	25	1930
169	LAKE NOCTURNE	E&A	6 x 7	35	1930
170	WINTER OAK	E	5 x 7	35	1930
171	SIERRA CLIFFS	D	4 x 6	15	1930
172	DEEP VALLEY	D	3½ x 4½	15	1930
173	BIG SUR FARM	E	6 x 8	35	1930
174	CARMEL MISSION	E	5 x 10	35	1930
175	SEA GULCH	E&A	6 x 8	15	1930
176	STALWART CYPRESS	E	6 x 8	75	1930
177	SUNLIT COVE	E	6 x 8	75	1930
178	SERENITY	E&A	5 x 7	75	1930
179	OCEAN MIST	E&A	5 x 7	50	1930
180	ROAD TO THE SEA	E&A	5 x 7	15	1930
181	ROCKY CREST	E&A	6 x 7	50	1930
182	CALM HARBOR	D	5 x 7	15	1930
183	CHINATOWN ALLEY	E	5 x 7	25	1930
184	JAPANESE TEA GARDEN	E&A	5 x 7	25	1930
185	THE MALOLA	D	5 x 7	15	1930
186	MORNING SUNLIGHT	D	5 x 6	15	1930
187	PLACID HARBOR	D	5 x 6	15	1930
188	OLD SCHOONER	D	6 x 9	15	1930
189	SAN FRANCISCO WHARVES	D	6 x 9	15	1930
190	IN GOLDEN GATE PARK	D	7 x 8	25	1930
191	THIRD STREET ESTUARY	D	6 x 8	25	1930
192	PRESIDIO WHARF	D	6 x 8	15	1930
193	EUCALYPTUS IN GOLDEN GATE PARK	E&A	7 x 8	25	1930
194	YACHT HARBOR	D	6 x 8	25	1930
195	LOADING HAY	D	6 x 8	25	1930
196	DRYING SAILS	D	6 x 8	25	1930
197	OUR LADY OF GUADALUPE	D	6 x 8	25	1930
198	SHIP PAINTING	D	6 x 8	25	1930
199	SAN FRANCISCO BAY	D	5 x 10	25	1930
200	EUCALYPTUS DWARF THE CAMPANILE	E&A	5 x 6½	15	1930
201	ROAD TO THE QUARRY	D	8 x 10	15	1930
202	CORNER OF OLD SAN FRANCISCO	D	8 x 10	15	1930
203	LAKE IN THE PARK	E	7 x 10	25	1930
204	SAN FRANCISCO-OLD AND NEW	E	7 x 10	75	1930
205	CANADIAN ROCKIES	E	3½ x 4½	25	1930
206	YELLOWSTONE LAKE	E	7 x 9	25	1930
207	MORAINE LAKE	D	4 x 7	15	1930
208	CANADIAN CRAGS	E	6 x 7	50	1930
209	AUGUST AFTERNOON	D	8 x 10	15	1930

	TITLE	MEDIUM	SIZE	EDITION	DATE
210	PEACEFUL HILLS	D	5 x 10	35	1930
211	THE CAMPANILE-EVENING	D	5 x 8	35	1930
212	CLAREMONT HILLS	D	7 x 8	25	1930
213	CITY	D	3½ x 4½	15	1931
214	YOUNG EUCALYPTUS	D	3½ x 4½	15	1931
215	FROM MY WINDOW	D	4 x 7	15	1931
216	COUNTRY ROAD	D	6 x 9	15	1931
217	MORNING IN THE HILLS	E	8 x 10	25	1931
218	SAUSALITO HILLSIDE	D	6 x 7	25	1931
219	TREE VIGOR	D	5 x 6	25	1931
220	EUCALYPTUS AND HILLS	E	4 x 6	25	1931
221	MOUNTAIN LAKE	D	3½ x 4½	15	1931
222	ELEMENTS	D	5 x 10	25	1931
223	THUNDERHEAD	D	4 x 6	25	1931
224	DESERT SKETCH	D	4 x 6	25	1931
225	RIO GRANDE GORGE	D	5 x 7	25	1931
226	NORTH PUEBLO-TAOS	D	5 x 10	15	1931
227	SPRING RAIN	D	5 x 7½	15	1931
228	STREET IN TAOS	D	5 x 7	15	1931
229	MARIN COUNTY ROAD	D	7 x 9	25	1932
230	CHINATOWN STORE-SAN FRANCISCO	D	6 x 7	25	1932
231	THE BAY FROM BERKELEY	D	6½ x 8	15	1932
232	ENGINEERING BUILDING	D	5 x 7	15	1932
233	BERKELEY HILLSIDE	D	6½ x 8	15	1932
234	SEA AND CYPRESS	D	3½ x 4½	25	1932
235	ALONG MONTEREY COAST	D	5 x 7	25	1932
236	LAKE TAHOE	D	5 x 6	25	1932
237	NEEDLES, CALIFORNIA	E	5 x 10	25	1032
238	DESERT CLOUDS	E	4 x 7	50	1932
239	ARID LAND	D	5 x 10	20	1932
240	SUN-IN-THE-WEST	D	6 x 8	15	1932
241	TAOS VALLEY	D	6 x 8	25	1932
242	SHADOWED MOUNTAIN	E	6 x 8	50	1932
243	MEXICAN HOUSES	E	7 x 9	50	1932
244	THE SPINNER	E	5 x 6	15	1932
245	ASPENS	E	5 x 7	25	1932
246	RAIN ON TAOS MOUNTAIN	E	7 x 9	25	1932
247	CAMPO SANTO	D	7 x 10	25	1932
248	INDIAN BREAD	D	8 x 10	25	1932
249	RESURRECTION	D	5 x 6	15	1932
250	DESERTED MINING TOWN	D	4 x 7	15	1932

	TITLE	MEDIUM	SIZE	EDITION	DATE
251	INDIAN MOONLIGHT SONG	D	6 x 7	25	1932
252	INDIAN PUEBLO	E&A	7 x 8	15	1932
253	STEPS TO THE SKY	D	8 x 10	25	1932
254	RED DEER SINGING	D	8 x 10	35	1932
255	DRUM PATTERN	D	8 x 10	35	1932
256	TAOS CORN DANCE	E&A	6 x 6½	35	1932
247	MEXICAN WOOD VENDOR	E&D	5 x 6	15	1932
258	NIGHT CEREMONY OF THE PENITENTES	D	6 x 8½	35	1932
259	MEXICAN VISITORS	D	5 x 7	15	1932
260	RHYTHM OF THE TOMTOM	D&A	8 x 10	35	1932
261	MEXICAN FAMILY	D	5 x 6½	15	1932
262	SPANISH SONG	D&A	5 x 7	15	1932
263	INDIAN DANCERS-TAOS PUEBLO	D&A	8 x 10	25	1932
264	ACROSS TAOS VALLEY	D&A	5 x 8	15	1932
265	MASS AT SANTA CLARA	D&A	6 x 7	15	1932
266	INDIAN POTTERY VENDORS	D&A	5 x 10	25	1932
267	NIGHT CLOUDS	D&A	4 x 7	25	1932
268	NEW MEXICAN SUMMER	D&A	5 x 7	25	1932
269	FIESTA DAY-SANTO DOMINGO	D	8 x 10	15	1932
270	APACHE JIM	D	5 x 7½	15	1933
271	SANTIAGO	D	5 x 7½	25	1933
272	ASENCIÓN	D	5 x 7	25	1933
273	UKALAE	D	5 x 6½	25	1933
274	THE KIVA	D	6 x 8	35	1933
275	THE GIFT DANCE	D	5 x 10	15	1933
276	RANCHOS MOUNTAINS	D	8 x 10	15	1933
277	PROVINCE OF THE TIGUAS	D	10 x 12	15	1933
278	SANTO DOMINGO CORN DANCE	E&D	10 x 12	15	1933
279	SANTO DOMINGO SINGERS	D	6 x 8	15	1933
280	ARROYO SECO MOUNTAINS	E&D	4 x 5	25	1933
281	HAYING TIME	D	7 x 9	25	1933
282	THREE INDIANS	D	8 x 10	35	1933
283	PUEBLO HARVEST TIME	E&D	5 x 6½	25	1933
284	WINTER STREAM	E&D&A	8 x 10	35	1934
285	DANCING LEAF	D	5 x 7¼	25	1934
286	CORN-ON-THE-STALK	D	5 x 7¼	25	1934
287	FOG WOMAN	D	5 x 7¼	25	1934
288	YOUNG TAOS INDIAN	D	4 x 6	15	1934
289	THE GUITAR PLAYER	D	5 x 7¼	15	1934
290	VAQUERO	D	6 x 7	15	1934
291	SNOW AND ADOBE	D&A	8 x 12	35	1934
292	INDIAN PUEBLO	D&A	10 x 14	30	1934

	TITLE	MEDIUM	SIZE	EDITION	DATE
293	INDIAN HARVEST	D&E	11 x 14	30	1934
294	INDIAN CEREMONIAL	D&E&A	11 x 14	30	1934
295	CHRISTMAS EVE-TAOS PUEBLO	D&A	11 x 14	30	1934
296	ÁCOMA	D	10 x 14	30	1934
297	NEW MEXICAN MOUNTAIN VILLAGE	D&E	11 x 14	30	1934
298	PENITENTE GOOD FRIDAY	D	11 x 14	30	1934
299	WINTER MASS	D&A	10 x 14	30	1934
300	THE SANCTUARY-CHIMAYÓ	D&A	11 x 14	30	1934
301	TAOS IN WINTER	D&A	10 x 14	50	1934
302	ALL SAINTS MORNING-TAOS PUEBLO	D&A	10 x 14	30	1934
303	NEW MEXICO WINTER	D&A	10 x 14	30	1934
304	CLIFFS OF THE RIO GRANDE	D	10 x 14	20	1934
305	PROCESSION OF THE PATRON SAINT-DOMINGO PUEBLO	D&A	11 x 14	20	1934
306	EVE OF THE GREEN CORN CEREMONY-DOMINGO PUEBLO	D&A	11 x 14	130	1934
307	RUGGED LAND	D&A	11 x 14	30	1934
308	THE REMOTE VILLAGE	D&M	11 x 14	30	1934
309	WIND CLOUD	D&A&M	7½ x 15	30	1934
310	RED WATER FLOWER	D	6 x 8	20	1934
311	DESERT PEACE	D	7½ x 15	20	1934
312	DELIGHT MAKERS-TAOS PUEBLO	D&M	8 x 15	20	1935
313	OLD MINE OF THE MOUNTAINS	D&A	10 x 14	20	1935
314	SUMMER COTTONWOODS	D	10 x 14	30	1935
315	TAOS DEVIL DANCE	D&A	11 x 14	30	1935
316	THE SKY ANSWERS DOMINGO	D&A&M	11 x 14	30	1935
317	WINTER WOOD ROAD	D&A	8 x 11½	30	1935
318	MOJAVE DESERT MORNING	D&A	10 x 14	20	1935
319	FISHERMAN'S WHARF-SAN FRANCISCO	D&E	7 x 9	30	1935
320	ACROSS THE GOLDEN GATE	D	7 x 8	15	1935
321	THE CLIFF HOUSE	E	6 x 10	35	1935
322	TELEGRAPH HILL-EVENING	D&A	10 x 12	30	1935
323	SAN FRANCISCO YACHT HARBOR	E	9 x 10	75	1935
324	COIT TOWER FROM RUSSIAN HILL	E	9 x 10	50	1935
325	SAN FRANCISCO FROM BELVEDERE	D&E	9 x 10	50	1935
326	BRIDGE TOWER-AUGUST 1935	D	7 x 10	20	1935
327	CABLE SPINNING-SAN FRANCISCO BAY BRIDGE	D	11 x 14	20	1935
328	GRAY DAY, TIBURON	D&A	10 x 14	50	1935
329	CITY	D&A&R	11 x 14	30	1935
330	ROAD TO TAOS	D	10 x 14	20	1935
331	SNOW BLOSSOMS	D	6 x 7	20	1935
332	APRICOT AND CHOKECHERRY TREES	D	6 x 8	20	1935
333	SUMMER FLOWER	D	6 x 8	20	1935
334	CHURCH AT TRAMPAS	D&R	9 x 12	30	1936

	TITLE	MEDIUM	SIZE	EDITION	DATE
335	RIO GRANDE PUEBLO	D&R	9 x 12	30	1936
336	NEW MEXICAN VILLAGE	D	9 x 12	30	1936
337	RANCHITO	D	9 x 12	30	1936
338	RIO GRANDE GORGE	D&A	10 x 14	30	1936
339	CALIFORNIA COAST	E	9 x 12	75	1936
340	MENDOCINO COAST	D	9 x 12	50	1936
341	NOONTIME-FISHERMAN'S WHARF	D	9 x 12	30	1936
342	GOLDEN GATE BRIDGE	D	8½ x 11½	30	1936
343	SANDIA MOUNTAINS	D	7 x 8	15	1937
344	DESERT PEAKS	D&A	11 x 14	30	1937
345	NIGHT MASS AT OUR LADY OF DOLORES	D&A	9 x 12	30	1937
346	ADOBE AND COTTONWOODS	D	6½ x 8	30	1937
347	VILLAGE PLAZA-NEW MEXICO	D	6 x 8	30	1937
348	TURTLE DANCE-TAOS PUEBLO	D&A	11 x 14	35	1937
349	PENITENTE PRAYER	D&A	11 x 14	25	1937
350	WESTERN PINE	D&E	10 x 14	25	1937
351	PROCESSIONAL-NEW MEXICAN CHURCH	D&SG&R	11 x 14	50	1937
352	PINES ON POINT LOBOS	E	7 x 9	75	1938
353	COAST SENTINEL	E	7 x 10	75	1938
354	PINES AND PELICANS	E	11 x 14	75	1938
355	STRENGTH FROM THE SEA	E	9 x 12	75	1938
356	EUCALYPTUS AT EVENING	E	6 x 7	75	1938
357	CIRCLE DANCE-TAOS PUEBLO	D&A	11 x 14	30	1939
358	NEW MEXICO HARVEST	E&D&A	10 x 14	30	1939
359	PENITENTE FIRES	D&A	11 x 14	50	1939
360	MORNING WORSHIP	E&D&A	11 x 14	30	1939
361	FAR ACROSS THE RIO GRANDE	E	10 x 14	75	1939
362	ADOBE OVENS	E	4 x 6	50	1940
363	PUEBLO POTTERY VENDORS	E	5 x 10	20	1940
364	INDIAN STORYTELLER	E	6 x 8	20	1940
365	RIDE OVER THE DESERT	E	5 x 10	20	1940
366	POTTERY VENDORS	E&D	6½ x 8	20	1940
367	HORSERACE OF TAOS INDIAN JESTERS	E	11 x 14	20	1940
368	TAOS INDIAN GIFT DANCE	E&D	11 x 14	50	1940
369	IN THE ROCKIES	E	3½ x 4½	20	1940
370	SUMMER EVENING IN NEW MEXICO	D&A	9 x 12	75	1941
371	CHAMA HILLS	D&A	11 x 14	50	1941
372	THE OPEN ROAD	D&A	10 x 14	50	1941
373	WINTER FIELDS	D&A	11 x 14	50	1941
374	CHURCH OF THE STORM COUNTRY	D&A	11 x 14	50	1941
375	ROAD IN RANCHOS	E	5 x 7	75	1941

TITLE	MEDIUM	SIZE	EDITION	DATE
376 NOONDAY SHADOWS	E	7 x 8½	75	1941
377 LATE SUNLIGHT ON THE CLIFFS	E&D&A	11 x 14	75	1941
378 WINTER WOODS	E	7 x 8½	75	1941
379 INDIAN OVENS	E	5 x 7	75	1941
380 SOUTH HOUSE	E	5 x 7	75	1941
381 EUCALYPTUS TREES	E	6 x 7	75	1942
382 POINT LOBOS SHORE	E	5 x 10	20	1942
383 CORN DANCE	E	2⅝ x 5¼	50	1943
384 SAINT'S DAY	E	2⅝ x 5¼	50	1943
385 THE WHEAT FIELD	E	8 x 11	75	1943
386 INDIAN SUMMER	E	8½ x 11	75	1943
387 SNOWY BANKS	E	8 x 10	75	1943
388 ADOBE WALLS	E&D	3½ x 4½	75	1943
389 SUNDOWN DANCE	E&D&A	11 x 14	50	1944
390 HERE COME THE SINGERS	E&D&A	11 x 14	50	1944
391 TURTLE DANCE AT SUNRISE	E&D&A	11 x 14	50	1944
392 TRANQUILITY OF WINTER	E	7½ x 15	75	1944
393 ADOBES IN THE SNOW	E	8½ x 11	75	1944
394 JANUARY EVENING	D&A	7½ x 11½	50	1944
395 DECEMBER AFTERNOON	D&A	7¼ x 9	75	1944
396 SONG AT SUNDOWN	E&D&A	11 x 14	30	1944
397 TAOS INDIAN JESTERS	E&D&A	11 x 14	30	1944
398 WINTER PASTORAL	D	6 x 7	20	1944
399 SOUTHWESTERN SUMMER	E&D	10 x 12	125	1945
400 PILAR	D&A	9 x 12	75	1945
401 ROCKY MOUNTAIN VILLAGE	D&A	9 x 12	50	1945
402 GORGE SHADOWS	D&A	11 x 14	50	1945
403 WINTER DEER DANCE	D&A	12 x 15	35	1946
404 CHAMA RIVER CLIFFS	D&A	10 x 15	30	1945
405 CHRISTMAS EVE-TAOS PUEBLO	D	12 x 15	75	1946
406 SOUTHWESTERN LANDSCAPE	D	10 x 12	15	1946
407 TIMSY SLEEPING	D	5 x 7½	15	1946
408 OCEAN FOAM	E	8 x 11	50	1946
409 ON THE ROCKS	E	10 x 12½	75	1946
410 OAKS IN SPRING	E	12 x 15	25	1946
411 AFTERNOON ON MT. DIABLO	E	12 x 15	75	1946
412 ALONG THE RIVERBANK	D	10 x 14	25	1947
413 MORNING AFTER SNOWFALL	D	10 x 14	35	1947
414 PEÑASCO VALLEY	D	11 x 14	35	2947
415 ROCKY CRAG LAKE	D	11 x 14	15	1947
416 RIVER AT EVENING	D	10 x 14	10	1947
417 WAR'S END	D	8 x 9½	10	1947

	TITLE	MEDIUM	SIZE	EDITION	DATE
418	APPROACH OF THE VICTORS	D	8 x 9½	10	1947
419	MESA VERDE CLIFF DWELLING	D&A	10 x 12	35	1947
420	THE CAVE OF SILENT SHADOWS	D&A	12 x 17	35	1947
421	EVENING IN THE WOODS	E&D	11 x 14	35	1947
422	SURVIVAL	D&A	12 x 13½	35	1948
423	EXILED	D&A	12 x 18	35	1948
424	DELIVERANCE	D&A	12 x 13½	15	1948
425	MONUMENT TO SPACE	D&A	10 x 15	35	1948
426	RESIGNATION	D	9 x 12	15	1948
427	TAOS MOUNTAIN AND THE PENITENTES	D&A	12 x 15	35	1948
428	THE OLD ROAD TO TAOS	D	12 x 15	35	1948
429	RIVER DUSK	D&E	10 x 15	35	1948
430	RIO GRANDE FOOTBRIDGE	D	10 x 14	35	1948
431	PROCESSIONAL-TAOS	D	10 x 14	250	1948
432	SOUTHWESTERN PASTORAL	D	9 x 12	15	1948
433	INDIAN MOONLIGHT SONG	D&A	10 x 14	35	1948
434	RETURN OF THE WOODGATHERERS	D&A	10 x 14	35	1949
435	SONG OF CREATION	D	12 x 15	75	1949
436	RED DEER FISHING	D	10 x 14	15	1949
437	CALL TO THE RAINGOD	D	11 x 14	25	1949
438	SUNSET AND EVENING STAR	D&A	12 x 15	35	1950
439	THE INTERPRETER	D	6½ x 7½	25	1950
440	RAIN IN TAOS VALLEY	D&A	11 x 14	50	1950
441	SELF PORTRAIT AND THE GOLDEN GATE	D	11 x 14	10	1951
442	VILLAGE EVENING	D	8 x 11	25	1951
443	INDIAN JESTERS MAKING DUST	D	10 X 14	25	1951
444	PACIFIC COAST EVENING	D	10 x 14	35	1952
445	PUEBLO FIRELIGHT DANCE	D&A	12 x 17	50	1952
446	FIESTA DAY POTTERY VENDORS	D	10 x 14	15	1952
447	CEREMONIAL DAY AT TAOS	D	9 x 12	75	1953
448	GORGE OF THE RIO GRANDE	D	11 x 14	25	1953
449	CLOUDS AT SUNSET	D&A	9 x 14	250	1953
450	FRIENDSHIP DANCE	D	9 x 12	200	1953
451	RIDERS AT SUNDOWN	D&A	8½ x 12	75	1953
452	MOONLIT KIVA	D&A	12 x 15	75	1953
453	APACHE WOMAN AT THE FIESTA	D	11 x 14	75	1954
454	HORSEPLAY OF THE INDIAN JESTERS	D	11 x 14	35	1954
455	FOG OVER THE GOLDEN GATE	D&A	11 x 14	35	1954
456	WATCHING THE CLOWNS AT OLD COCHITÍ	D	9 x 12	35	1954
457	YOUNG APACHE WIFE	D	9 x 12	35	1954
458	TAOS EAGLE DANCERS	D&A	11 x 14	35	1955
459	DANCE AT DOMINGO	D&A	11 x 14	35	1955

	TITLE	MEDIUM	SIZE	EDITION	DATE
460	CLAN CHIEF	D	11 x 14	15	1955
461	MOONLIGHT CIRCLE DANCE	D&A	8 x 10	110	1956
462	RAIN DANCE BEGINNING AT OLD TAMAYA	D&A	8 x 11	75	1956
463	FEATHER DANCER	I	11 x 14	25	1956
464	WINTER ROUNDUP	D&A	9 x 15	35	1957
465	PENITENTE MORADA	D&A	9 x 15	15	1957
466	GRAY DAY-BELVEDERE	D&A	10 x 14	25	1957
467	SHIELD DANCERS	D	11 x 14	35	1958
468	ANCESTOR SPIRIT	D	12 x 15	35	1958
469	ALL SOULS DAY GIFTS	I	10 x 14	25	1958
470	MANUELITA	D	10 x 14	35	1959
471	BUFFALO-DEER DANCE AT JEMEZ	D&A	10 x 15	35	1959
472	SAINT'S DAY PROCESSIONAL	D	10 x 15	35	1959
473	FIESTA DAY	D	11 x 14	15	1959
474	ZERO WEATHER	D&A	9 x 15	35	1960
475	HER GRANDMOTHER SPUN SO	E	10 x 14	15	1960
476	GIFT-BEARING AT DAWN	E&D	10 x 15	50	1960
477	TRIBAL MEMORY	I	10 x 15	15	1960
178	PUEBLO GOVERNOR	I	7½ x 15	15	1960
479	LA NIÑA	I	11 x 14	35	1960
480	CHERRY BLOSSOM TIME	D&SG	11 x 14	25	1960
481	CORN HUSKING-TAOS PUEBLO	D&E	11 x 14	35	1960
482	HUNTERS IN THE SNOW	E	11 x 14	35	1960
483	ADOBE HOUSES AND TAOS MOUNTAIN	E&D	11 x 14	50	1960
484	HORSES ON A SNOWY HILL	D&A	11 x 14	35	1960
485	VICTORY DANCE MOTIF	D&A	12 x 15	35	1960
486	OLD MAN'S SONG	D	7 x 9	15	1960
487	CHRISTMAS EVE FIRES	D&A	12 x 18	35	1960
488	RAIN OVER WIDE LANDS	D&A	11 x 18	25	1960
489	SINGERS OVER THE BRIDGE	E&D	11 x 14	35	1960
490	KERESAN DANCERS	E&D	11 x 14	35	1962
491	WINTER SOLSTICE DANCE	E&D	12 x 18	35	1962
492	MAGPIES AND RED-TAILED HAWK	E&D	9 x 15	35	1962
493	SAN FELIPE BUFFALO DANCERS	E	12 x 15	50	1962
494	YOUNG NAVAJO MOTHER	E&D	11 x 14	35	1962
495	CRYSTAL RIVER CANYON	E	11 x 14	50	1963
496	ROCKY MOUNTAIN VALLEY	E	12 x 18	50	1963
497	FIESTA AFTERNOON	E&D	12 x 18	50	1964
498	EVOCATION	I	11 x 14	15	1964
499	OPEN RANGE	E	7½ x 15	50	1964
500	THE ARCHER	I	12 x 15	50	1964

	TITLE	MEDIUM	SIZE	EDITION	DATE
501	FORCE AND FATE	D	11 x 14	35	1965
502	CHANCE ENCOUNTER	E&D	12 x 15	50	1965
503	OF TAOS AND APACHE LINEAGE	D	10 x 15	50	1965
504	INDIAN SINGER	D&E	10 x 14	50	1965
505	CRUSITA	D	9 x 15	50	1965
506	PUEBLO LEADER	D&E	11 x 14	50	1965
507	APACHES A-VISITING	I	11 x 14	50	1965
508	INDIAN INFUSION	I	13 x 18	75	1965
509	SNOW ON THE DALLAS DIVIDE	E&D&A	13 x 18	75	1967
510	AT THE LITTLE BRITCHES RODEO	E	11 x 14	5	1967
411	GUNNISON RIVER CLIFFS	E	12 x 18	75	1967
512	A MORNING IN APRIL	E&D	11 x 14	50	1967
513	MINE ON RED MOUNTAIN	E&D	5 x 6	50	1967
514	MINE AND MOUNTAIN SKETCH	E	11 x 18	50	1967
515	SO THEN	D	10 x 14	7	1967
516	PENITENTES BY MOONLIGHT	E&D&A	11 x 14	50	1967
517	SUNDOWN	E&D&A	12 x 18	50	1967
518	RETURN OF THE PROCESSIONAL	E&D&A	13 x 18	50	1967
519	THE JOURNEY	I	6 x 10	50	1967
520	PEAKS OF PAONIA	E	9 x 15	75	1968
521	THE COLORADO ABOVE MOAB	E&D	11 x 18	10	1968
522	RIVER TOWERS	E&D&A	13 x 18	75	1967
523	FEBRUARY IN THE SAN JUANS	E	13 x 18	75	1968
524	HIGH IN THE ROCKIES	E&D	10 x 18	75	1968
525	WINTER IN TELLURIDE	E&D	12 x 15	75	1968
526	WHERE RUBY SILVER IS FOUND	E	12 x 15	75	1968
527	REFLECTION	I	11 x 14	50	1969
528	CEREMONIAL BASKET	I	8 x 10½	75	1969
529	IN THE WAR DANCE	1	11 x 14	35	1969
530	FIESTA PARASOL	E	11 x 14	75	1969
531	DEER DANCE	3	13 x 18	75	1969
532	CHERRY BLOSSOM TIME 2ND STATE	D&SG	11 x 14	50	1969
533	BUFFALO DANCE MAIDEN	I	8 x 11	75	1970
534	FEATHER DANCER-DOMINGO	E	11 x 14	75	1970
535	ALL SOULS DAY OFFERING	I	10 x 15	75	1970
536	CHACO CANYON RUINS	I	13 x 18	11	1970
537	WATCHING A WINTER DANCE	I	9 x 12	75	1971
538	THE VISITOR'S TALE	E&D	10 x 14	35	1971
539	AGE-OLD RHYTHM	E&D	12 x 15	50	1972
540	MIDSUMMER FIESTA	E&D	12 x 15	50	1972
541	WAR'S END 2ND STATE	E&D	8 x 9½	35	1972
542	TRIBUTE TO THE EARTH	E&D&A	12 x 15	25	1972

TITLE	MEDIUM	SIZE	EDITION	DATE
543 PUEBLO FEATHER DANCE	D	12 x 15	25	1973
544 ON WINDY POINT	D	12 x 15	25	1973
545 RABBIT HUNTERS ON THE WAY	D	10 x 18	35	1973
546 IN RANCHOS DE TAOS	E	5½ x 8	75	1973
547 COURTYARD IN CHIMAYÓ	E	7½ x 9	75	1973
548 TAOS VALLEY WINTER	E	9 x 15	75	1973
549 JANUARY MORNING	E	7½ x 9	75	1973
550 JESTERS COOLING OFF	E	7½ x 9	75	1973
551 TO A WEDDING IN NORTH HOUSE	E&D&A	12 x 15	50	1973
552 ALONG THE ROARING FORK	E&D	7½ x 9	75	1973
553 THE VALLEY OF VALDEZ	E&D&A	12 x 15	50	1973
554 NOSTALGIA	D&A	11 x 14	25	1973
555 CORN DANCE MAIDEN	E&D	4¼ x 5½	50	1973
556 WHISPER-HAUNTED CLIFF CAVE	E&D&A	11 x 14	50	1973
557 STAUROLITE LEDGE ABOVE TAOS	E&D&A	10 x 14	25	1973
558 YESTERYEAR IN TALPA	E&D&A	10 x 14	50	1973
559 "QUOTH THE RAVEN, NEVERMORE"	E&D&A	11 x 14	50	1973
560 SHADOWS OF THE EVENING	E&D&A	11 x 14	50	1973
561 ENDURING SANCTUARY	E&D&A	12 x 15	50	1973
562 DOMINGO BASKET DANCE	E&D	12 x 15	50	1973
563 NAVAJO CANYON CLIFFS	E&D	12 x 15	50	1974
564 A BYGONE DAY IN SANTA FE	D	9 x 12	35	1974
565 VILLAGE IN THE SNOW	E&D	9 x 12	35	1974
566 OLD PUEBLO ROAD	E&D	9 x 12	50	1975
567 ALBERTO'S BURRO	E&D	9 x 12	50	1975
568 MORNING AT THE PUEBLO	E	9 x 12	75	1975
569 CORN DANCERS COMING	E&D	11 x 14	50	1975
570 BLESSINGS ON SAN FELIPE DAY	I	13 x 18	75	1975
571 HONDO VALLEY WESTWARD	D	11 x 14	19	1976
572 OLD MESILLA	D	10 x 12	25	1976
573 TO THE CORRAL	E&D&A	9 x 15	50	1976
574 PROSPECTOR'S PALACE	E&D&A	13 x 18	50	1977
575 DESERT DRAMA	D&A	11 x 18	35	1977
576 WINTER SUNRISE	E&D&A	11 x 14	35	1977
577 BUTTES AT LUKACHUKAI	E&D&A	8 x 15	35	1977
578 END OF THE DANCE-COCHITÍ	D	9 x 15	25	1978
579 WINTERTIME DANCE-COCHITÍ	D	11 x 14	25	1978
580 PENITENTE EASTER	E&D&A	11 x 14	25	1979
581 ON CHRISTMAS DAY	E&D&A	11 x 14	25	1979
582 TIWA INDIAN GIRL	D	5½ x 8	15	1979
583 CENTURIES OLD	E&D&A	9 x 15	25	1979
584 SONG OF THE BUFFALO HUNT	E&D&A	11 x 14	25	1979

	TITLE	MEDIUM	SIZE	EDITION	DATE
585	DAWN DANCE BEGINNING	E&D&A	13 x 18	25	1979
586	ON THE ROAD TO LATIR LAKES	E	11 x 14	50	1979
587	CORN HUSKING TIME	E&D	9 x 12	50	1979
588	HARVESTING HAY THE OLD WAY	E&D	9 x 15	25	1979
589	STORMCLOUDS OVER VALLECITO	E&D&A	11 x 14	25	1979
590	FORSAKEN CHURCH ON THE EDGE OF THE GREAT PLAINS	E&D	10 x 15	25	1979
591	ROADSIDE POTTERY VENDORS	E&D	9 x 12	35	1979
592	TRIP TO TOWN	D	9 x 12	25	1979
593	DANCERS WILL BRING RAIN	E&D	9 x 12	25	1980
594	MT. WILSON AND NARROW GAUGE TRESTLE	E	9 x 15	25	1980
595	SHADOWED BUTTES	E&D&A	9 x 15	25	1980
596	PACIFIC COVE	E	9 x 15	75	1981
597	CYPRESS POINT	E	10 x 12	75	1981
598	PINE AND PEAK	E	9 x 15	75	1981
599	GHOST CITY	E&D	11 x 14	50	1981
600	WINDCARVED	E&D&A	11 x 18	25	1981

NOTES

The initialed codes for the mediums are:

A — AQUATINT E — ETCHING R — ROULETTE
D — DRYPOINT I — INTAGLIO, MIXED MEDIA SG — SOFT GROUND
 M — MEZZOTINT

Copper plates were used for all prints, except a few early zinc plates.
All prints were made by the artist herself, even the special steel-faced award editions sometimes numbering 250.
She ceased submitting prints for prizes and awards years ago because of the repetitive work involved and the biased attitude of modernistical juries, but for referential information the special plates are numbered from the general list and briefly explained as follows:

306 EVE OF THE GREEN CORN CEREMONY: *California Society of Etchers Associate Membership Prize, 1934, edition 100.*

399 SOUTHWESTERN SUMMER: *Prairie Printmakers Associate Membership Print 1945, edition 125.*

431 PROCESSIONAL-TAOS: *Society of Print Connoisseurs Publication 1948, edition 250.*
 (50 additional prints were allowed artist and re-named Christmas Processional at Taos.)

449 CLOUDS AT SUNSET: *Print Club of Albany Membership Print for 1952-53, edition 250.*

450 FRIENDSHIP DANCE: *Society of American Graphic Artists Membership Print 1953, edition 200.*

461 MOONLIGHT CIRCLE DANCE: *Printmakers of California Gift Print 1956, edition 125.*

441 SELF PORTRAIT AND THE GOLDEN GATE: *required by the National Academy of Design upon her election as an Associate in 1950*

Nine plates were made for the Public Works of Art Project in 1934, thirty prints of each distributed by the Government to various museums, public buildings and offices. The general list numbers of these plates are:
292, 293, 294, 295, 296, 297, 298, 299, 300. And in 1936 four more plates: 334, 335, 336, 337.

Gene Kloss

www.ingramcontent.com/pod-product-compliance
Lightning Source LLC
Chambersburg PA
CBHW041922180526
45172CB00014B/1364